Acclaim for Tom Savini's
GRANDE ILLUSIONS

We went into BRAINDEAD with our imaginations sparked by the *Grande Illusions* book.
-Peter Jackson
Director, *Lord of the Rings* Trilogy, *The Hobbit, King Kong (2005)*

It's fun to remember the more significant influences over our early work—Tom Savini's *Grande Illusions* was not far from my side as we conceived of solutions for the multitude of crazy gags that Peter wrote into the BRAINDEAD script. We took great inspiration from the pages of this most entertaining of "How To" books. I still have my dog eared and blood splattered copy sitting on my bookshelf here at the workshop.
-Richard Taylor
Creator of WETA Workshop, Academy Awards Winner for Special Effects

When I first bought my copy of *Grande Illusions*, it was a life changing moment. Even today, when an FX gag comes up, I think about how Tom would have done it!
-Gino Acevedo
Make-up Effects, *Lord of the Rings* Trilogy

The best special effects were done by William Tuttle (Twilight Zone) probably only second to Dick Smith (or the new make-up genius Tom Savini).
-Stephen King, *Danse Macabre*
Author

You can't think about the state of modern horror cinema without thinking about Tom Savini. I will never forget sitting in the Gateway Theater in Pittsburgh eating licorice and popcorn with a 102 temperature…but hell with the flu…it was the premiere of DAWN OF THE DEAD! Having grown up watching Chiller Theater and seeing NIGHT OF THE LIVING DEAD on that very program…I was (at 14 years old) primed and ready for this film. All I can say is from Wooley's head explosion to "Miguel" zombie's bite on the tenement woman…I was forever changed. *Grande Illusions* provided the first glimpse into Tom's genre changing take on the creation of special make-up effects. From misdirection to sleight of hand, his genius inspired legions of fans and budding effects artists alike…myself included. Like hordes of the undead, Tom has done for horror and make-up effects what Spielberg did for swimming! I am proud and honored to call him my mentor, my inspiration, and my lifelong friend.
-Greg Nicotero
Co-Founder KNB Efx Group
Make-up Effects, *The Walking Dead*

GRANDE ILLUSIONS

The Art and Technique of Special Make-Up Effects

Original Books I & II

From the Films of
TOM SAVINI

www.AuthorMikeDarkInk.com

Cover Design by: Kevin Hill Studios
Illustrations for Book I by: Phil Wilson
Illustrations for Book II by: Brad Hunter

Grand Illusions: Book I – First Published in 1983 by Imagine, Inc. and Morris Costumes.
Also published under the title *Bizarro* by Harmony Books in 1984.
Grand Illusions: Book II – First Published in 1996 by Morris Costumes.

Published by *AuthorMike Dark Ink*, 10/13/2013

www.AuthorMikeInk.com

AuthorMike Ink, Dark Ink and its logo are trademarked by *AuthorMike Ink Publishing*.

INTRODUCTION

I love the transition possible with make-up effects...Dick Smith calls it the Frankenstein Syndrome. Something...some creature...some character...(and happily)...some monster that didn't exist suddenly does with make-up effects. The artist as the mad doctor gives life, existence, to something that wasn't there before. And like me, the guy who created Jason for the *Friday the 13th* franchise, sometimes you get to kill the thing you created... just like Dr. Frankenstein.

The best make up effects that happen today are a combination of practical make up effects and CGI. Yes, I also love CGI when it's done right, when it's good, when it is mostly practical and a little CGI enhancement. I wish we had such a tool when I needed an edge to disappear, or the make-up had to be subtractive and not additive, in other words...say when a zombie needed to look sunken and shriveled but you had to "add" a make-up to make them look that way. CGI lets you "subtract" to achieve that shrunken shriveled look.

Today noses can be gone, eyes can be bigger and whole creatures can be created over someone wearing a helmet and a bunch of dots. The best zombies that exist today are what Greg Nicotero and his KNB are doing on the *Walking Dead*. They are mostly practical but when one needed to have its legs gone crawling a across a lawn...voila'...CGI.

There seems to be a collective dislike for CGI and I think that's because of the awful stuff that passes for realism. We are training a whole new generation of moviegoers to accept CGI as the norm. We old timers have to pretend what is happening is really up on that screen and some of us don't want to have to make that effort because we grew up watching Rick Baker turn someone into a werewolf and it happened right before our very eyes, or when you watched my stuff...it was physically happening right in front of you.

I wrote these books when physical make up effects were in their heyday, and even today make up effects are celebrated by such shows as Face Off...and some new ones on the horizon, and well...whenever you see really great make up effects.

My students are coming to my special make up effects program at the Douglas Education center from all over the world, and like me growing up, they want to create the monsters and the make-up effects magic they see all over their favorite films. There are some students that come to my school because they've seen my work, even though I may have done it twenty or thirty years ago. The constant re -issue of my films on DVD and Blue Ray keeps my effects and my name alive out there.

I can't tell you how many artists today tell me they started and learned so much from my books. Many of the make-up artists I know tell me they "learned to make teeth from my books," or my books "are the reason they are make-up artists today." So I am proud to have inspired such people who have gone on to inspire me. I hope my work can continue to inspire more people, which is why I have decided to combine both of my Grande Illusion books into one in order to make one comprehensive edition, available to fans and the next generation of artists.

Hopefully I'll see your work on the screen someday.

-Tom Savini

GRANDE ILLUSIONS BOOK I

By
Tom Savini

www.AuthorMikeDarkInk.com

TABLE OF CONTENTS

Dedicated to Lon Chaney, my first inspiration. And, to all the make-up magicians who have inspired me since: Rick Baker, Rob Bottin, John Chambers, Jack Pierce, Stan Winston, The Burmans, George Bau, Charles Schram, Chris Walas, Stuart Freeborn, Christopher Tucker, and especially Dick Smith, whose continuous, tireless efforts to improve the state of the art, and his unending kindness to those eager to learn, have affected us all.

SPECIAL MAKE-UP EFFECTS AND THE WRITER by Stephen King

PHOTO COURTESY LAUREL ENTERTAINMENT

I'll show you things beyond your wildest dreams.

For a writer of novels—particularly spooky ones—showing the reader such wild things comes so cheap it's positively disgusting. THE SHINING cost roughly 19 million dollars to produce as a film; it cost roughly $24.00 to produce as a novel—costs of paper, typewriter ribbons, and postage. The thing is, when it's on the page it's what Paddy Cheyefsky once called "mental work"...and you can't put a price on that. No more, I suppose, than you can put a price on the special effects artist's genius. And genius is what it is, when it's done right.

My wife read the original script for CREEP-SHOW with quiet enjoyment until she got to the final episode, a little trick with cockroaches called *"They're Creeping Up On You."* That one blew her wig.

"How in the name of God do you think Savini is ever going to do that?" she asked.

"Dear," I said with a writer's *I am divorced from such mundane things* grandiosity, "that's Savini's problem, not mine."

Not that I've ever really felt divorced from special effects; the child's wonder I felt at ten, watching Ray Harryhausen's flying saucers demolish the Capitol dome, the pillars in front of the Supreme Court, and the Washington Monument differs not at all from the child's wonder I felt at thirty-four when I saw JoBeth Williams go floating up the wall in Steven Spielberg's POLTERGEIST, or that head crawling away on spider's legs in John Carpenter's brilliant remake of THE THING, or the fellow in CREEPSHOW who comes lurching out of the grave to get his cake.

And from a practical standpoint, I found I wasn't quite as divorced from all those bugs as I thought I was going to be. After you've given an interview or two with drugged roaches crawling sluggishly all over your "Disco Is Dead" t-shirt, you tend to lose most of your artistic impartiality.

We had a couple of "bug-wranglers" from New York's Museum of Natural Science who handled the bugs on the set. Tom doesn't even *like* bugs. And yet he *was* involved, because in a lot of the shots, those aren't bugs at all. They're painted pistachio nuts. Whose idea? Tom Savini's. And when all those bugs come bursting out of E.G. Marshall's chest, that isn't Mr. Marshall at all, of course. It's an almost hellishly perfect cast. The tradition of the trade suggests that actors must suffer for their art, but nowhere is it written that they must explode for it.

If working with Tom on CREEPSHOW taught me anything about special effects and the writer, it is simply that guys like Tom, and Dick Smith, and Rob Bottin, and Ray Harryhausen, and Albert Whitlock, and all the rest...those guys make dreams real. I think that's a truth my heart knew all along. The movies have always been extravagant, but science fiction and fantasy films have always been the most extravagant of all. *We'll show you things beyond your wildest dreams* is what each promises, and while true fans can remember half a hundred (or half a *thousand*) special effects tricks that looked just like what they were—tricks—each can remember those magic times when writer, director, and special effects man worked together to make the promise true: moments like Regan's head turning all the way around in THE EXORCIST, or the little girl aging 80 years under the camera's unflinching gaze in THE HAUNTING, or the top of the zombie's head cut off by a helicopter rotor in DAWN OF THE DEAD.

"How did he do that?" You're baffled. "How in the name of *God* did he do that?" You're amazed. "Myra, did you see that? I mean, *did you see that???*" You are, literally, zonked with delight.

For the writer, it's mental work—oh, don't think I'm selling myself or my trade short; do you think coming up with stuff like that is *easy?*—but for the special effects guy it's physical work: a thing that comes with tubes, wires, mirrors, surgical appliances, glue, clay. More than any of those, I think it's a thing in the hands and the eyes. And more than either of those, it's a glorious, childlike thing of the imagination.

The writer sees it in his mind, and that's good. Seeing it on the screen, carried through with vision and daring, is wonderful. Special effects may not be the greatest thing about the movies—I would not argue that they are—but when anyone really *can* show you something beyond your wildest dreams, I'd have to argue that it's pretty damn fine.

STEPHEN KING

SPECIAL MAKE~UP EFFECTS AND THE DIRECTOR
by George Romero

The biggest part of the challenge facing a movie director is that disbelief must be suspended in the audience or all is lost. There is no more frustrating experience than to stand at the back of a theater and hear the cries and cat-calls of one of today's irreverent audiences when a film doesn't "pay off." In the fantasy and horror genres, perhaps the single most important contribution to that "pay-off" is made by the special effects artist.

I have worked with Tom Savini on four pictures, and in addition to having a good time with a good friend, I found a collaborative talent which is in synchrony with my tastes and my sensibilities. Rapport is all important. The last thing anybody needs on a movie set is to have to spend hours explaining an aesthetic or trying to communicate an idea. Tom understands the medium fully, he knows when one shot will cut to another and when it won't. Occasionally he will design something that must be photographed from a specific angle, but he doesn't apply pressure that way, nor does he try to take advantage of his status and power, which is a disease plaguing many a production.

We truly do collaborate and we truly do have a ball. When Tom and I discuss ideas, we wind up behaving like two little kids, standing up, jumping around, acting things out. Tom's enthusiasm is infectious, and I find myself listening to his descriptions as one of his fans might. I'm almost able to see the sequence as Tom bounces around and explains it; it's a kind of preview of coming attractions. Not only does Tom execute what the script calls for, but he often brings new ideas to the party. A particular sequence will stimulate him to create an effect or an effect he has dreamed up will stimulate me to create a sequence designed specifically for that effect's inclusion.

This synchrony of mind and spirit is invaluable to the whole because we find that we are never working against each other in any way, and this produces a kind of synergy which allows the finished product to emerge unified and with a sharper personality. This goes a long way toward the suspension of disbelief in an audience.

It is of vital importance for an effects person to understand the overall flow of a film, its peaks

and valleys. It's important to distinguish between moments that are light and moments that require tension. In tense moments, the effects must be more realistic so as not to shatter concentration. In lighter moments, one can be more outrageous, more tongue-in-cheek. Tom Savini is sensitive to all this, and he responds instinctively. I've seen him work for weeks on devices that he knew to be "important," and the results each time have been brilliant creations. Conversely, I've seen him bash effects out on the spot, confident that they would serve for the fleeting moment they would be on screen. The point is that he measures it all out, and because of his command of the whole filmmaking process, he can make those judgments.

Most of all, Tom is a movie fan. He sees more movies than I see, and I see a lot of movies. He enjoys the experience, he hasn't fully grown up. Stephen King says that there's a part of all of us who work in fantasy and horror which stays a "little kid" for as long as we live. We leave certain response centers open in our minds. No matter what our physical maturity does to the other aspects of our lives, we make it a point to leave that back-door unlocked so the muses might always enter.

If Tom didn't love what he was doing, he couldn't do it as well. That's the simple, if understated, truth. I've seen huge effects, done with huge budgets, that don't score the emotional bull's-eye which Tom's work always scores. He has a casual, easy style. His effects shuffle right into the fabric of a film and they therefore are more startling, more unexpected. You never know when they're going to pop up. They don't focus attention on themselves at the sacrifice of the total experience.

I've seen Tom Savini pull off everything from contemporary, realistic violence to gothic and supernatural monsters, and he has done it all with the aplomb of a master. He makes it all come alive. All the rest of us have to do is shoot it. No matter how heated the conditions, no matter how much the "pressure-cooker" is boiling on the set, I can look over and there's Tom on the floor with his tubing and catheters and syringes. He looks back, jiggles his eyebrows, and makes a little ventriloquist-like whistle that sounds like a cricket. I know he's ready. And I know that there's somebody on the set who is just as ready to play with the toys as I am.

Tom's doing it. He's making movies. Like Chaney, he's devoted to the illusion, devoted to the effect that illusion will have on the viewer. He's not holding back, and he's not cheating. A good illusionist is not a cheater, a good illusionist is a magician. He may use secret methods and concealed apparatuses, but his goal is not chicanerous. His goal is to delight and amaze the audience.

Not everyone will appreciate Tom's work, just as many don't appreciate my work. I often say that some people like horseradish, some don't. Some people like rollercoasters, some don't. The realistic depiction of violence has become a controversial topic of debate recently. Yet Grand Guignol has been a classical art form for decades, and the audience for that form should not be deprived of its guarded execution in the hands of a master of modern techniques. Those of us who work in the form embrace it. It doesn't give us nightmares. In fact, it sends us off to sleep tucked in, with the lights out, and with a satisfied smile on our faces. It's...fairy-tales. It's ghosts and goblins and things that go bump in the night. And it's a helluva lot safer than what we experience on our streets and in our wars. Because no matter how much disbelief is suspended, we all know it's only a movie.

Keep doin' it, Tom, and keep lovin' it. There's a bunch of us movie fans that are countin' on you. Oh, and don't give too much away in this book. If we know how it's done...we might stop believing it.

GEORGE ROMERO

FOREWORD

L et's talk about "gore" and me. I'm sitting here looking at pictures scattered all over my desk, looking at cut throats and severed arms and pictures of people with bullet holes in them. There's a lot of *gore* here! (I personally have been called "The Gore King" or "King of Splatter." Splatter effects have been called "Savini-like effects"—a book called *Splatter Movies* even went so far as to devote an entire chapter to me and my work in films.) Splatter, as it's called, is very "interesting" technically. I often show friends or acquaintances examples of what I consider to be fantastic magic tricks, illusions, sculptures and mechanisms that are a part of splatter effects, and they just look at me in a strange way and say, "God, you're *sick*." I'm probably one of few artists who shows his artistic accomplishments to people and is met with a "You're *sick*" reaction. ("*Demented*" was the latest.) So, let's have an understanding here between you and me.

When I see something gory on the screen—a cut throat, a head being blown off or something like that—and I say, "Ahhh...beautiful!", I'm not saying "beautiful" because it was gory; I'm saying it because it *worked*, it was a technical achievement that worked, it fooled me or the person sitting next to me who screamed out loud. It was an *illusion*. Now there has been some comment about my experiences in Vietnam, and some people have said that I have tried to recreate things that I saw there, or that Vietnam is what began my interest in make-up. Not so.

My interest in make-up began, when I was twelve years old, at my neighborhood movie theatre in Pittsburgh, The Plaza. I saw the movie MAN OF A THOUSAND FACES starring James Cagney, it was the story of Lon Chaney; *For those of you who might not know, Lon Chaney was one of the silent screen's greatest stars. He was an actor, a stuntman, and a terrific make-up artist.* Anyway, my life took a direction that day. It's not enough for me to say that the movie sparked my interest in make-up; something *more* happened to me. I flipped out. I went mad over it. Here I was, a twelve-year-old little Italian kid from a relatively poor neighborhood, watching a man become many different people and leading many lives through make-up and the movies. This was for me.

I changed immediately. Make-up became a passion. I tried to find out everything I could about it. I asked relatives and friends where on earth I could get my hands on some make-up. Where could I get a book or something that would show me how to use it? A cousin of mine once told me, when I asked him what they use in movies to stick hair onto people for beards and mustaches or—better yet—a werewolf, that they use Spirit gum. Believe it or not, I thought he said *spearmint* gum (having never heard the word Spirit gum before). So there I was, in my bedroom one day chewing spearmint gum, sticking it on my face and trying to attach hair to it. I said, "This *can't* be right." So I went to the library—Why didn't I think of that before?—and lo and behold I discovered Richard Corson's book *STAGE MAKE-UP*, the very bible of make-up then and now. My brother Anthony

told me about a costume store in downtown Pittsburgh that sold make-up. That did it. *I think the store is still in business today because of the money they got from me back then.*

So, now I had a book and a source for make-up. I neglected my schoolwork. I was only interested in make-up. When other kids were outside playing baseball or something, I was in my room screwing up my face, or reading a magazine called *FAMOUS MONSTERS OF FILMLAND*, to see more about LON CHANEY. I couldn't believe it, I could read and study pictures of the real LON CHANEY. The monsters, the ghouls, vampires and strange creatures, or weird make-ups from those pages were the interesting ones to try to copy. They were three dimensional.

My favorite movies were the monster movies, or horror movies, or scary movies, whatever you want to call them. I learned by experimenting. By doing. By making up myself or my friends as these monsters. I was creating monsters for a local television horror show host and for his personal appearances, or halloween parades. Once a traveling show came through featuring "live on stage at your local movie theatre, MONSTERS FROM HOLLYWOOD." They did a magic show and then actors would come out dressed as Frankenstein, the Wolfman and Dracula. The lights would go out and they would show two horror movies. The Frankenstein and Wolfman actors wore masks, but the Dracula was a kid that they would pick out of the audience and make up as Dracula. Guess who they picked? I was fourteen, I already had a make-up kit, I did my own Dracula, and they took me to every theatre they played in the Pittsburgh area paying me with chocolate milkshakes. This was my first make-up job.

It seems like I've always had a make-up kit. I had one with me when I was in the army. Before I left basic training, I turned my drill sergeant onto nonflexible collodian; a liquid plastic that will dry and shrink on the skin, forming scars. He wanted to use it on his face to scare the next batch of trainees coming in. When I was in Vietnam, I sent home for my make-up kit and beards and mustaches or created fangs for the friends I was stationed with.

So, my interest in make up did not begin in Vietnam, but I personally have trudged through muddy fields and found myself not three or four

11

feet away from a human body, *a human being*, blown nearly in half by a grenade blast. I have walked around and nearly stepped on a human arm, one end of it jagged and torn, and the other, its fist clenched and grabbing the ground, completely severed from the body it was once attached to. I have walked through hospitals, talking to friends who've had certain private parts of their bodies blown off, so I have been really close to gore. *Real* gore. When you're forced into a situation like that, your body, your mind, has a way of taking care of itself, of protecting you, and in my case, I felt a kind of safety behind my camera—as a combat photographer (MOS84630) photographing this stuff. There was a distance between me and it. Perhaps my mind was seeing it as special effects to protect me. It was a distance I could not cross until long after I came back from Vietnam.

I think whatever notoriety I have received comes from how *realistically* I create it. There's something about seeing the real thing that sets me apart from, let's say, some other make-up artists who have never experienced that.When I'm creating an effect,if it doesn't look good to me—real—doesn't give me that feeling I used to get when I'd see the real stuff, then it's just not real *enough* for me. I am definitely *not* a ''gore monger;'' I simply do my job well. (Alot of people just don't realize how much is involved, sculpture for example—whole heads, various parts of the anatomy, the mechanics, the painting, the formulas.) Creating gore has given me the notoriety, and without having done it I would not be where I am today. Where *is* that, you say? Working as a special effects make-up artist.

Now I'm more pleased to be getting away from the gore. When I first started, with DAWN OF THE DEAD and FRIDAY THE 13TH, there weren't many films like that around. They were blockbusters; they were different; *they showed everything*. And pretty soon every movie that came out was just another excuse to butcher people. They treated actors as slabs of meat, hiring them only to find unique ways of killing them. As we go through from film to film, you'll see sometimes that the only thing that changes from effect to effect is the *weapon*. Now all these gore movies were coming out, one gore movie after another—PAJAMA PARTY MASSACRE, how obvious. Why not THE CRAZY, UGLY MANIAC WHO SLICES UP NAKED PRETTY GIRLS IN THE WOODS?—but when I first started doing it I thought it was good because it showed the violence as being horrifyingly *ugly*, a turn-off; people would turn their eyes away from the screen because it was presented as being hideously ugly to murder somebody. (When I was a kid growing up, we saw nothing, because

you weren't *allowed* to show anything like that on screen. When a guy got shot, he simply fell down; it wasn't *ugly* to kill somebody then—it was easy, it was slick, neat and clean.) But, as more and more films came out, I felt that people were becoming desensitized to all the murder and death and blood and gore; they were going to movies *just* to see people murdered, so I'm more than happy that's on its way out and the *monsters* are making a comeback. (They remade THE THING, may possibly remake THE CREATURE FROM THE BLACK LAGOON, Rick Baker's fantastic ape creatures for GREYSTOKE, AMERICAN WEREWOLF IN LONDON, Rob Bottin's THE HOWLING... monsters, monsters and *more* monsters!) I was lucky enough to be able to do CREEPSHOW, which had monsters in it, intricate make-up and *some* gore (but it didn't *dwell* on the stuff; it was just part of the story), but mainly monsters, strange creatures, ghosts and unusual make-ups.

ILLUSION: Something unreal presented to us which fools us, makes us believe it's real, fools our eyes. A false perception. Deceptive appearance.

An ILLUSIONIST is a ''professional entertainer,'' a professional producer of illusions.

Illusions are like magic tricks. A magician is able to fool you with misdirection, making you look up at his snapping fingers while behind his back with the other hand he's doing something else. (Preparing a batch of flowers to ''appear before your very eyes,'' perhaps.) Because all of your attention is focused on his fingers snapping, you automatically assume that's also where *his*

attention is. You're just not ready for what the magician might pull out of his pocket and snap in front of you. The magician also has a variety of mechanisms, and because you don't know about them, it's easier to fool you with them. That is *exactly* what we do as illusionists, make-up artists, in the movies. We make you look at the right side of the screen while the monster leaps out from the left and—"Boom!"—scares you. We're able to *scare* you by fooling you, by misdirecting your attention, and there are countless—let me repeat, *countless*—mechanical devices that you know nothing about that help us fool you: fog machines, lightning machines, wind machines, peanut shells made to look like cockroaches (as in CREEPSHOW, for example), mechanical heads, heads fabricated from lifemasks of actors' heads that perhaps have empty sockets so eyeballs can shoot out or flamethrowers inside can shoot flames out.

Two seconds after you see the real actor scream or turn his head, in make-up similar to the fabricated false head, we instantly cut in the next frame to the false head; we've misdirected you to make you believe you've actually seen something happen to the real person. You must always remember that, on the blank screen, we only show you what we *want* to show you in order to fool you. (Or maybe you *shouldn't* always remember this. After all, you are there in the wonderful, magical darkness of the movie theatre to escape from this ridiculous planet to an adventure created by the illusionists. For us who are involved in the mechanisms, it's a little more difficult.)

Editing techniques are used when, as in FRIDAY THE 13TH, I want to fool you by making you think a real axe has gone crashing through a woman's head. I, of course, first show you the person screaming, *the real person* screaming, and then we cut to a shot of the *real axe* perhaps missing her and crashing into the wood or breaking through a window *to establish that the axe is real*. (First we establish that the *person* is real, then we establish that the *weapon* is real.) In the very next frame where we see the axe heading directly toward her, it's a *foam rubber axe*, but you don't realize that because, in continuity, you believe it's the same axe you saw seconds before crashing through something. For the extreme close-ups of the axe actually hitting her, we actually have a real axe in the false head of the actress. A split-second later, we show the real actress with a foam rubber axe glued to her head as she falls against the bathroom stall. This "continuity trick" fools you into believing you've seen what you haven't. (What we *want* you to see.)

ILLUSION: A false perception. We are "illusionists." Special make-up effects could easily be called "special make-up magic tricks." As we go through the different films I've done, and talk about how the effects were achieved, you'll get a sense of what it takes to create such illusions.

It's important to understand that this business is a constant learning process. Every job you do, you discover something new, and it's important to file each new discovery away for future reference. That's the fun of it, finding new goodies. Your attitude as you go into even the most basic things should be one of a *commitment*; you should be committed to an on-going adventure, *a learning adventure*.

The wonder and greatness of it all is the *experimentation,* the *learning experience*, inventing how to do something you've never done before. Playing scientist, realizing that not everything will work the first time around but knowing that your own individual techniques can be expanded and improved upon with each trial-and-error attempt. Putting all of this knowledge to work for you, it's important for the make-up artist to know where to go for information; the next best thing to knowing something is knowing where to find it.

I will attempt to guide you (wish me luck), in many cases step-by-step, in the creation of illusions. I will also explain how many of the special effects I have used in film were achieved so that you can gain a better understanding of technique by example. This book should in no way be considered a "short cut" to becoming a make-up effects artist (the work, after all, has to be done by you). There *is* no short cut, and no book can be considered *the* book on make-up effects. (It changes every time someone picks up a brush or wonders how to achieve an effect.) *GRANDE ILLUSIONS* is a learning manual, a guide for the beginner. *And hopefully more.*

TOM SAVINI

13

PRE-PRODUCTION SKETCHING

Pre-production (preparing sketches, planning work schedules, casting actors) is very important. You should be patient enough, and sometimes I'm not, to just sit and think the entire project through before you do anything (be it a mask, a special effect, a cast of someone's head and hands, or whatever). Before each stunt, the stuntman stands there—thinking about every little thing that his body is going to go through, everything his body needs to do to successfully complete the stunt. He thinks about every little detail over and over again, in a way priming his "computer" so that when he starts, his body already knows what it has to do to get through it. This same technique applies to make-up effects.

If a director or a producer comes to me and says, "We need a creature," but they just don't know what they want, where do I start? ("*The deepest dregs of the mind,*" that's where!) It has to do with experiences, environment. What scares me and why, even though what scares me might not be scary to someone else. *THE EXOR-CIST scared the hell out of me, but to some others it was laughable. Why? I think because I was raised a Catholic.* First of all, I wouldn't advise anyone to sit down and begin sketching immediately. I would just sit there and *think;* maybe pretend I'm just going to quickly turn my head and *see* it, just see that creature, that character, that face or whatever...just simply turn and see it in my mind's eye before anything else happens. If it's supposed to be scary, I'll see if it scares me; if it doesn't, I'll try to realize why and *make it* scare me. (What little curve of the eyebrow, what shape of the bone structure beneath the skin would really make it scarier? I'd just keep turning my head until I got a solid picture in my mind of what I want, and *then* I would start sketching.

Knowing how to storyboard and sketch exactly what you've pictured in your mind is very important because as soon as you begin to sketch, that creature you've imagined will begin to change before your very eyes. With a sketch in front of you, you'll be able to see what needs improved upon or changed. You may have to leave it and go back to it later to see it as it really is. Trick yourself as you did when you originally imagined

seeing the character—leave the sketch in a drawer where it will surprise you later and you'll see it differently for the first time (hopefully); you'll see it like someone else's work. (You need to look at your work as if it's someone else's, remain objective, so it will be easier to see the flaws and correct them.)

If you're involved in a movie situation, there's a time limit involved; you must stop at some point and realize this is what is created—*for now.* If you stayed with it, it would continue to change. You would reach a point where, like writer's block perhaps, it would slow down and you'd begin to think the whole thing was wrong from the start. You might realize, perhaps, that you should have taken a completely different approach and, if time permits, you'd begin from scratch all over again.

Even before you get your first make-up kit, get and cut out pictures from *everywhere*—any kind of face that's interesting or unusual—an aged face, a youthful face, a baby, hairlines or beard-lines, the shape of the ears, the nose, the mouth; what does a combination of these shapes do, how does a combination of these shapes form a face that's pleasing, or strong, or weak when you look at it. These clippings will form your *"morgue"*—that stockpile of reference material which will be at your disposal time and time again. (*The Pittsburgh Press* entertainment section saves me promotional 8x10's, for example, which I use for reference on actors and characters and various make-up work.) For THE BURNING, I researched books on burn patients, visited the burn unit at Mercy Hospital, pouring through their photographs...*it was incredible.* Seeing the real thing helps you in creating the real thing. *Being realistic.*

Sculpting and sketching go hand-in-hand, both being developmental necessities to your growth as an artist and "illusionist." If you have no basic sculpting ability, the best way to start is practice, practice, *practice*. The more you shape meaningless balls of clay and move them into shapes, the more you'll realize what you have to do to turn that *nothing* into *something*.

I picked up sculpting on my own. When I was a kid, my brother was planning to become a mortician, and I saw him in the basement one day sculpting an Egyptian head; it absolutely floored me that he could do "that" with a lump of clay. I started playing on my own, *experimenting* and pushing the clay around. (I was ridiculous at first—stick figures and all that.) Gradually, I learned more about *anatomy*. The more you know about anatomy, the more you'll be able to signal your hand to shape what you know, what you are trying to see. You have to know about anatomy, the shape of muscles and how they relate to each other, and to bones. You may have to create—out of nowhere—an arm, a leg, a face. When you're sculpting appliances or sculpting a mask, you have to create cheek bones and eyebrows, eyelids, noses on top of a plaster cast of yourself or an actor to make a Cyrano nose, or to age a face; you have to *texture* it.

When I'm doing a mask or something for myself, for example, sometimes I'll take a long, long time just because I don't want to stop at any certain point; I just want to keep on working and changing and improving as I learn more about what I am doing while I'm doing it. And about never being satisfied—this feeling is *positive* because it takes you so far *beyond* what *you* think is great. When you're forced to stop, no matter at what point that may be, your work may look fantastic to anyone who sees it; in fact, you may find that the director would've been totally satisfied with something at an *earlier* point. But you persisted in taking one more step further. You always aim higher, as high as you can; you may even go beyond the point where what you're doing is great. By aiming high, wherever you stop is still good, maybe even *better*.

When I was a kid, the very smell of the make-up was just exciting! Just opening the kit and smelling the make-up was pleasant—a high, a tingling sensation—to just reach in there and smell that greasepaint. *"The roar of the greasepaint, the smell of the crowd."*

Commercial make-up kits are definitely leaps and bounds above your typical Halloween-type make-up kits. Once you understand this preliminary kit and you're ready to move on, it's better to start building your own kit rather than buying yet a larger commercial kit because sometimes there is a lot of stuff in those kits that you'll *never* touch, and sometimes it's old make-up. Better to build on what you want and what you know you need.

Commercial kits of various sizes are available from Alcone Co.

• • •

Whatever the materials, safety and first aid are important to keep in mind at all times. I had an experience recently which punched home this fact to me. I found myself getting deathly ill without knowing it; my liver was about to fail. It seems my blood picked up an abundance of chemicals through the surface of my skin and through breathing. Luckily, I learned what these "materials" were doing to me in plenty of time to avoid any extremely serious problems, and I've since taken extra precautions to avoid such things from happening again: using rubber gloves, a respirator, etc. when the need arises. It's extremely important to be aware of toxic, carsiogenic chemicals at all times; *acetone* is one of them.

• • •

I get a lot of questions about materials: foam latex, a good blood formula, plastic appliances. Before advancing to the more sophisticated materials, it's important to have a good understanding of even the most basic ones, those materials you'll spend the most time working

SUPPLIES

Throughout the text, the following companies will be singled out as good sources for the materials which are essential for the procedures which apply to that particular effect.

Adhesive Products Corp.
1660 Boone Ave.
Bronx, NY 10460
212/542-4600

Alcone Co.
5-49 49th Ave.
Long Island City, NY
11101
718/361-8373
Source for most make-up suppliers and theatrical equipment.

Baldwin Pottery, Inc.
534 LaGuardia Place
New York, NY 10012
212/475-7236

George Bau Foam Latex
from Charles Schram
Windsor Hills
Make-up Labs
5226 Maymont Dr.
Los Angeles, CA 90043
213/291-5891

Sculpture House
38 E. 30th
New York, NY 10001
212/679-7474

Fibre Products
601 West 26th St.
New York, NY 10001
212/675-5820
Source for make-up cases

Bob Kelly
151 West 46th St.
New York, NY 10036
212/819-0030
Source for hair supplies. John Chambers' bald caps, and a wide range of make-up supplies

R&D Foam Latex
5901 Telegraph Rd.
Commerce, CA 90040
213/724-6161

Research Council of Make-up Artists
P.O. Box 850
Somis, CA 93066
805/388-1136

with initially as you begin to develop your technique. (You can't always pick up these items in your home town, but there are places which will mail-order the stuff via U.P.S. so you can get it in just two or three days after calling them on the phone.)

Dick Smith's *MONSTER MAKE-UP HANDBOOK* was the only special make-up manual for beginners around. It is now in its sixth printing from Morris Costumes, Inc. In my opinion, the only other current "How To" books on make-up are Richard Corson's *STAGE MAKE-UP*, now in its sixth edition, and Vincent Kehoe's *TECHNIQUE OF FILM AND TELEVISION MAKE-UP.*

©1965, 1984, 1989 DICK SMITH ©1981 PRENTICE-HALL, INC.

19

DEATHDREAM

DEATHDREAM was directed by Bob Clarke (PORKY'S, MURDER BY DECREE, BLACK CHRISTMAS, CHILDREN SHOULDN'T PLAY WITH DEAD THINGS) and written by Alan Ormsby (MY BODYGUARD, CAT PEOPLE), who also did the make-up for the film. I was his assistant; *my first film.*

POSTER COURTESY THE MOVIE POSTER PLACE

Alan did beautiful sculptures of decayed corpses, and hands with mortician's wax holes in them so that maggots could crawl out. He had sclera lenses made for Richard Backus, the actor who starred as the "monster."

Sclera lenses are contact lenses made by a doctor to fit a specific person, but they cover a larger area than normal contact lenses—the whole front of the exposed eye.

©EUROPIX

My contribution included making false teeth

Casting Teeth & Fangs

PHOTOS: TOM SAVINI

A dental tray (U-shaped, horseshoe-shaped, exactly like a dentist uses) is filled with alginate and placed in the subject's mouth and pushed up against the teeth and the palatte to make an impression into the alginate, which solidifes around 2 minutes.

A thorough knowledge of materials is extremely important. Before you do *anything*, make sure you tell your subject exactly what you're going to do step-by-step so that they'll know what they're in for ahead of time. Then, as you progress from step to step, keep explaining what you're doing so your subject remains relaxed and comfortable. (You have to remember that perhaps this person has never experienced anything like this before; you can't take for granted that you're not going to surprise or jar this person at any step along the way.) Totally outline everything you're going to do for them; it makes them feel at ease, it prepares them for what you're going to do, and it also helps to discipline and structure yourself.

As far as the dental trays themselves, you can use plastic disposable trays, or metal ones which can be used over and over again, and they can be acquired from a dental supply house in your area. They're not expensive, but you have to make sure you get at least one for the upper teeth and one for the lower. (They're shaped differently, so you can't use one for the other; refer to the pictures so that you can recognize the difference.) Fill the tray just to the brim, because when you push it up against the teeth the extra will ooze out.

Before you fill the tray, make sure it fits the person's mouth. You begin by inserting one side of the tray, pushing it against the side of the mouth and gently move the other side of the mouth around it until it slides in, fitting over the teeth. Make sure it fits properly, and doesn't hurt the teeth or gums anywhere. Make sure you can move it around from side to side so there's enough room inside the mold for the teeth themselves. After this has been tried and you and your subject are both satisfied, pull the tray back out, mix up your alginate according to the can directions and fill the tray to the brim. Get your subject to tilt their head forward, chin down. That way, if any alginate should happen to overflow, it will spill down and out of the mouth and *not* down the throat.

Make sure the palatte part of the tray is pushed up against the palatte of the mouth, and the lips rest on the *outside* of the trays. Hold it there until it dries—usually 1½ to 2 minutes is all. There's a lip that sticks out of the tray—when the alginate dries, you gently tap this lip until the tray starts to loosen, and you can pop it out. Once the tray is removed, the impression is then filled with dental stone (white hydrocal), which is a

hard plaster. This has to be done immediately, because the mold will begin to shrink. If you have to wait, keep it moist—soak it in cold water. You then repeat this same procedure for the bottom, except that when you put the bottom tray in the person's mouth, have them place their tongue on top of the tray. Again, press on the top of the tray so that the alginate moves around and fills the space around all of the teeth.

You can buy rubber dental base molds—small, medium, large—and fill them with dental stone when you fill the

trays. When they start to dry, the plaster will be creamy and less runny. At this point, you can turn the tray over and press it a bit into the rubber base molds. The longer they're left to dry, the stronger they'll get.

When they are dry, gently remove the plaster from the molds and peel off the alginate and you will have the inside of the person's mouth—the upper and lower

23

teeth, including the palatte, the front of the gums, *everything*. At this point, anything you mold *onto* that is going to fit on the person because it's as if the person's mouth was sitting right there in your hands. *Without the obvious discomfort of the person's mouth actually sitting right there, you have a duplication of it in stone to work with. Coat the molds with a separator (Alcote).*

On this finished cast of teeth you can sculpt gums by using a pink powder called dental monimer and a white liquid polymer, mixing the chemical and powder using an eye-dropper to form gums over the cast. For fangs or false teeth, you can get a set of acrylic teeth from a dental supply house and file or grind them down thin—around 1/16" or 1/8"—hold these teeth against and covering the plaster teeth with wax on the inside of the plaster mouth, behind the

teeth with wax, behind the front of the mold. Drop the chemical (monimer and polymer); the wax will hold the teeth as you drop in the dental acrylic chemicals. With an eyedropper, first spread a little fluid where you plan to sprinkle the pink gum powder. Sprinkle the pink powder around the teeth until the liquid absorbs it, then more liquid on the pink powder, so you sprinkle powder and add liquid until you have the thickness you want. Let this set five or ten minutes until it hardens and then remove the wax. Clean the area and start building the back of the gums the same way, with the pink powder and liquid—a little of each, one at a time—until it becomes a thick paste around the teeth. This will remain soft for about ten minutes, so you can sculpt around the gums and arch the top of the teeth when it hardens. Remove this from the plaster mold and there you have a dental plate that fits this plaster mold of the teeth. It will also fit over the subject's actual teeth.

To make fangs over the canine teeth: first shape the fangs by mixing white powder and liquid to form a paste. With your fingertips (wear surgical gloves!) roll and form this paste to get the actual shape of the tooth you want. The more you work with it, the faster it will dry, eventually drying as a hard acrylic tooth. Then file or grind it, shaping any kind of tooth you want. You

can still continue to sculpt on it with a dremmel tool or fine sandpaper. These fangs are attached the same way as the acrylic teeth from the dental supply house (pink powder, liquid, wax, etc.) You then coat them with acrylic lacquer (from Unitec) to give it a "wet" look; you can use a pressure pot to cure them. (Instead of air-

drying them, you place them in this pot filled with hot water from the tap, turn up the pressure to 20 lbs. and the gas bubbles will go into solution, eliminating the little air bubbles in that pink and white dental acrylic. The finished teeth will be harder and smoother than if they were air-dried. Removing all of the air bubbles compresses the stuff and makes for a really nice pink dental plate.) Cutting grinding and sanding follows—trying them in the mouth to see how they fit. The drying and shrinking slightly makes them fit snugly.

What I have discovered, after ending up with a set of teeth that were completely molded over the front and back of the gums, is that I couldn't *speak* with them! I essentially had produced another palatte, so with that in my mouth it would take some time and a lot of practice if I ever wanted to speak clearly with two palattes (my own and the artificial one). This is something I discovered when they accidentally broke one day; the whole back section broke off. I cleaned them off (naturally), put them in my mouth, and found that there was just enough gum area left—overlapping onto the back of my teeth—to hold the fangs in place, and I was able to speak as I normally do. The back of my teeth was clear, the palatte was clear, and the teeth held. I couldn't have eaten an apple with those teeth, but you don't always need fangs to have the strength of normal teeth unless the job calls for that.

For buck teeth, you can either build up the gums a bit more or not grind down the teeth as much as you normally would, depending upon the degree of the protrusion you want. (Jerry Lewis in THE NUTTY PROFESSOR, Charlie Chan; Marlon Brando in THE FORMULA wore false teeth to do weird things to his speech. They were actually buck teeth that made him look more like the wimpy character you wanted to hate.)

Going from pearly white to rotted or somewhere in-between is relatively easy. There is white acrylic ranging from very dark to very light, perhaps as many as twenty different variations. Different combinations of materials, including the use of a yellow stain or just painting them to the desired color, can create a yellow or rotted effect.

No poli-grip or other solution is needed to hold the false teeth in because the outside of your own teeth become the inside of the false plate; made from your own teeth, they'll snap in perfectly. Grind sharp areas down to a soft edge before putting them in your mouth, or your subject's mouth, because there may be some painful places where hard plastic presses against portions of the gum. After filing to eliminate any discomfort, you may find they don't fit quite as snugly as they should; you can use the poli-grip to eliminate slipping. If speech isn't a problem and you're making an entire plate, you may need something like a poli-grip so that it attaches to the palatte and stays in. You'll want to do a little work to find that happy medium where they will clip in, be comfortable, and stay in enough to show, to make faces, or whatever. I have found just the fronts are necessary; just a little bit of gum overlapping the front teeth is enough to hold them in.

MODEL: DARLENE HELSEL

and the first bullet wound I ever did. (It was cut from the final print, but it made me stop and think about having to create an *illusion* for the very first time.)

The effect, or illusion, was a bullet hitting the side of the "monster's" head, tearing a section of scalp off. I soaped out a section of his hair,

> Soaping out involves taking a soggy bar of soap and alternately slicking down the hair, drying it until the hair is flat, conforming to the scalp.

and painted a kind of an underskin of raw tissue, and made it look like there was a hole in his scalp. I put a latex piece on top of that hole and attached a length of fishline to it. I put hair on this latex piece, matching Richard's own hair. I was off-camera, holding the fishline, ready to pull the piece off at any time, and I had two people (also off-camera) ready to fire air rifles at the side of Richard's head so that his hair would fly up. On "action" the two guys fired the air rifles and I yanked off the piece. The effect worked quite nicely; you first see a close-up of the actor firing the gun, then the side of Richard's head with this hunk of skin flying off and the hair flying up because of the air rifles. The hunk of skin/latex piece was made by brushing liquid latex on a piece of glass, forming an oval-shaped

section slightly larger than the wounded area. It was dried with a hair dryer and hair was glued onto it.

27

DERANGED

DERANGED was done for the same people (Bob Clarke, Alan Ormsby) one month after DEATH-DREAM; but this time I was chief make-up artist, and my assistant was Jerome Bergson, a friend of Alan's who is an excellent sculptor. There were just the two of us, and it was up to us to create all of the effects you see in the film. (Alan Ormsby was the co-director this time around.)

We had to create three or four corpses, and we made them quickly out of dowel rods, chicken wire, latex, and cotton, and colored them with browns and greens, and used toy plastic skull kits. We also had to make hollow latex appliances,

> **Appliances are things you apply: latex pieces, false noses and chins, hunchbacks, gorilla feet, etc.**

an old-age make-up for one actor,

PHOTOS COURTESY TOM SAVINI

In this case, Jerry Bergson sculpted an old woman's face over the life-mask of the producer's wife. When he poured plaster over the sculpture and let it dry, he had a negative plaster mold taken from the positive clay sculpture. Successive coats of liquid latex were brushed onto this negative plaster mold and dried.

The first two coats were painted in, completely covering an area that would produce a latex mask that she would wear—glued along the top of her forehead, down along the temples in front of her hears, and down along both sides of her neck. The remaining coats were painted in, avoiding the edge created by painting the first two coats in. This made a mask with a very thin edge that would vanish into her skin (hopefully). Once it was glued down, the edge was given another coat of latex and covered with make-up.

For the scene, she would just lie there without moving or having to speak, so this sort of quickie old age make-up would do. A quick false head of her was made by making a mask from the mold, attaching it to a styrofoam wig block and adding a similar wig.

For a scene that was added later, an actress—who had finished her part in the film and flown home—had to be seen lying in a coffin for a funeral scene. The same sort of false head was made and placed in the coffin—and only photographed from the side—showing her head in profile, lying in the coffin.

and create various parts of the human body—a belly drum, a club made from the thigh bone of somebody, and so on, because DERANGED was supposedly the true story that PSYCHO was based on; the killer kept the bodies of his victims, including his mother, around the house and used parts of them to make things for himself. The script for the film was written directly from newspaper accounts of the incident. (The belly drum was basically a kid's toy drum. I painted a section of a huge mirror with latex, forming a naval out of a small piece of cotton. When this dried, I removed it and stretched it across the drum.)

MARTIN

There were basically just three illusions in MARTIN: an arm - cutting sequence in the beginning, a stake in the throat, and the ending where Martin gets a stake through his heart.

In the beginning of the film, Martin (John Amplas) unwraps a razor blade, takes the arm of an unconscious girl lying next to him, and slices right down her arm from the wrist. A gash seems to open, blood gushes out and runs down her arm, and the thumb twitches to let you know this is a real hand. *A ghastly effect, I tested it by walking to George Romero's office, and I said, "Hey, George—Watch this!" I held my arm over a water fountain in the room, took out a razor blade, sliced my arm right there in front of him, and blood gushed out. (George's wife, Chris, nearly had a heart attack!) My little demonstration was staged to show them that this illusion could work.* I'd never done anything like that before, but I knew I had to show a razor slicing an arm, starting from the wrist down, and have blood gush out. I knew that's what I wanted to see, but without actually doing that, I had to try to find a way to execute the effect so that the illusion would work. My immediate thought was, obviously I cannot cut open a real arm; a fake arm?—well, because the camera had to dwell on the arm while the razor was cutting, the chance of seeing a fake arm *as fake* was pretty good. My solution? **An effect that involved using the actual arm.**

I took a razor blade and filed it down, rounding off the edges to dull it. *One day, I even jokingly took it out in drama class and started running it along my tongue. People around me cringed, naturally, but of course I knew it wouldn't hurt me.* I placed this dull razor blade in John Amplas' hand, along with a baby ear syringe filled with blood. (The tip of the syringe was placed behind the blade and away from us.) John squeezed the syringe as he placed the razor blade

One of the most original horror movies in years . . . a scary, ironic variation on the Dracula theme . . . Romero has become a dazzling stylist . . . his balance of wit and horror is the best since Hitchcock.

George A. Romero's

MARTIN

See it with someone you're sure of

to the girl's wrist, and this created a small spurt of blood; because the tip of the syringe was behind the razor blade, blood flowed out in a perfect line as he moved the blade down the girl's arm, giving the illusion that the arm had been cut. The more he squeezed the syringe, the more blood came out, and as he tracked down the arm, the blood in front of the razor blade looked like it was flowing out when it was actually flowing down because the arm had been raised; gravity simply did the rest. *I did the same effect in acting class one day. I had to sit in the room and think of an activity, so I opened my backpack, took out the razor blade, removed the little protective cardboard from around it, rolled up my sleeve, and proceeded to slice my arm open in front of the class and the teacher. I looked up at the teacher, whose chair had suddenly moved back four or five feet; some people turned away, some gasped, some laughed, but I had tested the illusion and it fooled an entire class. (Of course, I had prepared the razor blade and the syringe beforehand, **but they didn't know that. They were misdirected** by the razor as I concealed the syringe in my hand, and they didn't know I had a mechanical device.)*

The blood I used here was 3M Blood, from the 3M company. (It's a good blood for stage, but I didn't like the way it photographed in DAWN OF THE DEAD.) For DERANGED and DEATHDREAM, we used Alan Ormsby's formula involving flour, water, red food coloring and peanut butter.

The best and most widely-used formula for film blood was invented by Dick Smith: using red and yellow food coloring, karo clear syrup, methyl paraben as a preservative, and photoflo from darkroom suppliers.

Note: This information is presented in good faith but no warranty, express or implied, is given and Dick Smith assumes no liability for the use of this material.

For the stake in the throat, though I'd never done anything like it before, I felt it was possible to show the actor's face reacting in the same shot as the stake goes into his throat. (George Romero, the director of MARTIN, reminded me that the actor was going to be unconscious, but I still felt it was possible to show this was happening to a *real person*. George wanted to know how we could do it, and I didn't know; but I told him I'd find a way.) What developed was actually the evolution of the FRIDAY THE 13TH arrow-in-the-neck scene, and other similar effects to come.

My approach was to adopt the perspective of the viewer watching a blank screen, asking myself, "What do I need to see on this blank screen to be fooled into believing that I'm watching a stake pierce this guy's throat?" I knew we needed to see the actor's face, the stake, perhaps even his shoulders. I pictured the stake coming

from the right and entering the right side of his throat; I wanted to see the stake going all the way in, and blood squirting out. Obviously, I couldn't take the stake and put it through the actor's throat, or even use a throat appliance on the real actor, for that matter, because his real throat would still be under an appliance. I had to create something which was hollow, and deep, and yet something that still looked like part of the actor's throat. Now I had to figure out how I could see a neck on the actor, have space for the stake to go in, and have him look like he's actually on the ground. **(See color section)**

The solution? I had the actor kneeling, straight up—*not* on the ground—bending forward a bit and putting his head on this huge mound of dirt in front of him in a park on a very cold night. On the mound of dirt, just beneath his chin, was a false neck and shoulders cast from one of my

35

students at Carnegie-Mellon University (Carnegie Tech) who was the same size as the actor involved in the shot. The actor playing the part arrived the day we were actually going to shoot the effect, so there was no time to cast him and make a false chest. I got his measurements from the office, found somebody with exactly the same measurements (John Vargas), and took a life cast mold of his neck and chest area in plaster. (A negative mold.) In the mold I pressed some clay, about ¼" thick (thinner around the edges of the neck because I knew that those edges of the finished foam latex had to be glued to the actor), and then I poured a positive mold into that. After it dried, I separated them, removed the clay, cleaned the molds with carbon tetrachloride, put foam latex in the space where the clay had been, put the molds together, baked them in an oven, and pulled out this neck appliance.

Foam latex is a soft, flexible, spongy rubber similar to foam cushioning in pillows. We use it to make flexible rubber noses, chins, hands, full face masks and large appliances for the chest and back. It is so soft and flexible—as a face mask, let's say—that when the actor opens his mouth, or moves his forehead, or smiles or frowns, the foam latex appears to do so too, giving the actor a new face.

Some prime examples of how well this can be done are: Dick Smith's foam latex face on Dustin Hoffman in LITTLE BIG MAN, or the bulging and stretching arm sequence in ALTERED STATE; Christopher Tucker's ELEPHANT MAN make-up; Rick Baker's transformation make-up in AMERICAN WEREWOLF IN LONDON; Rob Bottin's in THE HOWLING and THE THING. All of these were elaborate processes using foam latex for the skin of these creatures. (I used it in Hong Kong recently to show a man pulling his mouth out about fourteen inches.)

There are a few brands of foam latex on the market: one is from the Alcone Company in New York City; one from R&D Foam Latex in Commerce, California; one from The Make-Up Place in Boston; and one from Charles Schram at the Windsor Hills Make-up Lab in Los Angeles.

The Alcone Co. foam is what I used when I first started out; it's easy to mix, but the foam was too rigid for movable face appliances. The R&D foam is simpler yet, and for me it was the best foam available. The Charles Schram foam is the best I've ever used; it is the softest and most flexible, and is also very strong—it's difficult to master, but it yields a fine foam latex. (I haven't experimented with the foam from The Make-Up Place in Boston at this writing, but the sample they sent me looks good and it, too, is simple to mix.)

I use both R&D and Charles Schram foam: R&D for strong, large constructions like Fluffy's chest and hands (the crate monster from CREEPSHOW) or the Jason head appliance for FRIDAY THE 13TH, and Charles Schram foam for flexibility—Fluffy's face which snarled, the spectre at the window who smiled and blinked, or for the full face masks on the sea-drenched ghosts (in the "*Something To Tide You Over*" episode) for CREEPSHOW.

First and foremost, become a scientist before you start using foam latex because a *hundred* things can go wrong. Even if you do it right the first time, you have to make sure that you document every single thing you do when you use foam latex: the temperature of the room, how old you are (just kidding), *anything* that can possibly go wrong. If it comes out right the first time, all you need to do is follow your documented instructions and it should keep coming out right from then on. (If you don't document your instructions, you could luck out the first time and then run into problems the second or third or tenth time around and have no idea of exactly what you did. *Documentation is essential.*)

By describing only the R&D foam here, you will get an idea of what it takes to make an all-around foam latex. Instructions come with all the foams, but experimenting is still necessary. (And don't worry; they are shipped quickly—usually within two or three days.)

The following is a detailed procedure on using R&D foam latex by Dick Smith, March, 1977:

R&D Foam Latex

By Dick Smith
March 1977

R&D Foam Latex 318C compound is probably the simplest foam compound to use and it produces a good quality foam rubber. It comes in only three parts: part A is the latex, part B is the curing paste, and part C is the gelling agent. One gallon of part A plus the necessary amounts of B and C cost $23.00 including shipping from R&D Latex Corp., 5901 Telegraph Road, Commerce, Calif. 90040; telephone: 213 724-6161. The mixing instructions in this paper are not suitable to other brands of foam latex.

EQUIPMENT

You must have an electric food mixer which has conventional twin egg-beaters and is on a stand with a rotating platform for the mixing bowl. Sunbeam is a good brand. If you don't have one, hunt in appliance repair shops for a used Sunbeam. It shouldn't cost more than $15.

For really accurate work, you need a weighing scale, preferably a "triple-beam balance" (2610 grams capacity) which can be purchased from a laboratory supply company for between $50 and $60. However, you can manage without it as I will explain below.

Most likely you will be baking your molds in a kitchen oven. The baking temperature is about 210⁰ F which is low for a kitchen oven. To check the temperature, it is best to have a good dial-type oven thermometer to put in beside the molds. It may be necessary to keep the oven door slightly open to get the right temperature. Higher heat will cure the latex even faster but it will also be more harmful to your molds.

The type of mixing bowl or vessel that you use to beat up the latex in makes a difference in the speed of foaming and its quality. The bowls that come with mixers are usable but not as good as a deep vessel with straight sides. A six-inch diameter tin can cut down is good. You can also make a good mixing vessel out of the plastic gallon jar the R&D latex comes in. Empty the latex into an empty water jug. Clean the plastic jar and cut it down so it is about 5 inches high or until it will fit on your food mixer.

When you beat up the foam, you need to know how much. If the original amount of latex becomes twice as big, we say it is "two volumes;" three times as big, "three volumes." You can make a measuring stick to use the cut-down R&D latex jar. On a clean stick about 6 inches long, mark the intervals shown here.

5

When this stick is dipped into the foam latex next to the side of the jar, it will measure the volumes of foam. The higher the volume, the softer the foam latex.

If you do not have a scale to weigh the latex ingredients, you can do almost as well with some good fluid measuring vessels. In a photography shop, buy a graduated beaker that measures up to 8 ounces and/or 250 ml. In a hardware store buy a good set of kitchen measuring spoons. And while there, get a narrow rubber spatula and a room thermometer.

Two more items you need: a stop-watch or a watch with a sweep-second hand and a note book to keep records in. The watch is for timing the mixing. The records are necessary to keep track of all the variables that affect the foaming and gelling. Get a book large enough to take these column headings: date, room temperature, amount of part A, part B, part C, time to beat up to volume, volume reached, time to refine foam, time for gelling agent (C) to be mixed in, time it took to gel, color used and amount, hours baked, results.

MOLDS

The type of plaster you use for your molds makes a big difference. All gypsum (plaster) products expand slightly as they set. The less expansion, the more accurate the molds are and accurate molds produce appliances with the thinnest edges.

Baking molds weakens them till they crack and crumble. Some gypsum products can take more baking than others. Ordinary plaster of Paris is not very accurate and it is weak. White Hydrocal is stronger but even less accurate. Dental stones (such as Kerr's Velmix) are strong and fairly accurate but very expensive. They are sold in dental supply stores. The best gypsum material is U.S. Gypsum Co. Ultracal 30. It is sold in 100 pound bags for about $16 by U.S. Gypsum dealers.

Reinforcing molds is very important to keep them from cracking. To reinforce molds of this shape

I insert an oval band of "wire cloth"

which has 4 holes per inch

into the wet ultracal. I cast the molds inside an oval wall made of a 4 in. by 2 ft. piece of black rubber floor matting which is sold in hardware stores. For irregularly shaped molds I use sissal fibre or potato-sack burlap or fibre glass in the outer layers.

You need only three keys in most positives. Make semi-spherical depressions in the surface by rotating the end of an old dinner knife. A 3/4 in. round router bit in a hand drill does a professional job.

After the plastilene model of the appliance has been sculpted on the positive, about a ¼ in. layer of plastilene should be modeled over the rest of the positive mold surface except for the keys and an 1/8 in. clean path

around the edge of the appliance.

When the negative half of the mold has been poured and hardened, the two halves should be pried apart and all the plastilene removed. Clean off the remaining grease with Tri-chloroethane or acetone. If the appliance is fairly large, drill a ¼ in. hole through the positive at a spot where the appliance is thickest. The hole will provide an escape for excess foam which might otherwise prevent the mold from closing completely.

New molds should be dried out somewhat by baking for a couple of hours before use. A separating agent must be applied to keep

the foam latex from sticking to the mold surfaces. R&D Foam compound is not like some others for which castor oil or silicones are the usual separators. The calcium in the gypsum affects R&D foam causing it to collapse into larger bubbles. It requires a separator that seals the surface. One coat of clear lacquer or two coats of diluted lacquer work very well and will last for many bakings. Be sure you have cleaned the molds thoroughly of all grease first with acetone. Instead of lacquer a stearic acid separator may be used. Sculpture House brand has one called Separol which might be found in some art stores or ordered through one. Apply it generously and brush off the excess with a stiff brush after it dries. Repeat it each time before you fill the molds with foam latex. It may be used over the lacquer separator to make the removal of the appliances even easier.

After you have baked your molds three times they will be getting very dry and starting to weaken. Before you use them again, dip them in water (not when they are hot) for 30 seconds to a minute. Repeat each time before use from then on.

MEASURING THE FOAM LATEX

A normal batch of R&D calls for 170 grams of Part A and 22 grams of Part B. The gelling is done with 8 grams of Part C. First weigh the empty plastic mixing vessel you made. Add that weight to 170 grams and set it on the scale. Put the vessel on the scale platform and slowly pour Part A into it till the scale balances. That means you have 170 grams in the vessel. Add 22 more grams to the number set on the scale and very carefully pour in Part B till it balances. Part B should be stirred very well first and it is easier to put a small amount in a paper cup and pour that into the vessel.

If you don't have a scale, measure out exactly 7 fluid ounces or 200 ml. (milliliters) of Part A in your graduated beaker and pour it into the mixing vessel. Shake up Part B and measure out one level tablespoon and add it to the Part A.

BEATING UP THE FOAM

Place the mixing vessel with Parts A and B in it on the food mixer platform. Adjust the mixer so the beaters are as close to the bottom and sides of the vessel as possible without scraping when the vessel revolves. Start your stop-watch and turn the beater on to its fastest speed. The vessel should rotate slowly. Help it if necessary. Beat the latex for two minutes. It should have increased in volume very quickly. Determine the volume with the measuring stick. Three volumes will make a firm foam latex; four volumes makes a soft foam, and five volumes, very soft. If your beater works like mine, your foam will reach four volumes in two minutes. If you want more, beat another minute and measure again. When you get what you want, slow the machine down to speed three or almost the slowest and continue for three minutes to refine the foam. The volume will stay the same but the texture of the foam cell structure will become finer.

GELLING AGENT (Part C)

The gelling agent and the color should be all ready to measure out or they may be prepared before the start of foaming. Since the gelling agent is a small but critical amount, you want as little as possible to remain stuck to whatever you measure it in. It won't stick to something waxy, so the cut-off bottom of a small waxed paper cup is a good receptacle or you might apply paste wax to some small plastic or glass container. If you are going to weigh the gelling agent, you must also find the weight of the container or paper cup & add it to the needed amount of gel. If you measure with a spoon, wax the spoon first.

The tricky thing about foam latex is getting it to gel at the right time in the right way. You don't want it to gel too fast for you to get it in all the molds and on the other hand if it doesn't gel in about 15 minutes, the foam will start breaking down and may collapse altogether. So the best gels are between five and ten minutes. Increasing the amount of gelling agent speeds up the gel. Low room temperatures slows it down. In fact it may not gel at temperatures below 70° F and when it is hotter than 80° F, the foam may get lumpy and gel very fast. Beating the foam to a higher volume makes it gel faster. So does beating it for a longer time.

Since so many things affect the amount of gelling agent needed, I can only give you an average. If it doesn't work, you will have to

mix another batch and try a different amount. Be sure to write down all the details in your record book so you can learn from your experience.

With room temperature in the mid 70's, foam up to about 4 volumes in 2 or 3 minutes, the standard amount of gelling agent is 6 cc. or 6 ml. or 9 grams or a measuring teaspoon filled till the surface of the liquid is as rounded as possible without overflowing. A level teaspoon is about 8 grams. If your batch does not set in 15 minutes, use 12 grams or 1½ level teaspoons in the next batch. Recently I've used 8 gr.

Parts B and C are both sticky liquids. It's a very good idea to wash out the lids and put a piece of plastic or wax paper over the openings before replacing the lids. If you don't, the lids may become very difficult to remove.

COLOR

Adding color to the foam latex is not necessary but it's easier to make-up over a flesh-colored appliance than a white one. In an art store you can buy casein paint in tubes. Don't get it in jars; might be too thin. Casein mixes into latex okay. I like to add the color to the gelling agent. Then I can see when it is uniformly mixed into the foam. That's important to prevent defects in your appliances. Burnt sienna casein color will give a golden flesh tone. Other colors can be used. For a light flesh tone mix ½ teaspoon of color with ¼ teaspoon of water and then mix it into the measured gelling agent. Use one teaspoon of color and ½ teaspoon of water for a deep flesh tone.

MIXING IN THE GELLING AGENT

After you have refined the foam for three minutes you are ready to add the gel. You may stop the beating for a few minutes to measure it out. Then restart the beater at speed 3 and your watch. Pour in the gelling agent and use a narrow rubber kitchen spatula in the foam like a rudder to direct the flow of color to all parts of the vessel as it rotates. Scrape the sides and bottom of the vessel with the spatula but try not to create any large bubbles. Use the spatula for one minute, then beat for another minute to refine the foam mixture again. Stop the beater, note the time so you can time the gelation and start filling your molds.

FILLING THE MOLDS

Your molds with separating agent should be lined up ready for filling, the negatives in the front row with their positives right behind them. Both halves of each mold should be labelled and a bold line should be drawn across the edges of the negative and positive to make it easy to fit the positive on after you have put the foam in the negative. Use a regular spoon to scoop the foam out of the mixing vessel and put it in a mold. You have to be careful not to trap air beneath a blanket of foam. If the negative has deep texture or pits, you have to poke the foam into those areas with a pointed tool before adding the rest to fill the mold. Work foam carefully into nose molds as it is easy to trap air in the tip. Do not put much more foam in the mold than necessary for the appliance because too much will make it difficult to press the mold completely closed. Do not clamp molds; just use hand pressure or put very big ones on the floor and step on them. Don't move them till the foam is gelled. Put them in a pre-heated oven. A two-piece mold about 4 inches high needs 3 hours or more at 210° F.

When you think the foam is cured, remove one mold from the oven with a cloth and gently pry it open slightly. Use a tool to dislodge the appliance from one mold surface as you separate the two halves. Poke the foam in an inconspicuous spot to see if it is cured. If it stays indented, it is not baked enough. Leave it on the half of the mold and put it in the oven for another ½ hour. Test it again before removing it completely. After appliances have been removed from the molds, the molds should be wrapped or covered in bath towels to prevent rapid cooling and cracking.

P.S. 1978

The foam can be made softer to the touch by adding 3 grams of potassium soap of castor oil*to the 22 grams of Part B and then adding it to Part A. Stir the "soap" and B together first. If you want to beat to a volume of 5, also add 10 gr. of water to the ingredients before beating.

*Nopco 1444-B from Diamond Shamrock Chemical Co., 350 Mt. Kemble Ave., Morristown, N.J. 07960

I then put the appliance back into the negative mold, poured plaster of paris in there behind it to give it support, and ended up with a foam latex neck appliance with plaster backing. I cut a very deep hole, or chamber, in the plaster backing where I wanted the stake to go through, and then I drilled two small holes leading into the chamber. In those two holes I placed rubber tubing attached to rectal syringes filled with blood, and these tubes were sealed in the plaster with wax. (A primitive, crude, early method.) The actual foam latex neck piece was glued to the front of the plaster backing, sealing the front, and this of course was all attached to the actor, with the actor's costume draped to the false shoulders. The actor was sitting upright (trying to look dead) and on a cue from me, I would drive the stake into the hole in the false neck and members of the crew would pump blood into it. I would drive the stake in and move it back and forth so that there was a space for the blood to flow out, and it worked quite well; in fact, as I pulled the stake out, the hole sealed itself. *What also was interesting that night was it was so cold that the foam "skin" seemed—seemed—to develop gooseflesh. I don't know what the phenomenon was that caused it, but I will say it was very eerie...driving a stake through this guy's neck and then having the wound actually bruise up and turn blue because of the saturation of the blood mixing with the make-up, and then get goose pimples. It was quite eerie, very creepy.*

The stake in the heart at the climax of MARTIN was achieved by taking a piece of drain pipe about a foot-and-a-half long (which I found in my basement) and pounding one end of it so that the whole thing was tapered, and then attaching that to a piece of wood so it would stand upright. I pounded the top edge so that it would be slightly smaller than the stake; thus, if I wanted to pound the stake into it, it would hold tightly against the stake and I could then pound with some resistance. This "stake receptacle" was positioned between John Amplas' body and his left arm so the stake went under his armpit. The camera was at such an angle, however, that it looked like the stake was going to be pounded into his chest. (This followed a previous shot showing the stake positioned right over John's heart.) Now, there were four or five people under the bed with various size syringes filled with blood. I had a large syringe pumping blood into tubes that would empty on top of John's real chest, coinciding with the angle that we saw the stake "going in." When the actor pounded the stake into the drainpipe, John screamed and convulsed and his chest filled with blood; the actors below the bed were shooting blood up against the

actor pounding the stake in, to make it appear that the blood was actually shooting out of John's chest and onto the actor. *As I remember, the first take didn't quite work; the blood intended to splash up against the actor pounding the stake in missed him and shot straight up into the air and onto the ceiling. We had to stop, the whole room had to be cleaned, and we had to go back and re-position everything all over again. John needed new pajamas.* In this effect, it was the angle that created the illusion of the stake going into a real actor. *I try to use real actors and real props as much as possible in creating these illusions because it's hard to believe we would drive a stake into a live actor.* So, when you see it, you believe that's what you've seen. That's what scares you, that's what makes you turn away, that's what *fools* you.

After it appeared that the stake had been driven into John's chest, the camera did a pullback shot from John's face which gradually showed more and more of his body and eventually pulled back far enough so that you could see the stake actually sticking in his chest. For this, I simply made a duplicate—the top three or four inches—of the stake and fastened it to a round piece of tin which was glued to John's chest at right about the heart area. I then just simply covered the piece of tin with mortician's wax, which blended in perfectly around him, and I made the top of the skin look like it was turning blue or discolored because of the great amount of blood there, or lack of it. As the camera pulled back, we saw the top of the stake sticking out of John's chest, which further enhanced the illusion that this long, pointy, ugly stick had actually pierced John's body. **(See color section)**

DAWN OF THE DEAD

AWN OF THE DEAD has become a kind of "cult classic," and I also think it began this current splatter trend in films. DAWN OF THE DEAD was full of gore, full of effects, all done quickly.

One of the first effects we see is a zombie biting a large chunk of flesh out of his wife's neck. To do this, I first made a cast of the woman's neck and collarbone area up to her chin, behind the ear in the back, and just below the shoulders, and on a positive copy I resculpted the side of the neck which was to get "chewed." The trapizious muscle, the collarbone, and the shoulder were sculpted in clay, approximately ½" thick in the deepest place. I then made a negative mold of that, and followed the same steps I used to create the "stake-in-the-neck" in MARTIN: pressing clay, placing the two molds together, filling that space between them with foam latex, and I ended up with a foam latex piece—a new neck, collarbone, shoulder, if you will. I pre-cut a hole where the zombie was to take a bite, and I colored the foam within by injecting food coloring into the foam itself, making it all red inside. Before gluing that to the person, I painted the skin black just under the bite area and attached tubing leading from the bite area to a blood-filled syringe. (The skin was painted black so that when the foam was bitten out, it would be dark in there, making it look deeper than it really was.) The neck was glued down; we knew where the foam had been pre-cut and the actor knew where to bite. *However, as it turned out, the actor bit down a little too hard, biting through the foam and actually biting the girl, so her scream was real.* He tore off that section of the foam, leaving the red gushy flesh and the black hole painted on her skin, and as blood was pumped through the tubing, blood appeared to gush out of the wound.

I did the same thing with the back of the girl's arm. I cast her arm, resculpted the back, made the foam piece, and rigged it with blood tubing; but this time I *forgot* to pre-cut the foam; the actor actually did end up biting out a nice, neatly ragged section of her foam arm, and the blood spurted out. (At the time, there wasn't a really great blood formula floating around. The blood I used in DAWN was 3M Brand Stage Blood, which sometimes photographed terrifically—really deep, red blood—and other times looked like a tempera paint; I don't recommend it for use in the movies because of the way the film stock picks up on that particular shade of red. It doesn't look realistic. It is safe to use, and works well, for blood effects on stage, however.)

For the wounds, I took a large photographic developing tray and sculpted lots of wounds, cuts, scars, lower lips, upper lips, in different sizes and shapes, and then made a cast of the entire tray so that when it dried I had a huge mold filled with these wounds. Then all I needed to do was mix up a batch of foam latex, pour it into this mold, scrape off the top, bake it in the oven, and instantly I would have a slab full of various wounds which I could use on a variety of different zombies.

43

For the exploding head, I took the head mold of Gaylen Ross, the female star,

> The head mold was two negative molds taken from Gaylen Ross. One was the front of her face from the top of the middle of her head down along her ears and neck; the other was the back of her head. When the molds were put together, filled with foam latex and baked in an oven, they produced a foam rubber head of her.

and I made it up as a black person with a short Afro hairdo, glass eyes in it, an Afro beard on it, and then attached it to "Boris," the dummy I built for the film. Boris was made by cutting lengths of 2x4's to be arms and legs, chicken wire to be the shape of the chest, and covering all this with sheets of urethane foam from an upholstery shop. An electric carving knife was used to cut and shape the foam into the contours of a human body. Richard Rubinstein, the producer of the film, and I sat in the basement where the scene was filmed and filled the head with blood-filled prophylactics. Richard threw an apple core or two in there, and I threw in some corn chips. We sealed the bottom up and attached it to Boris. We placed the hands of the dummy into his pockets to make it look like he was just standing there in a natural, casual position. I stood back by the camera, and on my cue we rolled the cameras and I blasted the head with a 12 ga. shotgun, the same one used by the actor supposedly doing the shooting. *The head reacted like a real head would react; after all, it was constructed just like the real thing: an outer skin surface (foam), a skull (plaster underlayer), brains and "innards" (prophylactics and apple cores and corn chips). (See color section)*

There's a scene where I am riding by (as "Blades") and a zombie pulls me off the motorcycle. **My reaction to that is to leap into the air, kick him to the floor, pull out a machete, say, "Say goodbye, creep!" and plant the machete right into the zombie's head.** What I did here was use a piece of soldering wire and trace the shape of the actor's head from the wire onto a machete. I then had the machete cut out in that exact shape so that it would fit onto his head and give the impression that it was imbedded deeply. I simply placed the machete onto his head, and the scene was shot in reverse photography—I actually pulled the machete *off* his head; when you see this scene in the film, you simply see it going on the guy's head in reverse, looking like it's buried deep. (The sound effect helped, of course.) There was blood tubing in his hair, so in the close-up where you see the machete buried in his head and

PHOTO COURTESY TOM SAVINI

©1978 DAWN ASSOCIATES PHOTO: KATHERINE KOLBERT

me moving it around and him writhing, you see the blood gush out around the weapon. This is another example of the continuity of shots making you believe you actually saw the machete go into his head. When you see me raise the machete and swing it at him, I am actually just swinging through empty air; the actor wasn't even there. Then we go to the shot of the machete going in (the reverse shot), and from there go to the close-up of the machete in there with the blood gushing out (blood tubing). Finally, we do another close-up of me pulling the machete out; we did it so fast, you weren't even aware there was a huge hole cut out of the blade!

When you see me riding along in the sidecar of the motorcycle, brandishing a huge sword and cutting off the head of a passerby-zombie, the first shot you see is me coming right at the zombie (the real girl), waving the sword at her and her moving away from the approaching motorcycle. From this we cut to a different angle, where a dummy of the girl (same costume) with a false head (I can't remember whose head it was...what I *mean* is, I can't remember whose *head-mold* we used) in a wig attached to the foam dummy with toothpicks so that the head was just tetering there on the dummy. From there, it was up to me to strike the dummy at just the right point so that the head would look like it was lopped off. It took two takes; the first time I hit the dummy right in the middle of the forehead. The second time, I cleaved it off right at the neck.

For the many zombies in DAWN OF THE DEAD (about three thousand total; two to three hundred each weekend for two-and-a-half months), I had a crew of eight people who would put the basic grey make-up application on many of the zombies, and then my assistant (Nancy Allen, and later Jeanie Jefferies) and I would do all the "gore" zombie effects, using the foam pieces (scars, wounds, etc.) made on that plaster slab I mentioned earlier. *Sometimes I would go home and get an idea for a "special" zombie or two, and I would take a lifemask and sculpt a distorted lip or tongue appliance. When I got to the set, I would see which zombie those appliances would fit, which extra they would fit, and he would become a "special" zombie. At one press session, where many reporters from different magazines came onto the set, we made them all "special" zombies.*

Since the zombies were people recently killed and then arisen from the dead, I tried to make them look like victims of car accidents, cancer patients, and so on. We had one zombie who walked around in a very nice suit, and I made him up to look like he had been freshly "done up" by an undertaker. *Sometimes undertakers overdo it a little with basic make-up, and rouge, and lipstick, so this guy could have been a heart attack victim, for example. There was no gore; he simply walked around in a business suit, pretty.*

PHOTO: H.C. ARMSTRONG

©1978 DAWN ASSOCIATES

The motorcycle rider who gets his stomach torn open by the zombies toward the end of the film (my best friend, Taso Stavrakis, who assisted me with the stunts and some of the make-up) is *shot* off his bike and immediately set upon by a bunch of zombies. They begin to rip his T-shirt and tear open his stomach to pull out intestines and so forth. For this scene, I made a foam latex chest for Taso that went from his crotch up to his collarbone.

> **A chest was sculpted on a flat table-top. A negative mold was made of it, filled with foam latex, and baked, producing a foam chest that could be hidden under his T-shirt.**

We first glued it up to his stomach area, and then placed the intestines we got from a slaughterhouse in the pocket formed by the foam chest. (Taso wouldn't let me place the intestines against his own skin; he took them into the bathroom and washed them for maybe a half-hour under hot water before he would let this

"disgusting stuff" touch his body.) We then inserted the blood tubing, glued the rest of it up along his ribs and over his shoulders, and put his costume on over it. The zombies then simply tore the T-shirt and tore into the rubber chest where the intestines were resting. We then pumped the blood through the tubing as they ripped his stomach open and the intestines oozed out. For the eating scenes, just as George had done in NIGHT OF THE LIVING DEAD, the actors were actually eating things like *bologna* and *chicken*.

The making of the controversial corpse. This corpse was found later in a local costume shop and caused some flap with the city coroner's office.

'Dawn of the Dead' skeleton is a real mystery

(Continued from Page 1)
ears in two movies, including the Pittsburgh-made "Dawn of the Dead."

Until this week it did all those things without raising a fuss.

Perper was called to police A. Perper Scott Township police officer opened the township while looking in the newly opened store for a costume.

Marilyn Work, the store owner, said she thought the skeleton was fake when she bought it last spring. It had been by ... ing stock of

Maves Costumes, an Oakland store that was going out of business. Larry Wintersteller, who said Work she bought it eight to 10 years ago that it was real.

Wintersteller now living in San Diego, said he bought it from a man who said it was part of a skeleton who said it was part of a lodge. The skeleton was used in initiations, he said.

"It's the funniest thing I ever heard of," Wintersteller said of the publicity the skeleton has brought to Work's store.

"Why didn't they see it while it was sitting in my store window, when I needed the publicity?" he asked.

Work was not so sure how amusing things were after Perper, Chief Deputy Coroner James Gregg and a morgue photographer trooped into her store yesterday.

"I can't believe it I can't believe it," Work repeated after Perper pronounced the skeleton human.

"Get this thing out of here," Work's daughter, Kimberly, said. "I'm ... ur back to Florida

Perper was puzzled at first by what appeared to be dried human skin covering the upper half of the skeleton.

"It looks exactly like mummified flesh," Perper said.

It looks much that way, according to Tom Savini, a Pittsburgher well known for his ghoulish makeup and special effects work for movies.

It was Savini who applied the commodified flesh, actually rubber cotton and rested the skeleton from when he rested the skeleton from Wintersteller for "Dawn of the

Dead."

Savini thought Perper's puzzlement was quite complimentary given that he often consults the ... for on how to make his creators look real

After rolling back Savini's work, Perper found the skull had been cut and a spring inserted to hold open the jaw for ... specimens used to teach medicine.

The other bones had been wired together, making Perper believe it may have been in a school of medicine at one time

Tony Buba is prepared to lose his arm to a mob of zombies.

PHOTOS COURTESY TOM SAVINI

The Helicopter Zombie, or the zombie who loses the top of his head when he wanders too close to the moving blades of an idling helicopter. *This particular effect got applause in the theatres I went to. This pleased me, for I felt the audience* *was also getting off on the technical aspect of the scene. They knew an effect was coming the closer the zombie got to the blades, and when it happened, they approved of it—technically.*

I made a full head cast of the actor, Jim Krut.

Casting A Head

The best way to make a full head life cast that I have found—after years of doing it the hard way—is the method used by Dick Smith. *It is a trouble-saving idea to have everything you are going to need laid out and ready to use before the subject arrives.* Once again you must make the subject feel at ease with what you are going to do. Part of this is to tell them that the method and material (alginate) is perfectly safe, it will not stick to their skin or hair, and that most people find the experience a relaxing one, like getting a facial. (And, in the unlikely event that they want it off, it can be removed instantly.)

When E.G. Marshall arrived on the set of **CREEPSHOW** to have his head and hands cast for his role, the first thing he said to me was, "I've had this done before, and I *hate* it." I thought, *"Uh, oh."* So, we cast his *hands* first, putting him at ease with us. Five of us sat there with him, radio going, talking him through it to let him know that when he's "under the stuff" he's not alone. *Make sure your subject knows he'll be made comfortable and content; he can relax and listen to his favorite music, and he can talk and answer questions. Talk to him, telling him every step of the way exactly what you're doing and when, and devise a system*

for him to answer back; not by forming words because the face must stay absolutely still, but showing "one finger means yes, two fingers means no." You'll be surprised at how much communication you can establish just through questions that can be answered with "yes" or "no." A life-mask casting such as this takes about fifteen minutes to a half-hour, and most people who've experienced it say that it feels like nothing more than a comfortable mud pack, refreshing and very relaxing. (When we did E.G.'s head, he proved to be the best subject of all, sitting there perfectly straight and still throughout.)

First the hair is protected by a plastic bald cap (Alcone Co.). It is transparent, and the hairline can be traced on it with an indelible pencil which will transfer into the alginate and onto the plaster positive, if necessary. Some mortician's wax (Naturo Plato #2 soft, also available from the Alcone Co.) should be modeled behind the ears, for full head casts, so the finished plaster ear will be thicker behind and less likely to break. Also, put a little wax on the eyebrows and some cotton in the ears.

I usually cast the head *and* shoulder area, so I tape a barber apron of some plastic drop cloth material to the skin around the

shoulders, exposing only the area to be cast. The subject should sit upright in a comfortable chair; I like a barber chair because it supports the subject's feet, the height can be adjusted, and it can be rotated. The upright position is best because the face is distorted when reclining or lying down. It's also a good idea to have a radio on so the subject's mind is occupied and the time will then pass quickly.

Dental alginate (Supergel, Jeltrate, or—best of all—DP Impression Cream) is mixed with water. The cooler the water, the more time you have to spread the alginate. The more alginate you add to the water, the pastier and less runny it will be. (You do *not* want it runny.) You want to spend your time spreading alginate to all areas, not scooping up great gobs of it that are running off. Wet alginate will not stick to already-dry alginate, so you must cover the head completely with the first batch, or have an assistant begin a second or third batch while the previous one is being applied.

In Hong Kong recently, I had a subject whose head was so large (he played a giant demon in the film) that we had to use this overlapping-batches-of-alginate technique. We also had to protect his hair by forming

and gluing a section of plastic drop cloth over his head. (None of our bald caps would fit him.)

Before opening a can of alginate, shake it to fluff it up, open it and pour it into your measuring cup. *Proportions:* ½ **cup or 4 oz. of alginate to 100 mil. or 3½ oz. water; 1 cup or 8 oz. of alginate to 200 mil. or 7 oz. of water; 2 cups or 16 oz. of alginate to 400 mil. or 4 oz. of water.** (It takes around four or five cups to cast a whole head and part of the shoulders.) *Body temperature affects the setting time. If the water is 70 degrees F. the mix should set in 4½ to 5 minutes. You should do your own experimenting. Keep notes. If you know the water temperature, and the amounts of alginate and water you use, you'll get good results each time.*

Pour the proper amount of water over the alginate in a bowl and mix until the lumps are gone. (I've been using an electric mixer at high speeds and getting a smooth, creamy paste.) Apply it with your hands, beginning at the top of the forehead and working down. (It's easier if two or three people apply it for a full head cast; two work on the back of the head and ears while you do the face.) Press the alginate against the face to eliminate air bubbles caused by alginate not reaching all areas—the corners

of the eyes, near the bridge of the nose—and make it thicker down along the back of the head and above and below the ears. *Make sure it doesn't drip into the nose.* Save the nose for last, and carefully spread alginate with a small brush or Q-tip around the nostril openings. (If some does get into the nostril, ask the subject to exhale sharply, clearing the nostril.)

Imbed two pre-cut pieces of terrycloth fabric (the cheap stuff), one to a section of the forehead and one over the mouth area. *The plaster bandages will stick to this, insuring that the alginate does not separate from it or shift when it is removed.* Check the head and cover thin areas until the alginate jells. When it does, you're ready to apply the plaster bandages.

Precut strips of bandage from say 12 inches to 24 inches, and some small ones say 2 inches by 6 inches for small areas around the nose. Roll all of your strips into individual scrolls and place them into a container—a bucket, perhaps. You do the front half first; begin by taking a 24-inch scroll, put it in water for about 10 seconds, remove it, and squeeze out the water firmly—*but not hard*. (The more water you leave in, the slower the set, but if it is too dry the bandages will not stick together well.) Unroll

the strip, and the idea here is to separate the front half of the head from the back with a thicker layer of bandage. *A median strip.* Center this strip on the top of the head, fold it over lengthwise—doubling its thickness—laying and conforming it down the sides in front of the ears (do not cover the ear area) and down along the sides of the neck (and shoulders, if necessary). If it doesn't cover both sides all the way down both sides, wet another strip and lay it on, always overlapping the previous strip.

Now cover the front of the chest and neck to overlap onto the median strip. Fold back the excess onto the strip to make its edge thicker. Cover the forehead, then across the eyes, with the bottom edge at the tip of the nose, always overlapping. Cover the mouth with the top edge just below the nose. Do under the jaw and neck by pressing the wet bandages so that they hug the contours of the face. Place the little nose strips vertically over the bridge and the tip of the nose, pinching it together into a narrow ridge so it will go between the nostrils and end on the upper lip. (Keep in mind that the heavier the face mold, the more the face will be distorted). The alginate need not be more than ¼" to 3/8" thick. The plaster bandage should be only four layers,

the thickest part being along the median strip.

When the front half is completely covered, coat a 2 or 3 inch band along the edge of the median strip with vaseline, and lay an overlapping strip of bandage along it, including the ears, beginning the back half of the plaster bandage mother mold. (Make sure it conforms along the strip to create a lip where the front and back halves will meet.) Cover the rest of the back of the head and neck to the median strip, continuing to overlap onto the front half forming the lip. (The vaseline will keep the front and back bandages from sticking together.) When dry, carefully pry the back off and set aside.

Now with a spatula or butter knife, carefully slice the alginate open from the middle of the top of the head, down the back of the head to the backbone. Reach inside and loosen the alginate away from the head and ears. Have the subject lean forward and wrinkle his face slightly to loosen the alginate and you should now be able to pull the cast off. *The alginate should stay with this front part of the cast because of the imbedded terrycloth.*

Before pouring in the plaster positive, the nostril holes need to be filled in. You can use water clay, or mix a little alginate with hot water (for fast set), spatula it on the outside of the mold, and force it into the nostril openings with two fingers until it sets. While you're doing this, hold the mold with the inside facing up, and stop pushing the alginate in as soon as you see that it just fills the nostril holes. Put the back plaster half back on, making sure the lip touches together all the way around. Run tape around them, firmly locking them together. *If the alginate flops away from the plaster around the edge of the mold, stick it back with poli-grip or a little wet plaster. Reach inside and you can feel if the alginate is seated properly in the plaster mold.*

Now you're ready to pour in the positive head in plaster—or Ultracal 30 if it is to be used as part of a foam latex mold.

Ultracal 30 is the brand name for a U.S. Gypsum cement product. It dries super hard, and is one of the best mold-making materials for foam latex.

I sculpted a new top to his head in clay. I made a mold of this sculpture, and after cleaning the molds I duplicated the sculpture in foam latex. I placed the foam latex piece on top of his plaster head positive, and cut the top of it into five sections. I connected the sections to each other with flash fishline and connected tubing to the inside of the uncut section. For the effect, Jim is standing on the crates next to the helicopter. An assistant pulls the top of his head off with fishline as another assistant and I pump blood to the head. The helicopter blades were animated in later. (I also put a beard on him, just to make him look a little different.) **(See color section)**

PHOTO TOM SAVINI

©1978 DAWN ASSOCIATES PHOTO: KATHERINE KOLBERT

PHOTO: KATHERINE KOLBERT

There's also a scene where my beautiful assistant, Jeanie Jefferies, has her face blown off as she attacks one of the heroes (Scott Reiniger) in the cab of the truck outside the mall. One of the other heroes (Ken Foree) pulls up in another truck and yells, "Lift its head up! Lift its head up!" Our hero lifts its head up—Jeanie's head—and the other hero fires from behind; we quickly cut to the front, where we see a part of her face blow off onto the hero. For this I made a cast of Jeanie's face, resculpted it so that I would wind up with a ¼" foam latex piece of her head which I could glue right to her face. I did that, cutting out a piece over her right eye and cheek. I put all kinds of blood and gore underneath that section (little bits of foam, saran wrap) with some tubing for blood. I replaced the piece on her face and then simply pulled it off with fishline. We then see a reverse shot of Scotty, the hero. I fell on his chest, spitting blood all around the cab, wearing a blonde wig like Jeanie's hair so I'd look like Jeanie. What we see in the film is Jeanie choking Scott, him struggling with her, Ken's (Ken Foree) gun going off, and that side of Jeanie's face being pulled off; then the reverse shot of Scotty with blood splattering all around him and me ("Jeanie") falling against him. He then kicks me out of the cab. *When I pulled Jeanie's face off, I made sure the fishline was parallel to the viewing angle of the camera so you couldn't see it. When I pulled the piece off, it came right out and hit Michael Gornick, the director of photography, splashing blood all over him.* The first time we tried this shot, the fishline broke, and the part of her face which was to come flying off *wouldn't.* Jeanie was in the cab of the truck with all the blood inside the face piece, up against her nose and mouth—she had a pretty rough time with that make-up. But we did it again, and it worked. **(See color section)**

56

It
Will
Freeze
Your
Blood.

The Prowler

False head of Farley Granger
as the killer before and after
the shotgun blast. Killing
Cindy Weintraub in the pool,
the pitchfork through the
back, and the bayonet in the head.

CREEPSHOW

©1982 LAUREL-SHOW, INC.

Inflating bladders in the E.G. Marshall head, pumping out the roaches and preparing Robert Harper (the student) for his attack by Fluffy.

©1982 LAUREL-SHOW, INC.

PHOTOS COURTESY TOM SAVINI

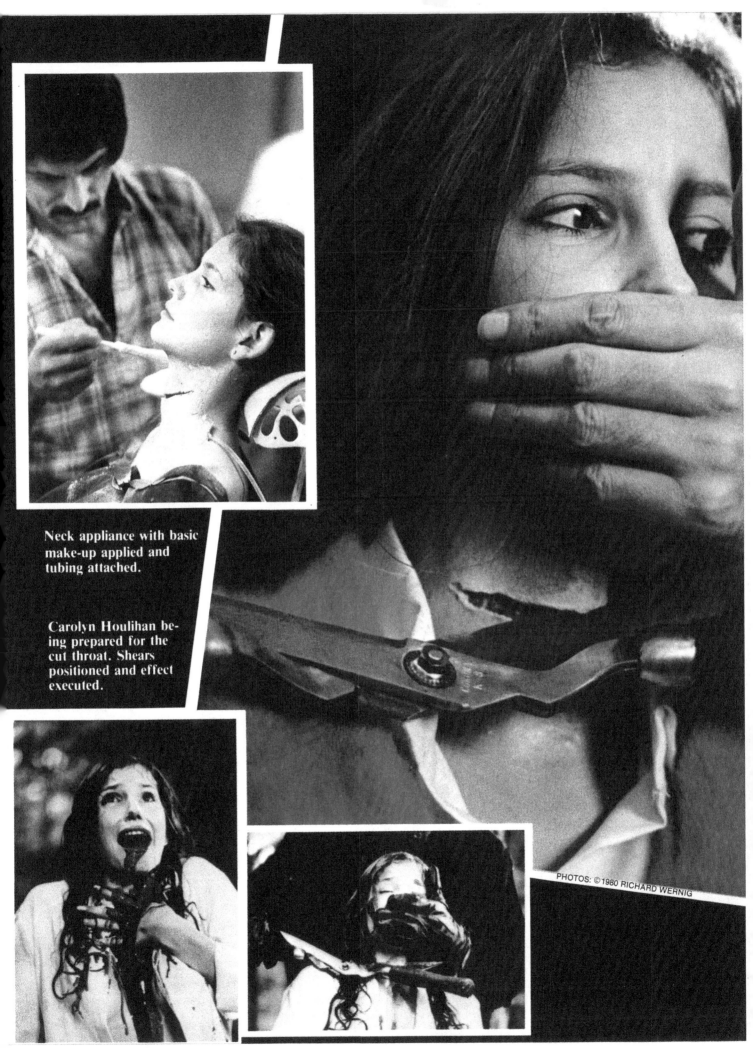

Neck appliance with basic make-up applied and tubing attached.

Carolyn Houlihan being prepared for the cut throat. Shears positioned and effect executed.

Larry Joshua (Glazer) is carried by the Cropsy maniac. The trick shears, the hooker's death, and Fisher Stevens as another victim.

PHOTOS © 1980 RICHARD WERNIG

PHOTOS: TOM SAVINI

Demon head of Cinema City Co. Ltd.'s (Hong Kong) production of *Till Death Do We Scare*.

Yet another corpse this time in Hong Kong.

Making up for my role as Ben Franklin in "1776" at the Fort Bragg Playhouse, N.C. Staying in practice, applying a beard in Vietnam. Pat Reese and me in "The Fantastiks" at the Fayetteville Little Theatre, N.C.

PHOTOS COURTESY TOM SAVINI

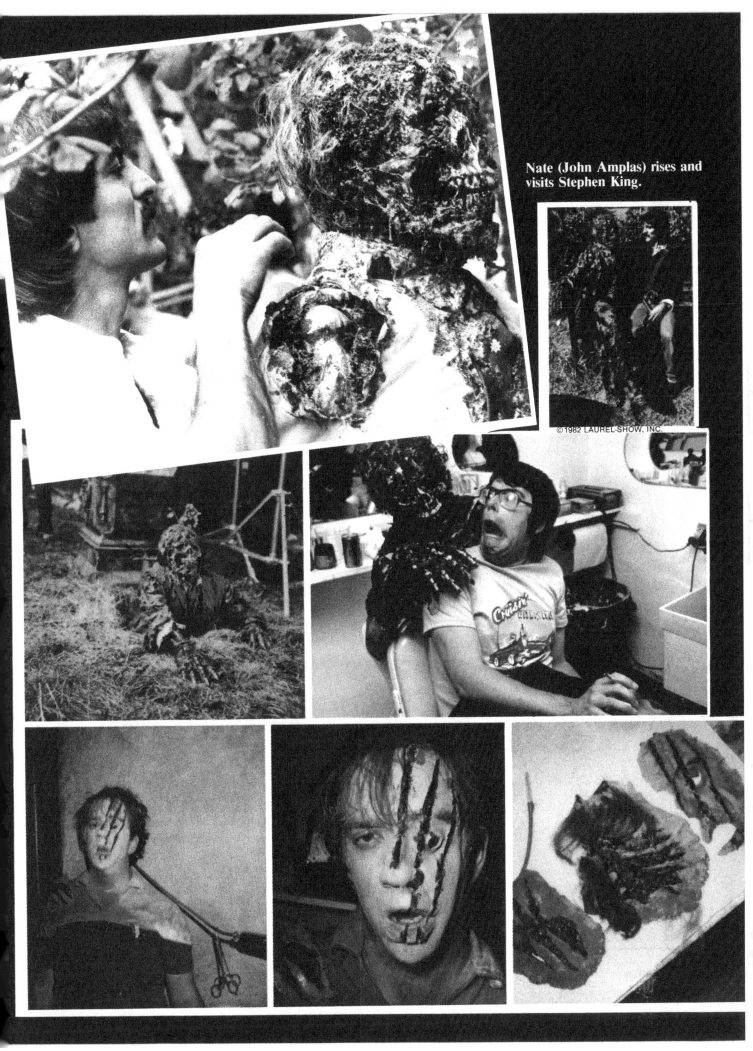

Nate (John Amplas) rises and visits Stephen King.

The many stages of "Fluffy."

Jeanie Jefferies is fitted with a squib by Don Berry. The results are exit wound bullet hits.

© 1978 DAWN ASSOCIATES

The exploding head, the screwdriver in the ear, and the airport zombie.

PHOTOS: KATHERINE KOLBERT

Me as a zombie being hit by a truck, and then as Jeanie Jefferies kicked out of the truck.

MARTIN

©1977 BRADDOCK ASSOCIATES

©1977 BRADDOCK ASSOCIATES

DAWN OF THE DEAD

PHOTO BY BARRY GRESS

©1978 DAWN ASSOCIATES PHOTOS: KATHERINE KOLBERT

©1978 DAWN ASSOCIATES

Jim Krut as the zombie who meets the helicopter blade.

© 1980 MAGNUM MOTION PICTURES

Me executing the stages of scalping on Rita Montone, and getting hit by a shotgun blast. Bottom: Joe Spinell with his false head.

The BURNING

Making the burned arm on Alan Brawer for the hospital scene. The Cropsy dummy getting the axe hit.

FRIDAY THE 13TH

Rare shot of Jason in test make-up.

PHOTOS COURTESY TOM SAVINI

Below: real axe, false head; then, real head, false axe.

Harry Crosby readied for arrow effect. Below: me as Laurie Bartram crashing through the window.

FRIDAY THE 13th

The first effect came at the very beginning of the film. We see a girl running through the woods, quick cuts of ominous feet stalking her, and her looking panicked, and finally we see her fall at the feet of the killer. She gets up, and **the knife comes up and slices across her throat.** *Even the knife was fake, made from a real one and painted to look like the real thing to prevent an accident.* I made a cast of Robin Morgan's neck, from the under-jawline of her head down to her collarbone. On top of the positive cast of her, I sculpted a new throat, 1/8" to 1/4" thick in some places, and then sculpted the cut right in that clay throat. Then I made the foam latex appliance of that. I took copper tubing and pounded it very, very flat against the positive mold of her collarbone area so that the copper tubing would fit her actual body. (Another crude, primitive method of pumping blood. *See the latex bladder section in THE BURNING.*) I attached the tubing to blood-filled syringes, actually once a fire extinguisher. The copper tubing was glued to her collarbone so that the end of the tubing where the blood emptied out coincided perfectly with the slit sculpted in the foam throat; the foam throat was also glued to her, made up, and she was taken to the set and placed against the tree. I instructed her to keep her head down so that the pre-sculpted hole (cut) was closed; after we see the knife pass in front of her, and after a second's pause, she lifts her chin up and we see the hole appear in her throat. We pump the blood, she reacts and falls out of frame, and we have a very realistic effect.

PHOTOS COURTESY TOM SAVINI

One effect in particular in FRIDAY THE 13TH generated a lot of interest; "You must have really *killed* that person!" **That was the scene where an arrow goes through the throat of the young actor, Kevin Bacon, lying on the bunk.** This effect was handled much the same way as the stake-through-the-neck scene in MARTIN which we've discussed, except in this case, instead of pushing the arrow into him from the *outside* of his neck, I pushed the arrow through the underside of the bed and out a false neck appliance which was glued under Kevin's jawline and included his collarbone and shoulders. I made this appliance the same way as the appliance in MARTIN: the plaster backing, the foam latex skin over it and attached it to Kevin. But this time I glued an ice bag by its metal lip to the plaster backing, just behind the hole, with epoxy. Into that ice bag, the arrow was fastened and sealed with tube clamps. (Another tube, attached to the ice bag, went into the good old blood-filled syringe.) Taso, my assistant, was under the bed, ready to pump the blood to fill the ice bag surrounding the arrow. The neck piece was attached to Kevin, who was kneeling under the bed with his head through the mattress and through a special pillow that was made to make him look like his head was resting on it. On cue from the director, I would stick the arrow up through the hole in the plaster, and push it through the flexible foam latex while Taso pumped the blood. *When Taso started to pump the blood, the tubing popped off the syringe. Thinking quickly, he immediately grabbed the tubing and started to blow into it, which caused all the gurgling and bubbling effect of the blood. That "accident" actually ended up adding to the effect.* The scene was shot from two angles; what we see in the movie is the side angle.

Now for **the famous axe-in-the-head illusion.** I did actually use a real axe crashing into a false head, and then a false axe attached to her real head. I hit her false head with the real axe, and then immediately cut to the real actress with a false axe attached to her. (She was holding it by the handle just out of camera range.) The shot of the false head being hit by the real axe was ommitted from the film because it didn't move quite right; it was set on top of a foot locker, and when the axe hit it, the whole thing shifted out of frame, instead of just the head articulating backwards like the real, loose head would have reacted. What we see instead is the real axe smashing the light and going out of frame; we hear the sound of the axe hitting her, and then we see her with the false axe attached to her face. *(See color section)*

75

Foam rubber duplicate weapons: a real rifle, a fireplace poker, woodworking tools, or—as in CREEPSHOW—a real .38 revolver was greased with vaseline, and pressed sideways halfway into a specially-built box containing plaster (Ultracal 30). When this dried, the exposed plaster surface around the object was greased with vaseline and more plaster was poured in, filling the box. When this dried, the plaster halves were separated, the object removed, and foam latex was poured into the area the object occupied. The mold was closed and baked—producing a foam latex duplicate.

What we did here was cast the axe and duplicate it in foam rubber. Taso painted it exactly like the real axe. I cut out a section of the head of the axe so it would conform and fit on the head of the actress. (Like the machete in DAWN OF THE DEAD.) I built up mortician's wax against that cut foam axe head, making sure we could still see a gap in the wax, and there was blood tubing in the girl's hair pumping blood into the wound area. I was holding the actress (Jeannine Taylor)

by her bum, and lowering her to the floor; she was holding the axe handle, keeping the blade against her head, and blood was pumped at the same time.

There is another victim in the film who is not killed graphically on-screen, but who later on is tossed through a window, tied up in ropes. What we see are the finished results; it looks like she's been beaten up. Here we simply made up the actress (Laurie Bartram), rolled camera, and had her fall back against the floor from a sit-up position, and I threw breakaway glass all around her at the same time. *It was me who went flying through the window wearing a wig and nightgown to look like her. (See color section)*

For the scene where another victim (Harry Crosby) is pinned against a door with arrows, I did a number of things. **For the arrow in the throat,** I took the cut throat appliance from the first death scene, glued a thin wire screen to the tip of the arrow, and then glued the wire screen to the actor. The foam cut throat appliance helped hold it in place, and a little black fish line held up the other end. **For the arrow in the eye,** I created one of those Steve Martin-type arrows by pounding a half-inch strip of tin to fit over a positive head mold from the eye area over the top of the head to the base of the skull. (This would fit over the actor's head.) The arrow was glued to this tin piece. I also made a forehead and eye appliance that slipped over the arrow after it was placed on the actor's head, and that helped hold the arrow in place. (There was a piece of cotton over his eye to protect it from the metal of the clamp where the arrow was attached.) Blood tubing was added, of course, and the wire-screen technique was used for the arrows in his chest and crotch.

In the scenes where Mrs. Voorhees is chasing the girl at the end of the film, there is alot of action: rifles hitting people, leather-working tools hitting Mrs. Voorhees, alot of fighting and struggling. (I choreographed the fight on the beach.) For these fight scenes—the girl hitting Mrs. Voorhees with a fireplace poker, for example—it was necessary to cast and make molds of all of these "weapons" and then make authentic-looking foam rubber versions of them for the actors to use.

Beheading Mrs. Voorhees was done by first casting the full head and shoulders of Betsy Palmer (who starred as the character), duplicating that in foam, cutting the head away from the foam, and making the neck up to look as if

the tissue, bone and spinal chord had been severed. (Inside, two blood tubes were placed to produce the effect of blood shooting out of arteries.) The head was attached to the neck appliance with toothpicks (like the "Boris" dummy in DAWN OF THE DEAD) so it was just tetering there. In the film, we see a scene of the real Mrs. Voorhees, eyes wide and mouth open to scream, so we cast Betsy Palmer making that expression so that the false head's expression would match perfectly to the one her character has when she gets her head chopped off. The false head and shoulders were then attached to Taso. So, we had the false head attached to an actual body (Taso's) so that when the head was chopped off we'd see real hands coming up into the frame and flailing. *We even put her ring on Taso's finger; if you look closely, you'll see Mrs. Voorhees' hands with little black hairs on them.* I stood there with a machete in one hand and blood tubing in the other, and the make-up girl stood by ready to pump more blood, if needed. (Taso had his head down, and the shot was framed just above him, so it looked like Betsy Palmer's own shoulders.) I swung the machete, cut the head off, and pumped the blood tubing at the same time; Taso's hands came up and jiggled in the frame. (The false head and shoulders were attached just behind Taso's own head and shoulders with ace bandages.)

77

For Jason, a life mask was made of Ari Lehman, the first actor to play Jason, and originally I was only going to do an appliance make-up on his face—lowering one eye, giving him kind of a "dumb" look on his face, re-sculpting a new ear on his right side, giving him a hair-lip, a protruding lower lip and some false teeth. I completely finished that make-up, and we did a test on it. The producer came in later and told the line producer that he would like Jason to be bald, a kind of hydrocephalic head, because he'd seen a child like that once and it had scared him. So, I completely *re-did* the Jason make-up, making him a bald, hydrocephalic, hair-lipped, buck-toothed, slope-eared child. This was a one-piece appliance, including the false ear on the right side of his head, blending in just under his right cheekbone, coming down and including his upper lip, up alongside the left side of his nose just above his left eye, continuing along the left side of his face just above his left ear, and then down along the back of his neck just above the base of his real skull. (There was a separate lower lip appliance.) After this new sculpture was complete, clay walls were built leading up to the edges forming the "flashing." Negative molds of the front

and back of the sculpture were made, the clay was removed, and the molds were cleaned. After they dried a few days, the molds were given a coat of separol and placed back together. Foam was then injected through a hole in the back negative section of the mold. We baked it in a nearby pizza oven, and later pulled out the finished Jason head appliance.

Flashing is the cutting edge where one mold, say a positive, joins against another mold (a negative). After you have sculpted a nose or a chin or a face, etc. on a positive mold and made a negative mold from it, the clay is removed and the foam latex is poured into the negative mold. The positive is pushed into the negative mold until the cutting edge stops it, cutting the flow of foam out of the mold. The amount of foam left between the molds is equal to the amount of clay used to sculpt that nose, chin, or face appliance. This insures that the edge of the appliance is as thin as you have sculpted it in clay.

78

MANIAC

The effects for MANIAC were the goriest I have ever created. *There are two cut-throat effects at the beginning of the film, a scalping about ten minutes later. I get my head blown off a few minutes after that, a nurse is stabbed clear through shortly after that. The maniac's mother pops out of her grave, and last—but certainly not least—the maniac is attacked by his victims (in his own fantasy nightmare) and is stabbed, dismembered, and has his head torn off.*

In the first effect there is a girl lying on a blanket, and we see the knife coming in frame (actually a retractable artist's cutting knife for posterboard and stuff like that, which can be bought at an art store). I rigged up the underside with tubing, on the side away from the camera, to pump blood as the blade was pulled across her neck, appearing to slice her neck. The cut was made just under her chin, so her chin camouflaged the actual skin area the knife came across. This is similar to the effect in MARTIN where we see the blood dripping from the blade, but here it appears as if it's dripping from her throat.

The second effect is her boyfriend, who comes back to her after looking for some firewood and is grabbed from behind by the maniac with a wire garrote. We see this happen to the actual actor without any make-up or appliance attached to him; we stopped, and immediately applied the make-up. *I had no idea where we were going to shoot the scene. We got on the movie bus, the movie trailer—which is very comfortable, with berths for sleeping and so on—and I had all my stuff packed up and dragged it on the bus. I crawled into one of the berths, fell asleep, and when I woke up, we were on a beach. I had no idea where. It was October sometime. We used this deserted, very cold men's room to put this make-up on the actor.* The appliance was made

from a cast of the actor's neck down to the collarbone, pre-cutting it across the neck where I knew the garrote was going to go, and I actually used the same copper tubing attached to plastic tubing and the blood-filled syringe set-up I'd used in FRIDAY THE 13TH. This was the last shot of the day; the sun was fading, and we had to shoot it quickly. We put the wire garrote inside the cut throat and pumped the blood. The illusion works because you see the maniac putting the garrote around the character's neck, without make-up, and then we cut to a scene of him being lifted off the ground, feet twitching, and then cut back again to the actor with the appliance in place bleeding. Cutting from there to a sunset, a fly on a parking meter, all sorts of gimmicks, and then cutting back to the garrote, we show more of the bleeding and the effect is over. *I did MANIAC within two days after I finished FRIDAY THE 13TH, so I had alot of things left over, like the copper tubing from the throat-cutting effect; it worked in FRIDAY THE 13TH, so luckily it fit and worked for the garrote scene.*

The scalping scene was a very complicated effect to accomplish. The close-up scene was shot in my apartment, the apartment I was given to use as workshop and living quarters while I worked on the film. (The rest was shot at the St. James Hotel in New York where, within a week after we shot the scalping scene, a real maniac

79

killed a prostitute and decapitated her...a real eerie coincidence.) Since the scalping scene was mainly done in close-up, we recreated the headboard of the bed, the pillows and bedsheets and all that, and shot it in my apartment, walking from the barber chair in one corner of the room to the "bed set" in the other corner, for each stage of the make-up.

The girl was placed on the bed in the same position she was in before any cutting took place. We had the advantage of cutting quickly from her to the maniac's face to set up the scalping scene, so we used the same artist's knife we had used in the beginning of the film to begin to cut on the left side of her head and into the hair; as the knife was pulled along harmlessly, I pumped blood into the tubing off-camera, and when it moved from the hair to the skin on her forehead, that's where we stopped. (We cut to the maniac's face.) He put her into the barber chair and applied a very thin layer of mortician's wax to her forehead, giving her a new forehead, so the next time we see the knife (dull, of course) it's cutting into the mortician's wax. The blood tubing and

the blood flowing on the opposite side of the knife, away from her eyes, pushed blood into the groove made by the knife in the mortician's wax; the head appeared to be sliced and bleeding from the wound made by the knife. That shot continued until just a little beyond the middle of the forehead; at that point we stopped again and cut back to the maniac's face.

Now the girl goes back to the barber chair, where an elaborate make-up job took place. I soaped out her hair so that I could mold and sculpt the red, shiny, fatty undertissue that is below the skin layer. I used clown white make-up over her soaped out hair (see soaping out section of *Richard Corson's Stage Make-up, Sixth Edition*) and mixed in a little red, turning it pink. Then I blotched on little blobs of black and red. *What helped greatly in this effect was a visit to the plastic surgeon who fixed my nose for me. I was permitted to view slide after slide of restorative surgery he had performed—before and after shots of his patients. One in particular was a man whose throat had been cut. In that*

particular slide I was able to see this white, fatty undertissue which exists just under our skin layers; it had little tiny black and red globules in it. I duplicated this look on the actress' head. I covered that whole thing with K-Y lubricating jelly to give it a slick and shiny, kind of "living" appearance. I took the front of her head and built up mortician's wax where her real skin stopped and the scalped area began. Before all of this I had taken a cast from a life mask of a bald head and covered that with latex, and built a latex scalp on which I glued and *punched in hair* to match the girl's hair color. That was placed on top of the scalped make-up. On the underside of this false latex scalp, I taped blood tubing and pumped a little blood, so that when it was pulled away from the girl's head it still appeared to be bleeding, completing the effect. **(See color section)**

> **Punching in hair means taking strands of hair and, using a needle, punching or pushing them into foam latex or rubber masks, etc. The needle is a sewing needle prepared in the following way: With wire-cutting pliers or needle-nose pliers, chop the eye of the needle at an angle (as shown). Grind the edges, producing a sharp tong that will grab the hair and easily imbed it into rubber. The pointed end of the needle can be easily pushed into a wooden handle—such as a piece of dowel rod—making it easier to handle.**

There's a scene in a subway where the maniac corners and traps a young nurse and sticks a bayonet through her. To achieve this effect, there were actually two bayonets: the real, long, shiny, uncut bayonet and one that was cut through, removing the top third of the point. This top third was attached to a metal plate with epoxy and the actress wore it on her chest just above the sternum. The bottom two-thirds of the bayonet

was held against her back to make it look like it was partly in her. I used "Boris" again in this scene, with him wearing the nurse's costume, so that we could have a shot of the bayonet being placed against the back and shoved in; it was actually beneath—and sticking through—her uniform. It made her look like the point of the bayonet was sticking out of her chest. We did the same kind of shot again, this time from the front, so that we see the tip of the bayonet actually burst through the chest, through Boris. (I placed a blood sack there so the impact would cause blood to saturate the costume.) The final shot is of the girl standing there with the maniac behind her, and the top third of the bayonet's sticking out of her (actually attached to the metal plate she wore). All of the Boris shots were not used in the film; we see the maniac begin to hold the bayonet against the back of the real girl and then all of a sudden we are shown the front, with the first third of the bayonet sticking through. *In my mind, the illusion would've been better achieved if we had seen the maniac taking the knife against the real girl, going to the close-up of it going through and out the front of Boris, and then cutting to the real girl with the bayonet already through.*

One of the most "interesting" effects for me was blasting my own head off with a double-barrelled shotgun. In this particular scene, you see me with a young girl, leaving a disco, and getting in a car and driving off. The maniac follows in his car, and you see this from his point of view. We pull into a lover's lane and so does the maniac. The girl and I begin to make out in the back seat and she looks up to see the maniac's face in the window of the car and wants to leave. (I don't see him, of course, and I think she just wants to get away from me and go home to her boyfriend, etc.) We get back into the front seat of the car, and you see—from the point of view of the back seat, looking over our shoulders and out the window—the maniac in our headlights.

He jumps onto the hood of the car, points the shotgun at me, and we cut to the outside of the car over the shoulder of the maniac and the shotgun blast at me through the windshield. Then we cut back inside the car to see my head receiving the blast, in slow motion, de-crinkilating into a dozen pieces and blood flowing everywhere, including onto the girl next to me. *She then screams what I think is one of the best movie screams I have ever heard.* This effect, for me, was the closest I've ever come to the feeling of having committed cold-blooded murder. When this effect was over, I actually felt like I had killed somebody, and to top it all off, it was *me* I was killing!

What I did was make a life cast of my head and shoulders, and from it a thin latex mask of myself with a thin plaster lining on the inside of it. (I used the negative molds, painted in a latex skin, put the latex skin back into the mold, poured a thin layer of plaster in there, sloshed it around, and when that dried, took the outer molds apart and there I had a plaster-lined latex skin head of myself.) I filled that with blood filled prophylactics and calf brains from a slaughterhouse (I think it held about ten blood-filled condoms). The head was sealed on the bottom with foam scraps and placed on the "remains" of Boris. *Boris was looking pretty shabby by this time—he'd been run over in DAWN OF THE DEAD, been thrown off cliffs—just ragged. My best friend and I even used him as a target one day for archery.* I attached the head in such a way that it would tilt backward, pulling the body with it, with any kind of hit it would take in the front, by attaching the head to the dummy using the elastic-and-hook-type cables that cyclists use for holding packages and things on the back of their motorcycles. Boris, of course, was dressed like the character I played in the movie; I then donned the maniac's costume, adding padding to the arms, stunt-padding to my legs, goggles for my eyes, a wig and a hat. (I'd never actually taken a shotgun and blasted it through the windshield of a car at close range before, so I had no idea what would happen.) There I was, sitting in the front of the car (in dummy form) and also sitting on the hood of the car looking at myself sitting behind the wheel of this car! I had a double-barrelled, 12 ga. shotgun in my hands with no shells in it so I could practice pulling both triggers at the same time until I felt comfortable that I could do it. There were three cameras going simultaneously: one just behind me and higher up, one looking from the passenger's side of the car at me, and one looking from the rear window at the back of "my" head. All were ready to film the scene in slow-motion. *I must tell you here that you're not allowed to fire a weapon in the city of New York. We shot the scene under the Verranzano Bridge with the cooperation of a few policemen who were close friends of the production company, which added to that feeling of cold-blooded murder I mentioned before. I felt like an assassin; immediately after I fired the shotgun, I gave it to the policemen, who drove it off, and then I was taken to a car and driven off. The set was torn down immediately, and I think within five minutes everything and everybody was **gone**.* I fired both barrels of the shotgun through the windshield and at the dummy head of myself. The force of the blast knocked me off the hood of the car and into the waiting hands of a grip who'd been placed there just in case something like that happened. I gave the gun to the policemen, and then I had to go around to the driver's side of the car just to see what the damage was. I saw myself, with my head splattered all over the car. They showed every angle of that in the finished film. (See color section)

The maniac then walks around to the passenger side and does away with the screaming girlfriend. You don't see this in the film, but you do see the after-effects later on when she comes back to life in his fantasy at the end of the film. However, that particular shot was filmed two weeks later in a garage near the river. *During that time, the remains of Boris were in the trunk of that car, without having been cleaned of blood and brain. So, when we got the car back to try to use it for the scene of the girlfriend's demise, it was unusable because the smell was unbearable; it smelled like a real corpse had been rotting away there. The car was junked, with Boris included; dumped in the river, I think. We used the interior of a similar car to shoot the scene of the girl reacting to the maniac coming around to her side.*

There is a nightmare sequence toward the end of MANIAC where he envisions all of his victims coming back to life. We see them sitting around his apartment as mannequins that he has dressed up like his victims. He has placed the scalps of his victims on them. We see them come to life in their various stages of murder: cut throats, scalped, bloody, and so on. **The first thing one of these living zombies does is stab the maniac in the chest.** For that we simply see the zombie wielding the full bayonet down on a slab of wood placed on the bed. We then see a close-up of the cut bayonet placed on the maniac; I think that was done in reverse, or we simply see it pressing on him; we cut to his face and we see him spurting blood. **Then another zombie takes a machete and cuts his arm off.** For that we simply took a false hand and placed it strategically in his sleeve on the bed so that when the machete hits it, it would bounce off the bed. We stuffed the empty sleeve of his shirt with some foam padding, and the

sound effect helped when the hand hit the floor because the sound was a "THUD!" and the hand was made of light foam. **A headless torso** appears, wearing the sweater of the garrotted victim at the beginning of the movie, an added, thrown-in effect using the severed shoulder and head appliance from FRIDAY THE 13TH. We

pumped blood at the same time, and it was fastened to the actor the same way it had been fastened to Taso, so that the hands could be moving and looking as if they were grabbing for the maniac. He, of course, was screaming through all this, and as he was screaming, **about three or four of the zombie apparitions grabbed hold of his head and tore it right off!** (For this illusion, we had the actor assume the same facial expression as a screaming maniac false head and shoulders I'd made of him.) We see the zombies moving his real head back and forth as if to tear it off, then cut to the maniac's point of view seeing all the zombies staring at him in all their bloody "glory," and when we cut back it is the *false* head and shoulder appliance which I'd slit open in the back and stuffed with all kinds of gory little goodies: shrimp dip from dinner, barbecue sauce, blood—I was originally going to put some animal scraps in there, but the stuff the slaughterhouse sent was too large...it was like *dinosaur* intestines. When the girl-zombies tore into the side of his neck to rip his head off, we saw all this "lovely stuff" dripping and oozing out. They finally snapped the head off, leaving—unexpectedly—this long, tendon-like, bloody "thing" on the pillow...the end of the Maniac.

This was a rough shooting day, and, indeed, it *was* a whole day—more than a twenty-four hour shoot for this particular scene. All of the individual zombies had to be made up (with cut throats or scalpings or the like), the maniac's head had to be prepared, and so did the scenes of the maniac getting stabbed and the appendages getting cut off; the actual tearing off of the head was the last scene. *Before we left, just about the whole room was splattered or covered with blood: the crew, myself, assistants, actors,*

passers-by, interested parties, studio personnel, a watchman, a cat. The cut throats and the scalpings on this particular 24-hour shoot had to be done very quickly, obviously. They were done with mortician's wax on the throat, which is not advisable because mortician's wax works best on bony surfaces. Here we were, putting mortician's wax on the very fleshy area of the throat, slicing it irregularly and filling it with black make-up and red make-up, and making it up to look like the rest of the actors. The same thing was done for the scars on the foreheads to show scalping marks; all mortician's wax and colors.

The maniac's false head was constructed almost the same way as my shotgun blasted head, except his false head needed to turn left and right on its shoulders. So, instead of pouring a thin plaster lining into a latex skin mask, I made a ¼" foam latex skin mask and completely filled it with plaster while it rested within its negative molds. I removed the foam latex from its newly formed plaster *core*. Then I cut the neck section away from this core and replaced it with a short ½" dowel rod. This rod connected the head section to the shoulder section of the core, and enabled the head section to swivel left and right. When the foam mask was placed over it again, it looked like the maniac's head turning left and right. This also left the neck section empty inside the foam mask, except for the ½" dowel rod. That's where I placed the "gory goodies." When the zombie apparitions tore into it they also snapped the dowel rod and tore his head off.

EYES OF A STRANGER

After I finished MANIAC, I got a call from the producers behind FRIDAY THE 13TH. A movie they were handling called EYES OF A STRANGER was nearing the end of shooting in Miami. It had no graphic murders in it at that time, but after seeing how FRIDAY THE 13TH was coming along, they wanted to hire me to go down to Florida and put some graphic murders into the film. *I felt like an assassin again. I load up my car, drive someplace, and kill people.*

The severed head in the fishtank—The killer takes a meat cleaver and chops off the head of the unsuspecting boyfriend sitting on the couch. The girlfriend comes home and sees the head of the boy bobbing in her fishtank.

Luckily for me the actor (Timothy Hawkins) was a singer with excellent breath control, because I decided to use his real head in the water-and-fish-filled tank; it would be the most realistic way. *Unfortunately, his body was attached to his head, and he really didn't want to change that arrangement. So I devised a plan:*

PHOTO COURTESY TOM SAVINI

The illusion here is that there are books in the bookcase and a severed head is in a fishtank on top of the bookcase. (There couldn't *possibly* be a body attached underneath, because we see all the books.) First I prepared a large fishtank by cutting an oval hole in the bottom right of it so the actor's head would come up into the fishtank facing sideways. Then he would turn his head to face out the front of the tank. Meanwhile, I had a special bookcase constructed. Instead of having shelves that were open in the front so you could put books into them, each shelf had a wall in the front, making them only 1" deep. ½" mock-ups were made of the side bindings of the books, and they were glued to the fronts of these shelf walls.

This gave me nearly a foot of space behind the bookcase to conceal the actor's body. He was, in fact, behind the bookcase with his head stuck up into the fishtank. I put his head through a section of plastic garbage bag and glued it around his neck with a surgical adhesive. I added a foam latex neck appliance to the side of his neck, making his head look severed (similar to the effect of Carrie Nye's head on the platter in CREEP-SHOW). The actor, with the appliance and garbage bag glued to his neck, got behind the bookcase and stuck his head up through it into the fishtank. The garbage bag was glued inside to the bottom of the tank, sealing the actor in. Those little colored aquarium stones were added on top of the plastic and then little fish toys. We placed a scuba regulator in his mouth so he could breathe while we filled the tank with water. (Then we added the little fishies.) We then rolled camera, and on a nod from the actor, we removed the breathing regulator. He'd then assume the facial expression we wanted (relaxed) and tilted his head to the side of the tank, exposing the severed neck appliance. I reached under the bookcase and grabbed the actor's knee. (If I applied pressure upward, that meant he had to lift his head up. Down meant he must lower his chin. Left or right meant he must move his head left or right. This way, if the director didn't like the position of the head, the actor would know how to move by my signals.) The fish swam around exploring his eyeball and open mouth. When he needed air, he would signal us and we'd instantly

put the air regulator back in his mouth, vacuum the water out within five seconds, and in case of an emergency I had another person placed close to the fishtank holding a small sledgehammer. (His job was to break the glass of the tank if anything went wrong. The water in the tank would force any broken glass away from the actor. Luckily, this never became necessary, and the scene was shot over and over again).

There's also a scene where the girl's boyfriend goes over to the killer's car to help him get his car out of a swampy area where the wheels are stuck and just spinning in the mud. For some reason (I guess he didn't want any witnesses), the killer rolls down the window and clicks open a long-bladed switchblade. In the long shot, we see the blade coming out of the car and toward the actor's neck; in the close-up, we see another prepared switchblade (I'd cut off three or four inches of the blade and prepared it with blood tubing) held against the boyfriend's throat, blood gushing out. The illusion is that, in continuity, we see the blade come out of the car and toward his neck and then we see the prepared switchblade pressed against his neck so that it appears the blade has actually gone *into* his neck.

For the scene in the bedroom where Jennifer Jason Leigh (Vic Morrow's daughter) fires a gun blindly at the maniac, shooting things on her dressing table, we simply took a slingshot and started blowing things off the dresser to make it look like the bullets were hitting all around the killer.

The final scene is where the killer gets hold of Jennifer in the bathroom set and begins to strangle her. **Lauren Tewes (LOVE BOAT) comes in with a two-handed grip on the .38, fires, and hits the maniac in the forehead, dead-center, right between the eyes,** forcing him through the shower door and into the bathtub; later we see him in close-up, bleeding from the bullet hole.

PHOTOS COURTESY TOM SAVINI

I put a squib inside a prophylactic filled with blood, hair-pinned it to a metal plate on the back of the actor's head, and when I pressed the button on the detonator, it would explode, sending blood all over the shower door the maniac would soon be flying through. At the same time, I pulled a button out of a plastic appliance glued to the actor's forehead. What you saw was the hole appear in the forehead, and the blood splattering off the back of his head, the illusion being that the bullet was going right through his head. *(See DAWN OF THE DEAD)*. John DeSanti, the actor, then forced himself through the shower door, backwards. *The shot didn't work at first. The shower door was made of safety glass, and there was no way John could break it. We even*

scored the hell out of it in the back, in various patterns, and he still couldn't break it; and John is a hefty, strong man! What we eventually ended up doing was padding John's back and his rear end, and at the point of impact when he was heading toward the shower door, a technician (John Boisseau) fired a B-B gun at the glass, causing a little hole which was all that was needed to make it very weak. When DeSanti's body hit it, it shattered into little pieces. A small sliver of glass found its way into the fleshy part of John's rear end. He went to the hospital for it and reminded us of the incident for the next few days by flashing the X-rays of the glass stuck in his ass. In the next shot we see him in the bathtub bleeding from his forehead wound. I attached my blood-filled rectal syringe to the tubing leading to the blood passage in the plastic appliance, and we did a long, close-up shot of the blood spurting out of the bullet wound as Lauren Tewes approaches and stares at him in the tub.

1980 RICHARD WERNIG

THE BURNING

THE BURNING is the film I chose to do instead of FRIDAY THE 13TH: PART II. *I turned FRIDAY THE 13TH: PART II down for a few reasons: mis-communications between myself and the backers of the film, and because I really wasn't too crazy about the script. It had Jason as a "live" character, after we established in PART I that he simply existed in the mind of our hapless survivor. To bring him back to life meant that he would have had to be living at the bottom of the lake since he was a child, and I just didn't think that was believable. However, the film did turn out very well for first-time director Steve Miner, who had been the line producer of PART I. I thought he did an excellent job on it, and I'm sorry things didn't work out for us.* I felt at the time that THE BURNING was a much better film, and I was very happy to have worked on it. It contains some of the best effects I've done.

First and foremost in THE BURNING was the creation of **the Cropsy Maniac**. (He was taken from a true story.) In the film a burn victim is haunting the woods near a summer camp seeking his revenge on the people he thinks caused him to be burned. For the Cropsy Maniac, I first made a life-cast of the actor and then sculpted the maniac features on the positive mold from it. *I*

*kept asking for more time in the schedule, away from doing effects, so that I might spend some exclusive time creating the face of the maniac; after all, that's what we keep hiding from the audience during the whole movie, and when we see his face at the end it's a climactic moment. I wound up doing it in **four days**.* We cast the actor's head (Lou David); he was a bit unusual-looking in that his nose was pushed up, exposing his nostrils. (If you were looking down on him, it was like looking at the nose of the Phantom of the Opera.) We pushed his nose up even more, with silk fabric glued to the tip of his nose, pulled back and glued up on the bridge. We did the same thing with his lower lip: we attached silk fabric to one side of his lip and pulled it way down and glued the fabric underneath his chin. We cast his head in this condition. On the positive I sculpted Cropsy's face remembering the pictures I'd seen at the burn unit at Pittsburgh's Mercy Hospital and a beggar I'd seen on the streets of downtown Pittsburgh when I was a kid, and the book *Nursing the Burn Patient* by Feller. I wanted to make a full-head, thin foam latex mask that I could glue to the actor at special places around the mouth, nose and eyes so that when he moved his face and talked it would move with him. I took the life mask, ground down some acrylic teeth and fastened them over his upper lip and gums. I think I did his lower lip the same way, and then sculpted the face over these teeth. At some point during the sculpture I removed the teeth and put some clay inside the mouth so that when I made the positive-negative molds it would give me his upper and lower lip. I knew the mask would fit over the teeth because I had sculpted it over the teeth. I sculpted his upper lip pulled up into the side, lots of scar tissue and texture, and I gave him a "dead" eye on one side. (I sculpted over the glass eye and then removed it before casting.)

Once I had the positive and negative molds, I removed the clay and cleaned the molds with carbon tetrachloride to remove all of the clay residue. I drilled holes in the top of the back section of the negative mold, and it was through these holes that I injected the foam. Later when the mask was on, I filled the hole with cotton and

vaseline. We put the two molds together after being coated with a separating agent (separol—because we were using R&D foam). *I had not yet used George Bau foam—I'd heard about it, but hadn't done any experimenting with it yet.* We produced many masks, roughly one mask each day for almost a week so that we'd have extras. (We knew we needed extras for the last scene in the film, where the maniac is killed by an axe in the head.) I took a perfect mask, placed it over

the life mask of the actor, and painted it with rubber cement paint. First the teeth were glued to his upper lip and the fake eye area blacked out; the head was put on and glued around the mouth, nose, and chin. *I glued it on with Sloman's medico adhesive; I hadn't heard of the Dow-Corning 355 adhesive yet—a Dick Smith discovery.*

There's a **cut throat** in this film too, done about the same way as other cut-throat scenes I've done before, except in this case, instead of using the copper tubing for pumping blood out, I found that I could make a very thin bladder by sandwiching a thin piece of plastic sheeting between layers of liquid latex. *This evolved from reading about an effect Dick Smith did using plastic appliances. I tried it with latex, and it seemed to work.* I painted latex on the plaster

positive mold of the actress' throat, just about where I thought the cut on the throat would be. I extended the latex around the back of the neck in one long, strip-like section, and then painted it several times until it was four or five layers thick. I took a piece of plastic garbage bag, which latex would not stick to, and inserted this tiny strip along where I thought the cut would be, and then continued it along the back. Painting a few layers on top of this gave me a hollow section inside the latex leading to the back of the neck where I attached the tubing to pump the blood. I then cut little holes into the latex so the latex bladder would bleed from several places. This was glued to the girl's neck, and then the foam latex cut-throat appliance was glued on top of that, positioning the cut in the appliance slightly above the hole in the bladder. In the scene, only the weapon was different: a pair of hedge-clipping shears.

For the fire scene when Cropsy is burned, I hired Reid Rondell from Stunts Unlimited, and his father Ron. They did a full-body fire suit stunt. (I met Reid on KNIGHTRIDERS, the film I did for George Romero before THE BURNING, where Reid and a slew of other stuntmen were hired to do all the cycle stunts.) *Reid is a professional stuntman. Stunts like the 'fire-gag' should only be done by professional stuntmen!* In one scene, however, later on in the shooting schedule, we needed to show the hand of Cropsy trying to open the door from inside the cabin, fully on fire. This was done by setting up a doorway outside in the woods someplace where I, wearing two pairs of long underwear, Cropsy's shirt and a thick, flesh-colored glove—all soaked in sodium silicate and coated with rubber cement—was set *ablaze. I don't recommend this technique. I nearly steam-cooked my arm! When Reid did his whole body, he was wearing a fire-proof suit, a ceramic face mask, and breathing from several small air tanks concealed in the suit.*

For the burned-arm-and-hand effect in the hospital scene, we used Alan Brower, the musical director. I attached blood tubing down along his arm to his hand, ending in the fist area around the knuckles. Then, using a combination of latex and cotton, mortician's wax, various pink and white colors, black for making the edge of wounds look like they were seared and rice krispies for globular effects, working from that book *Nursing The Burn Patient*, I was able to produce a good example of what a burned hand looks like.

The Cropsy Maniac vs. The Big Axe: I had to make a dummy head of the Cropsy Maniac for his death by axe in the final scene. I made the same sort of underskull that I'd used for the girl who was hit by the axe in FRIDAY THE 13TH.

Using the negative molds of the Cropsy make-up, I pressed ¼" of clay into the whole mold, front and back. I took the front negative mold and built a ½" clay wall surrounding the area where I decided the axe would hit him, from above the right eye to below the lower lip. I then poured plaster into this area about ¼" thick. When it dried, I removed the clay wall, and I had this oval of plaster, covering the axe-hit area on top of the pressed clay inside the negative mold. I built up a large clay ball on this plaster area and coated the exposed plaster edge with vaseline.

I tied the back mold into place, and filled this entire negative head mold with plaster. When this dried, I had a plaster positive core that the foam latex Cropsy mask would fit over. This core also had a trap door that I could lift out, created by coating vaseline on the exposed edge of that plaster oval. I removed this oval and behind it

was a chamber created by the clay ball. I dug out the clay ball, cleaned-up the chamber, and before replacing the trap door section, I scored it (cut grooves into it) to weaken it. When the axe hit it, it would collapse inside the chamber, releasing the blood through the foam mask from the blood-filled condoms stored in the chamber.

I glued the lid back into the head and filled it from above with blood. I put the foam mask over this underhead and painted it, and attached it to the dummy. (I hit it with the axe because I knew exactly where the pocket was.) The hollow part of the neck was at the base so that it would fit onto the poles sticking out of "Boris II." (The head was also held down with the motorcycle elastic bands and hooks.) The dummy was fastened upright against a beam in the mineshaft where the maniac meets his end.

© 1980 RICHARD WERNIG

For the throat-cutting-with-shears effect, I first cast the actress' neck and made a FRIDAY THE 13TH-type throat-cutting appliance with the slit already in it. I then took a pair of shears, welded them open, ground the edges down—rounding them off to make them totally harmless—and attached "ye olde blood tubing" to the underside (the side away from the camera), placing the shears in the actual wound of the girl. On "action" the shears were pulled through the wound, the initial blood causing the wound to fill up with it and drip. After the slice was made, the blood bladder was filled with blood and made to pour out blood after the first few seconds.

The hooker-stabbed-in-the-chest effect was accomplished by standing the actress up in the workshop, her arms outstretched and resting on stands, lubricating her slightly and covering her from the neck to just below the belly button with plaster of paris reinforced with plaster bandages. *Had I known about micro-crystalline wax at that point, it would have been alot easier for us—and for her. We would have simply made an alginate mold reinforced with plaster bandages, filled that with wax, sculpted and corrected it (making it perfect), then made an ultracal mold from the wax, sloshed some foam around in that mold, baked it, given it a plaster backing, and we would have had it. But we didn't...*

> **Micro-crystalline wax is a brownish wax that melts and solidifies quickly. If you let it dry longer it can get pretty hard. Using turpentine, you can smooth out areas, add texture, and resculpt places before making negative molds from it (Sculpture House).**

We made the plaster mold, being sure there were no bubbles, because the inside surface of this mold had to become the finished surface of the foam appliance. The inside of the mold was sealed with shellac, and foam was poured into it to give us an even ¼" thickness all around (thicker in the breasts because they filled up more). When the foam was done, we left it in the mold and poured plaster in the back of it, imbedding a coat hanger so that we could fasten that to a sort of wooden cross for the stabbing effect on a grip stand. A hole was then drilled into the plaster to make a passageway for the scissors to go in. (This chest piece was only used for an insert shot of the long-bladed scissors going into the hooker's chest. Later, we cut to a pair of cutoff scissors with blood tubing attached to them held against the actress' real chest, with blood flowing from the scissors, making it look like the shears were actually in her.) The chest piece was attached to a stand, with the same costume the hooker wore, and the real actress stood alongside

it with her real hand on the killer's hand as he pressed the scissors into the false chest. As the shears went in, she stretched out her fingers to look like her hand was reacting to the pain of being stabbed. (See color section)

The massacre on the raft: here, the counselors are killed on a raft as follows. We see the hedge shears rising in the air and coming down. The shears open up a huge gash from the collarbone of the first victim (who's just sitting there) down to mid-pectoral. Next we see the shears entering the back of the girl wearing the football jersey and she falls into the water. Then the shears go down again, barely missing somebody's hand, and come up, snipping the fingers of someone else, blood splattering on the victim's face. The next victim falls backwards against sleeping bags on the deck; the shears come down and plunge into his throat. The next victim is sliced across the forehead.

For the first victim, slashed across the collarbone, we simply sat him down on a wooden box, with a nice, clean T-shirt (pre-cut along his collarbone). We removed the T-shirt, and on the spot where we knew the slice would be, we placed the old tape and condom trick. I stuck a ruler inside a condom, made a long slice in it, and sealed the slice with nylon packing tape—a thin strip, ¼" wide, extending 1" beyond the cut on both sides. We filled the prophylactic with blood, tied a knot in the end, and taped the ends down—one over the actor's shoulder, behind him on his back and the other across his chest. We attached very fine black fish line to the top edge of the tape, placed the T-shirt back on and closed the cut in the shirt using very small pieces of weak tape (just strong enough to hold the T-shirt closed). The fish line came out of the T-shirt and was in my hand. On "action" we had the actor scream, and I yanked the fish line and opened the prophylactic and the T-shirt, releasing the blood and exposing what appeared to be a huge gash in his collarbone and chest area. In the film, we see the swish of the shears and then cut to the actor with the gash appearing on him.

Since no special death had been planned or discussed for the second victim, we simply put her costume on "Boris II" and shot a close-up of the shears going in the back. We then instantly cut to the girl falling into the lake, making it look as if she had just been stabbed and was thrown into the lake.

For the guy who gets his fingers chopped off, I built a small box which his hand would fit into horizontally, and filled the bottom half of the box with some alginate. He placed his hand in the box and we poured the rest of the batch of alginate on top, all around the hand. He kept

pushing downward so that the alginate would not lift his hand up out of the box. The alginate dried in two or three minutes, and then the top of the box was filled with plaster for support. (He carefully moved his fingers and flexed his wrist until he could pull his hand from the alginate with a "popping" sound.)

© 1980 RICHARD WERNIG

The alginate mold was filled with plaster. When it dried, we removed the plaster hand from the alginate, and I snipped off the fingers at the points where the shears would cut the fingers off. Since I knew we would only see the back of the hand, I dug trenches in the palm of the hand and placed blood tubing leading to the fingers which had been severed (the middle three fingers, leaving the little finger and the thumb intact). I built this before I learned I could buy little plastic Y and T valves on Canal Street in New York so I

had to build a valve-like device that I could pump blood into and it would, in turn, pump blood into the three tubes leading to the severed fingers. This was used for the after-effect when the fingers were severed and bleeding. For the actual snipping of the fingers, we did another cast of the actor's hand in the alginate and filled it with

silicone—Dow-Corning Silicone 3112 with #4 catalyst.

> **Dow-Corning Silicone—Check your directory to find out if there is a supplier of Dow-Corning products near you. The silicone I use is 3110 or 3112 (the 3110 is more rigid) plus a number 4 catalyst or an "S" catalyst (which is slower setting).**

When it was dry we made it up to match the actor's real hand. The actor held the hand in the shears, and on "action" I snipped the fingers and he screamed. We cut away to something else and when we came back he was holding the plaster hand with the blood passages in the fingers.

For the shears in the neck—an actor gets the long blade of the shears plunged into his neck—I built an elaborate apparatus identical to the one built for FRIDAY THE 13TH. *With one exception: here we were stabbing from the outside in, not from the inside out.* The appliance was made the same way: plaster on the back of a foam latex appliance, fastened to a plank of wood. A large

hole was cut above the neck area for the actor's head and shoulders, allowing us to fasten the false chest just under his jaw. A hole was pre-cut in the plaster backing, making a passageway around his head since the plywood was in an upright position, making it look like the deck of the boat we'd seen the actor lying down on. *The camera was at a corrected angle to make it look as if the actor was lying down.* We rolled the camera, placed some blood in the actor's mouth, and on "action" I, wearing the costume of the maniac, drove the shears into the hole; the actor reacted, spitting out the blood. We cut away, and when we came back we did a shot of the real shears, with half of the blades removed, pressing against his skin. We then cut to the real actor lying down on the deck of the boat so we could in-

clude his arms flailing, and then cut back to the appartus shot for the shears being pulled back out. *These were not collapsible shears, but actual shears pressing against the skin of the foam apparatus, plunging in, and then pulling back out again.*

For the last victim—**the actress who is slashed across the forehead**—I glued one end of a piece of worm-shaped foam latex (1/8'' diameter) to her forehead and imbedded the whole thing in mortician's wax, with fish line attached to the other end. (Blood tubing was first glued to her forehead). On ''action'' I ripped out this latex ''worm'' from the mortician's wax, exposing a deep gash, and blood was pumped into the wound area.

For the effect of the shears being driven through the throat of Larry Joshua, I designed a special pair of shears and had a local machine shop manufacture them. *They are similar to the arrow-in-the-head gag, where the arrow seems to be going through the guy's head because the middle section of the arrow is replaced by a loop that fits over the actor's head.* We cut out the middle section of the shears and fastened steel loops in them to fit over the shoulders of the actor. (The tips of the shears protruded from the back of the sweatshirt he was wearing. He held the front of the shears against his throat). In the film, we see the shears rising up through the frame and coming out the actor's back. (On ''action'' we pulled the sweatshirt tight in the front so the tips of the shears popped through and then pumped blood into the area.) For the close-up of the actor holding the shears against his throat, another pair of shears was made with the blades cut off and rounded; blood tubing was fastened to the underside of both handles, leading up to the underside area where the shears met his throat. A special hole was drilled in the tips where the shears touched his throat so that the blood that was pumped beneath the shears would also hopefully go through the hole and appear over the top of the shears, making it look as if he was bleeding on top of, as well as beneath, the shears.

For the effect of this victim being lifted off his feet by the shears in his throat, two grips lifted him like bearers with long 2x4's under his armpits (as if he was on parallel bars) and walked with him as the maniac, standing within the wooden bars, walked with him. *The camera was on their feet, so it looked as if he was being carried by the maniac and then pinned to a tree.* Pulling the shears out was accomplished by simply putting a real pair of shears along the side of the actor's neck, away from the camera, and pulling them away while I sprayed blood into the air, making it look as if the blades were actually being pulled out of the actor's neck. **(See color section)**

THE PROWLER

The first illusion—"the pitchforked lovers"—involves two lovers necking in a gazebo on a lake. We first establish the weapons the Prowler uses: a pitchfork planted into the ground and a bayonet which cuts an electrical light cord, putting the two victims in darkness. The lovers continue to embrace as a pitchfork rises in the air and then plummets down into the back of the boy. We then cut to the girl screaming, and we see the Prowler's foot push the pitchfork further into the back of the boy. The Prowler pushes the pitchfork even further down, and we see it come out the back of the girl; the pitchfork has gone through the boy, into the girl, and out her back, the tips of the pitchfork protruding out the back of the girl between the boy's fingers as he hugs her tightly. We used a close-up of a real pitchfork actually stabbing a foam-rubber dummy which was originally one of the bodies from the movie COMA. We put the tuxedo jacket the boy was wearing on this foam rubber dummy, and the close-up was of the pitchfork stabbing it. It was shown being jammed in more and more into the dummy. After one of the cutaways—either the girl screaming, or the guy's face reacting to the pitchfork—we substituted a cut-off pitchfork that was specially prepared with blood tubing going to all the blades through special grooves, made by a machine shop nearby. One large tube ran along the handle, emptying into a chamber that had four or five tubes running out of it. (The chamber first filled with blood, then pumped blood through each of the four or five other tubes leading to the blades of the pitchfork). The pitchfork was held against the back of the actor this time, so his hands could reach back as if he was reaching for the pitchfork showing that this was not a dummy with a pitchfork in it, but a real person. (Blood was squirting out of the blades themselves, but it looked like the blood was squirting from his back.)

For the illusion in which we see the back of the pitchfork blades coming out the girl's back, I took a glad bag and taped it flat against the back of the dummy. Doing so made the blood fill up the bag (¼" thick at its thickest point). I took the blades of the cut-off pitchfork and welded them to a little piece of metal about 2" wide by 1 ft. long and 1/8" thick. Then I put the boy's costume on, the shirt and tuxedo jacket, so that my hands became the boyfriend's hands for the shot. I put the points of the pitchfork against the chest of the dummy (who was now wearing the girl's dress) and, using my chest, I pushed the back of the bar, sending the pitchfork blades through the dummy and out its back. *I did this several times so that the blades would pass through the styrofoam body easily, creating holes on the back. Over the holes I taped the glad bag blood-pack. The costume was then placed over the blood-pack and the dummy, the blades already positioned half-way through the body.* On "action" I hugged the dummy; my chest pushed the bar, pushing the blades through the foam body and the blood-pack and in-between my fingers. The back of the dress saturated with blood as the blades pierced through and stuck out about 2".

The bayonet through the head. A young, well-built "stud" sort of guy visits his girl's room when she's in the shower and she asks him to join her. He goes out to the bedroom, starts to take off his clothes, sits down on the bed, and our Prowler grabs him from behind and sticks the full length of a bayonet into the top of his head, sending the point out the bottom of his chin. The camera pulls back, and we see the victim's eyes roll back and the bayonet stuck in the top of his head—the point sticking out of his chin—all in the same shot.

THE PROCEDURE I'M ABOUT TO DESCRIBE IS PRIMITIVE COMPARED TO THE THINGS I DISCOVERED WHILE WORKING ON CREEPSHOW. IN FACT, THE CREEPSHOW SECTION SHOULD BE SUB-TITLED "ADVANCED TECHNIQUES" BECAUSE THERE'S A WORLD OF DIFFERENCE BETWEEN THE PRIMITIVE WAY I'M ACHIEVING THESE EFFECTS HERE AND THE WORK I DID IN CREEPSHOW. PART OF

THIS IS DUE TO HAVING SO LITTLE TIME, HAVING TO DO ALL OF THESE FILMS—THE PROWLER, THE BURNING, ETC.—IN FOUR TO SIX WEEKS AT THE MOST. WITH CREEPSHOW I HAD A LOT MORE TIME TO EXPERIMENT AND PERFECT THESE TECHNIQUES, ALLOWING ME TO USE MORE ADVANCED, MORE TIME-CONSUMING METHODS.

AFTER CREEPSHOW, AND DURING THE HONG KONG FILM SCARED TO DEATH, I WAS ABLE TO DO THE EFFECTS MUCH QUICKER, HAVING DONE ALL OF THE EXPERIMENTATION ON CREEPSHOW.

For the bayonet going through the top of this guy's head, I first constructed a false head using foam latex for the outer skin and a thin plaster (again) understructure. After making a thin foam mask of this character's head by the pressed clay, 3-mold (negative front and back, positive core) technique, I put the mask back into the negative molds and sloshed around a thin plaster coating to the inside of the mask. I then removed the negative molds and had a head with foam latex skin and plaster underskull. I removed the foam mask and cut a hole into the plaster top where the bayonet would go and another hole in the lower jaw area where the point of the bayonet would pierce through. I then filled the head with blood-filled condoms and put the mask back on. When I stabbed through the top of the head and out the chin, the blood oozed through the foam. *On one take, the bayonet came through the chin with this condom hanging off it!* So, we see the real guy sitting on the bed, and the maniac comes from behind him and covers his mouth. Then we cut to a shot behind the dummy head attached to "Boris II," who's wearing the same costume. Dressed as the killer, with the fatigue jacket and gloves, I grab the false head and simply plunge the bayonet into the top of it. We cut to the front, my gloved hand over the face of the false head, as the real actor's hand reaches up into the frame and grabs at my hand; the impression being that it was actually *his* head. When the camera pulled back, we used the real actor with special white sclera lenses in his eyeballs to make it look like his head rolled back, and a cut-away bayonet—about 5" long—which a stand-in held on top of the actor's head. For the chin effect, I made a mold of the tip of the bayonet, reproduced it in foam, and fastened that to a piece of fabric that was glued underneath his chin. So, the cut-away bayonet was held on the top of the actor's head, and the rubber point was sticking out of his chin. Blood tubing emptied out against the rubber tip of the false bayonet point, adding the finishing touches to the effect.(See color section)

The killer then heads toward the bathroom, pitchfork in hand. We see the girl's point-of-view as the killer lunges at her with the pitchfork. We placed a large piece of wood on the chest of the cameraman, and with me wearing the steel helmet and facemask, fatigue jacket and gloves of the killer, I stabbed the pitchfork at the camera, hitting the piece of wood—the victim's point-of-view. For the front shots of the pitchfork going into the girl's stomach, I had two more pitchforks with the blades cut off at various lengths. The first one had only two or three inches of the tips cut off and it was prepared with blood tubing to force blood to the tips of the blades. *When placed against the girl's stomach, it would look like the blood was coming out of her.* We cut back to the killer forcing the pitchfork in a little more, and when we come back again to the front shot of the girl, we used the second pitchfork, which had five or six more inches of the blades cut off, making it look like the blades had gone in even further. The same blood tubing arrangement was used, again making it look like blood was coming out of her. *It was really coming from the tips of the blades.*

And now another amazingly different cut-throat effect. A young girl is swimming around in a pool. As she gets out, the killer springs out of the water, grabbing her from behind. He brings the bayonet up and starts to cut her throat; we see the knife go deep and blood flow out. We cut to an underwater shot of her sinking into the water, illuminated by the pool lights, and we see air bubbles and blood coming out of the cut.

For the initial shot of her throat being cut, we used two bayonets: one the full-sized, dull bayonet we see placed against her throat, and (for the close-up) a bayonet with a groove cut out of it to conform around her neck, making the blade look like it was deep in her neck. *Blood tubing was also attached to the underside of this bayonet so that as the killer moved it around, the blood was pumped out, creating a familiar illusion.* We then put a throat appliance on her with the latex bladder technique from THE BURNING. As she sank into the water, I pumped blood out of the cut in the foam latex appliance, which sent a cloud of blood and air bubbles out of her neck. *Later on, she's discovered in a coffin; she has the same throat appliance on, with dried blood and dirt, etc. to add to the effect.*

The double-barrelled surprise." At the end of the film, the killer (unmasked, revealing Farley Granger) struggles with our young heroine for a double-barrelled sawed-off shotgun. *He's trying to kill her, she's trying to kill him, and the killer's the weaker of the two because there's also a pitchfork jammed in his back.* For this I made a mold of the pitchfork, including about a foot of the handle, poured expanding urethane into the mold, and made an entire series of styrofoam pitchforks. I then glued one to a plate which was

PHOTO COURTESY TOM SAVINI

permanently fastened to a duplicate of the killer's costume. We see the girl head toward him, and with a downward movement she plunges the pitchfork in his back. We cut to a stand-in wearing the special jacket with the pitchfork sticking out of it, his body pressing against the back of the jacket holds the bar in place which held the lightweight pitchfork (Painted to look like the original). He's understandably weak; there's a pitchfork sticking out of his back—*what a man*—and he's overpowered by the girl in the struggle. She places the shotgun just under his chin, pulls the trigger, and we see his head explode into a million pieces. *This was actually the*

same sort of false head and plaster underskull mechanism filled with prophylactics we'd used before. I made a dummy with it and fired both barrels of a 12 ga. shotgun at the false head with magnum pellets. Seconds later, it was raining blood, false ears, glass eyes and so forth, marking the end of the effects in THE PROWLER.

CREEPSHOW

CREEPSHOW is a living comic book —five little horror movies within one two-hour movie. It involved a variety of different make-up special effects, but let's begin with one of the most difficult things I've ever had to create—*something I'd never done before*—an articulated creature involving fiberglas under-skull, foam latex face,

and mechanisms I'd never worked with before.

"Fluffy," as he's come to be nicknamed (every creature we created for CREEPSHOW was given a nickname) is *"The Crate"* creature. *I called Rob Bottin after seeing his TANYA'S ISLAND*

creature and THE HOWLING, and he was a super help to me. I spent an hour on the phone with him one day discussing mechanisms and fiberglas; "Fluffy" is the combined result of the things he told me and the things we discovered while putting him together.

The first thing I did to create Fluffy was to sketch what I thought he should look like from the brief description in the script:

"...an alien, furry thing with a body like a whippet...arms ending in huge claws, and a great head which seems mostly luminous eyes and great gnashing teeth..."

I then had a local artist, Phil Wilson, draw up sketches which I submitted to George Romero, the producer Richard Rubinstein, the art director, and Stephen King. They selected my version shown here, and I immediately proceeded from there.

I had three months of pre-production; I had

no idea how long it would take to create Fluffy because I had never done anything like this before, but I knew I wanted to start working on him right away. First, I did a life mask of the actor who would play Fluffy. I wanted Fluffy to have great, creepy eyes, so the actor was sent to New York to be fitted for sclera lenses. The lenses were done by Theo Obrig, from a color rendering I prepared of cat eyes.

After this, the sculpture of Fluffy was created on a life cast of the actor. *Just the front part of the face and ears was sculpted, because I knew he'd be covered with hair on the back.* Fluffy was sculpted using *Roma plastolina* from Sculpture House in New York (a combination of #2 and #4 consistencies).

> **Roma Plastolina is a high-quality plastiline clay available from Sculpture House in New York, or sometimes from a local art store (depending on where you live). It comes in grades 1 through 4—1 is soft, 2 is sort of medium soft, 3 is more firm, and 4 is very firm.**

The sculpted mask area around his eyes had to be thin because we'd be using the actor's own eyes; the mask had to blend into his real eye area. The only movements he would control would be eye movements and the opening and closing of the jaw. *Fluffy's jaw was much bigger and lower than the actor's. The opening and closing movement of the actor's own mouth would move Fluffy's jaw up and down by use of a chin cup glued to the fiberglas jaw inside. (See color section)*

After the sculpture was finished, a large negative mold was made (using ultracal 30) of Fluffy's entire head and neck. The mold was separated from the sculpture, the clay was removed, and then about 1/8'' of clay was extruded through a *clay extruder*

> **Clay Extruder—(Available from Baldwin Pottery, New York) Clay is loaded into a chamber and forced through interchangeable templates by pushing down on a handle. It saves time making perfect forms for clay walls, veins, thin clay skins, etc.**

and pressed into the negative mold of the sculpture (Except in those places I knew would become *undercut areas.*)

An undercut in a mold is an area that creates an overhang. If you pour plaster in a mold into an undercut area, it will be extremely difficult—if not impossible—to separate the molds.

Clay had to be pressed in thinner around the eyes, leaving a 1/8" space between the eyes and where the clay sculpture ended. *You have to think of the clay pressed into the mold as what eventually becomes the finished mask. The foam mask is what results from pouring foam latex between two molds where the clay once was—the positive and the negative.* All the exposed plaster surfaces inside the negative were greased, and the positive was poured. When that dried, the molds were separated and the clay was removed. We now had a positive and negative mold which would form a foam latex mask once the foam was poured in between them.

Then we poured face after face of Fluffy; we kept making them until we had over a dozen. I knew we'd need some extras. (One for the puppet head, and one for the underwater scene).

When we had a sufficient amount of foam latex Fluffy masks, I took the positive mold and made a rubber negative mold of it in *adrub* and plaster bandages.

> **Adrub—Adrub kwikset rubber is a red rubber mold-making material formed by mixing equal parts of an A and B kit (Adhesive Products).**

After this dried (overnight), fiberglas was formed into it, giving me the underskull that the foam mask of Fluffy would fit onto. *It was also on this underskull that all the mechanisms were built, the eyebrows, the upper and lower lips, etc. The teeth were also formed onto this underskull.* The eye holes were cut out, and we placed this fiberglas underskull over the positive plaster bust of the actor to see if it fit him well, since he would have to wear this while playing Fluffy.

A helmet was formed in fiberglas over the positive plaster bust and then placed on the real actor so we could see how much of the eye holes to cut out, what areas to sand down, and where we needed foam padding to make sure it didn't hurt him to wear it. *The fiberglas eyeholes had to be cut out so that they wouldn't interfere with the mask touching the actor's skin. A realistic blend was needed between the mask and the actor's own eye area.*

The helmet, the fiberglas underskull and the foam mask of Fluffy were all placed on the actor. *First the helmet, then the fiberglas underskull with the eyeholes cut out, and then the foam mask.* The foam mask and underskull were placed on top of the helmet and positioned so that there was room below the chin for the mechanism that would open the jaw and also so we could place the eyes correctly against the actor's eye area. Once that was done, all was held in place while the fiberglas underskull was hot-glued to the helmet. *Hot-glue, by the way, is one of the greatest inventions since the toothbrush.*

Fluffy's teeth are actually copies of a male gorilla's fangs. We made rubber molds of the fangs from a male gorilla skull obtained through Carolina Biological Supplies in North Carolina. Using white dental acrylic and liquid hardener, we poured a little bit of powder in the molds, and then liquid, a little more powder and a little more liquid. We let those dry about ten minutes and pulled out whole fangs. We made entire vats of

fangs because we had absolutely no idea of how many we were going to use in the finished Fluffy face, or how many we'd need for extra heads, and so on.

I sculpted in clay the front section of his upper teeth, making different lengths of fangs, coated the clay with a plastic sealer called plastic cap material

> **Brushing plastic cap material over clay gives the clay a thin plastic protective coating. This makes the clay easier to remove from molds. It also produces an effect similar to placing a plastic food wrap onto the clay; your modeling tool doesn't cut harsh grooves into the clay. Instead, it creates a nice rounded-edge line similar to forehead wrinkles, and is an aid in sculpting such wrinkles. Texture can be pressed right into the plastic coat without messing up your texture sponge, or stamps. (Plastic cap material is available from The Research Council of Make-up Artists.)**

(which you can get from the Research Council of Make-up Artists) and then made a silicone mold of the sculpture. The front fangs

were made the same way I made the others, in the rubber mold of the gorilla skull fangs. All of these teeth were hot-glued into the fiberglas underface after the right amount of fiberglas was cut away to make room for them and so they would overlap and fit between each other when the jaw was closed.

Holes were drilled into the fiberglas, around the teeth, so that when the pink acrylic (for the gums) was laid on it would stick a little better around the teeth. *If I were to do it again, I would not place so much pink acrylic (gums) into the fiberglas because it did add extra weight to the head.* Later, the teeth and gums were coated with five-minute epoxy to give them a permanent shine. Behind the two front major fangs, I glued in some plastic tubing, through which we pumped glycerine, making Fluffy drool when we wanted him to. *We pumped glycerine behind the teeth and let it drip off them.* After the teeth had been added, the foam mask was placed on and taken off to make sure that when the jaw was closed we would not see any teeth; not until Fluffy either opened his mouth or snarled.

There was some difficulty in making the mouth move realistically; every time we pulled a cable, only a small area of the mouth would move in a very pointed way. *It looked exactly as*

Chin Cup

if a cable were pulling on foam rubber. So, I discovered (in one of my all-night sessions with Fluffy) that if I poured some white dental acrylic into the rubber mold used for making the fiberglas underface—say in the upper lip area or the eyebrow area—when it dried it would give me a whole section that would fit neatly behind the foam mask face in those particular areas. Through experimenting, and carving and sanding down those little pieces of dental acrylic and hinging them in the right places, I found that I could pull on a whole section at one time, using the same, single cable, making for a much more realistic movement in the foam face.

The lower lip was pulled down on a track that went from the middle of his lower lip down under the chin and into the neck crevice. This track was lubricated with graphite and the dental acrylic attached behind the lower lip rode along in the track, making the whole lower lip section move down, exposing the lower teeth. The upper lip was divided in half so we could make the left or right side snarl if we wanted to, or pull both cables and make the whole upper lip move upward. *If I were to do this again, I would not sculpt the wrinkles in Fluffy's upper lip **vertically**, but **horizontally**, so that the wrinkles formed from raising his upper lip would have bunched up in a more realistic manner.*

The eyebrows were no problem, once a whole dental acrylic piece was glued in behind each brow. (They moved up and down realistically). We also glued condoms in the hollows of his cheeks, just below his cheekbone, and with a T-valve, we were able to fill both prophylactics with one large rectal syringe, making it look like the cheeks were puffing out and he was breathing. *Those condoms are still functioning in there, and it's been over two years.* I also inserted, though these were hardly ever used, a pair

of Walkman earphones into the ear area of the mask so the actor (who was in a tight, hot costume with sclera lenses in his eyes and breathing air that we pumped into the head area) would not have to listen to orders from twenty thousand people on the set, but from George or me. *I thought if George or I could talk to him directly, and he could only hear our voices, it would be easier.* This proved to be unnecessary because he was able to listen to George directly—although there were times when more than one person was giving him directions—the air pumping into the suit and to his face made him quite comfortable. (At times, after he got used to the sclera lenses, he was in the suit for an hour at a time.)

If I had it to do over again, I would have made his ears wiggle. Once we started moving the cables, with the jaw moving and the eyes moving back and forth, Fluffy did come to life. The more movement we had in the face, the more alive he seemed to be.

Fluffy's tongue was made by just sculpting it so that it would fit over the actor's face. Otherwise, when Fluffy opened his mouth, we'd see

the actor's chin and lower lip area. I sculpted it to swoop down just behind the lower teeth, painted it, and coated it with five-minute epoxy to give it a permanent shine.

Later, various wounds and scabs were added to Fluffy's hair and ear and nose area to make him look like he was sick. *After all, he was supposed to have been in this crate many, many years.* I then added hair to the nose, and "boogers" (which I later removed, now that Fluffy does sit on my dresser at home).

After all of the mechanisms and teeth were added to the fiberglas underface, Fluffy's foam face was then hot-glued, strategically, to the mechanized fiberglas, and foam padding was added where the foam mask ended to help cover the back. Velcro was added to open and close the back easily, and hair was laid (glued) on all the way up to about five to ten inches from the mouth and eyes. The remaining hair was then punched in, one hair at a time, beginning with the same color that was laid on the body. The hair closest to the face was lighter than the hair

Syringes and cable for movement.
Tube for saliva.
Squeeze ball for breathing.
Jack for headphones.

108

leading up to it, and the very edge of the hairline was *punched in* with a combination of grey and white.

NOTE: BEFORE ALL THIS HAIR AND STUFF, FLUFFY'S FACE WAS PAINTED WITH ACRYLIC PAINT MIXED WITH LATEX. IF I WERE TO DO THIS AGAIN, I WOULD TAKE RUBBER CEMENT—A TINY BIT—AND MIX IN A LITTLE ACRYLIC COLORING. WHEN THAT WAS MIXED, I WOULD ADD A BIT OF RUBBER CEMENT THINNER (AT A RATIO OF ABOUT FIVE PARTS THINNER TO ONE PART RUBBER CEMENT) AND A FEW DROPS OF ACRYLIC COLORING, AND THEN AIRBRUSH THE WHOLE MASK. (THE ACRYLIC PAINT MIXED WITH LATEX TENDED TO MAKE THE FOAM FLUFFY MASK A LITTLE RIGID, NOT STRETCHING AS MUCH AS IT WOULD HAVE IF I'D SPRAYED ON RUBBER CEMENT PAINT. RUBBER CEMENT PAINT TAKES A LITTLE "BITE"—IT IMBEDS ITSELF INTO THE FOAM—BUT ROUGH TREATMENT WILL MAKE IT CRACK AND PEEL.)

For Fluffy's body, my intention was to sculpt the chest, kneecaps and elbow areas, duplicate them in foam latex, and fasten them to a foam rubber suit built by Christine Oagley, the assistant wardrobe designer, and then cover everything around these areas with hair. As it was, only a chest was made. Rick Catizone (a local artist-animator-model builder) sculpted the basic chest and hands, which I later enhanced by sculpting some more areas and adding texture.

PHOTOS: TOM SAVINI

PHOTO COURTESY RICK CATIZONE

The foam chest was glued to the urethane rubber suit and hair was glued on close to the edge of the chest. The hands were slipped on separately and blended into the arm hair which was combed over them.

Fluffy was actually a glorified "Muppet." Alot of his functions were controlled by other people. Sometimes it would take maybe six or seven people to operate him. One person operated the eyebrows, one the lower lip, one the upper lip, one the drooling saliva, one the breathing, and there were times when somebody was even operating the feet. The actor moved the eyes, opened the mouth and moved the arms and hands.

Sometimes Fluffy was just a puppet. For the attack scenes where his teeth actually come in contact with someone, or when he had to look *super mean*, I made another fiberglas underskull and attached a cast of the real Fluffy teeth, but made of foam rubber (they had to be rubber because they would bite people). I glued on one of the extra Fluffy faces, and attached this to a foam rubber upper body which included the shoulders and the back. Glass eyes were painted and inserted into the eye sockets, and the hair was laid and *punched* in: My hand slipped into a glove fastened to the roof of the mouth and lower jaw. The end result was a hand puppet. It was used for quick movements and exposed teeth attacks. (Its expression was a permanent snarl, the meanest expression Fluffy had.)

A trick floor was built by Ed Fountain, making Fluffy appear to be walking on his own. You see, Fluffy's feet were attached at the hips of the actor who wore him, because Fluffy had to be short to live in a crate. (Had we hired a dwarf to play Fluffy, his arms would not have been long enough.) I cast Marty Schiff's hands on the bottom of Fluffy's legs and sculpted Fluffy's feet over the hand-molds. When Fluffy's suit was on the actor, someone else—Debbie Pinthus, sitting in a pit—played the feet of Fluffy. *She put her hands into Fluffy's feet and made them walk, and the toes wiggle, as if they were Fluffy's own.*

So, the actor was in a pit below the trick floor level, and only his upper body (actually Fluffy's *whole body*) stuck out of it. The floor in front of Fluffy was kind of a magic box. Canvas was stretched over a long plank of wood that slipped right in a slot. The wood could be pulled back between the canvas sandwich, making the slot open up in front of Fluffy. The canvas floor itself did not appear to move forward because only the wood *between* the canvas would move forward and away, making the floor sort of collapse, or disappear, as Fluffy moved forward. Debbie Pinthus (Fluffy's feet) would walk on top of the canvas, giving the impression that the whole Fluffy body was walking on top of a normal floor.

When Fluffy ate the janitor, he pulled him up inside one of many trick crates that were specially made for different effects scenes. For this particular one, there was a hole on top of a lab table and the actor stood inside. There was also a hole in the side of the crate (it was turned on its side, which then became the bottom). The janitor, who was a stand-in, was actually pulled into the crate and then down into the lab table while blood tubing was squirted on top of him, making it run down his arms and chest and so forth.

For the Fluffy bite on the back of the student's head, I cast the actor's *(Robert Harper)* head, sculpted the already-chewed-out area, made a foam latex piece from it, and glued that to the actor. I also made a small piece of torn-out flesh that was placed over the finished wound. That, in turn, was attached to the inside of the (Fluffy) puppet's mouth. The puppet was simply placed over this wounded area after we'd established, and *seen*, Fluffy (the puppet) coming up behind the student and grabbing him on the back of the head with those nice rubber teeth. We cut away to Fritz Weaver; when we come back, we see the Fluffy puppet with the piece of flesh attached to his mouth, wiggling back and forth like it's grabbing and biting and then pulling away, as an assistant pumped blood into the piece already glued to the student's head.

When Fluffy scratches down the student's face, finishing the effect, the scratched face piece was already attached to the student. It was a sculpture of large wounds down through the eyes, across the nose and across the lip, with a glass eye added. (All this was glued to the actor's face.) Fluffy's hand was positioned on the student's head, covering the wound, and he simply moved his hand down over the face and blood was being pumped in simultaneously. (The sound effect added to the illusion.) *(See color section)*

In CREEPSHOW, just about every time there is a blood effect, or somebody is eaten or chewed and we do see actual blood, the scenes were shot in harsh red light to insure that we'd be able to leave the scenes in the film. *It reduced the effect of the blood and was accepted by the rating board without any problems.*

The first attack on the student is to his shoulder. For that I made a cast of his shoulder and simply sculpted the finished wound area as if Fluffy's claw had dug through it. Then I did the old BURNING trick, placing the split condom filled with blood and taped with fish line, over the actor's shoulder. The costume went over that, the shirt was pre-cut, and I donned one of Fluffy's arms and a hand. As the Fluffy hand, I swished by the actor's shoulder. I pulled the fish line, opening the condom at the same time. The illusion is that the hand opened up this nice, fresh shoulder.

PHOTOS COURTESY TOM SAVINI

One of the first illusions that you see in CREEPSHOW is **the spectre who appears at the window** of the little boy who is mistreated so badly by his father for reading a comic book. (You really don't get to see all of the things this creature does in CREEPSHOW.) The boy looks to the window and there's a spectre, the wind blowing through it, the full moon behind, and we briefly see its hand come into the frame. We cut back to the boy and then back again to a close-up of the spectre at the window, and it's a cadaver, a corpse. It smiles, its eyes move around, and it beckons the little boy. Then it laughs and immediately turns into animation.

We used a real skeleton (purchased from Carolina Biological) to save time, because to build a real corpse from scratch would have taken more time—and one of the things that is always haunting you when doing a film is *time.* Time becomes a real problem. Time becomes your enemy sometimes; it keeps you from making an illusion perfect. Lack of time makes you work long hours to create an effect when it is due. Time is money. Time is thousands and thousands of dollars every day on a movie set. If you hold something up, you're costing someone a lot of money. (These are things that are always working on my mind.) Despite time, you want the effects to be perfect. You only have one chance to do this, and when you're finished with it, it's completely done forever—captured, frozen in the movie you've created it for, so you only have the time it takes for you to do it, to create something that lasts for all time. *(Now that's scary!)*

113

PHOTOS: TOM SAVINI

For the spectre we used the best machine possible, the best machine there is, to make a corpse move around realistically: *we used a real skeleton.* We took the real skeleton hand and articulated it so the wrist would bend and all the fingers would close in, and the index finger could beckon, a very slow and realistic movement. This was done with cables and hinges: an assistant replaced the wires which held the bones and fingers together with hinges to strengthen the hand and make the fingers bend a little easier, and stretch out if we wanted to push the cables. We had one mechanism that would bend all the fingers except the index finger, making it stand straight out and point if we wanted it to. Then, through a combination of bending the wrist and the index finger, we could make it *beckon.*

The skull itself was cut and drilled out to adapt and hold the remote control mechanisms that would make the eyeballs move back and forth. The jaw was simple: a spring and a cable. We'd release the cable and the spring would close the jaw. We made a mold of this skull before doing anything else to it, giving us a positive stone mold of a skull on which the finished corpse face was

sculpted (with the help of Rick Catizone). When I had that in clay, I made a mold of it and duplicated it in foam latex, burning it and tearing away at it and adding the hair until it was ugly and rotted enough. Two cables on either side of this real skull, fastened just below the cheekbone and attached to the corners of the foam latex mouth, made the creature smile.

114

The glass eyes in the head were painted to look yellow and then coated with five-minute epoxy for a permanent shine. *Realistically, there would never be eyeballs like this left in a corpse rotted to the degree that this corpse—"Raoul"—was... but this was a living comic book, and he was much nicer looking with nice, bright eyeballs moving around in his head.*

This particular brief scene of Raoul at the window required about eleven people. There was a person blowing smoke in front of the huge moon transparency to make it look like clouds were drifting by. Another operated a wind machine so that the costume of Raoul would blow here and there. Two or three people were pushing the dolly back and forth that Raoul was attached to, operating the huge lever that would make him go up and down (originally he was going to fly into the window frame and then fly back out). One person operated the head movements, left and right. *The head movement was an accidental discovery. At a car dealership here in Pittsburgh,* *I found a carburetor adjusting tool, a long L-shaped instrument. When you turned the bottom, it rotated the top. To the bottom part we attached a large doorknob. The whole head mechanism was fastened to the top so we could turn the knob at the bottom and make the head rotate left and right.* One person operated the smile, and another operated the cable to make the head move up and down. All of us were crouched below the windowsill of the set, watching a television monitor aimed at Raoul so we could watch what all of our efforts were creating. (I worked the arm movement and the wrist and index finger mechanism.)

Another effect in CREEPSHOW was **Nate's corpse** from the first episode, *"Father's Day."* Viveca Lindfors is visiting her father's grave when her father comes to visit her (from beneath the grave, naturally...). For this, Jon Lormer—a great character actor, you've seen him in STAR TREK and many other things on television—was cast as the living Nate. Having never seen him, I was told he was a big guy, so my idea was to cast a head, and hands of this little guy (a very thin guy) because anything we would then build up on this little guy would still be less than the total living human being, Jon Lormer, making the corpse more believable.

So we cast John Amplas, who is a very thin guy, and did all the sculpture of the skull and the rotted flesh on his lifemask. When we had the finished foam mask, I coated it with rice krispies, latex and weeds from outside the studio—and then Jon Lormer came in—and he was almost as thin as a human skeleton himself! *But, every time we see him he's sitting in a chair, and he was padded a bit, so he did look like a big guy; the costume for Nate's corpse was larger, making him look smaller.* The grave itself was dug and

built by Ed Fountain and Cletus Anderson, so when Nate comes up out of the grave, he's actually coming out of a very neatly-built room beneath the ground, with panelled walls, a fan, a fog machine, and a light. He walked up a pair of steps and simply tore through a tar paper roof as he came out to strangle Viveca Lindfors.

Later on, Nate goes into the house and twists Carrie Nye's head off. For this I made a head of Carrie Nye in foam—a solid foam head, foam neck and hollow shoulders—and this was glued onto plaster shoulders so that we could actually twist the head. *Imagine twisting a huge blob of foam—in this case we were twisting a huge blob of foam that looked like Carrie Nye.* My plan was to start twisting the real Carrie Nye's head because I felt the illusion would be stronger if we used as much of the real Carrie Nye as possible to catch any nuances in facial expression—blinking eyes and things like that—and then end up with Carrie Nye with the dress on backwards and an appliance on the *front* of her neck and shoulders that looked like the *back* of her neck and shoulders. *In other words, at the end of the effect we would see the real Carrie Nye's head with the twisted neck appliance, making it look like the head had been twisted around.* What ended up in the film, however, was, beginning-to-end, the twisting of the dummy head.

119

For the scene where **Nate's corpse walks through the swinging kitchen doors with Carrie Nye's head on the plate**, a special plate was made so that Carrie Nye could sit on a chair, draped in black velvet, with her head sticking up through the tray, a neck appliance on the side of her neck, making it look like she was a severed head. We also shot a scene of Nate walking through the swinging doors with the fake head on the dish, with all the cake icing and stuff, but we shot that scene twice because Carrie Nye wanted to have candles burning on *her* head. *It was a good idea.*

Cletus Anderson decorates Nate's cake (Carrie Nye).

120

There is also a scene that didn't make it into the film where **Viveca Lindfors' lover, Yarbro, is shot in the face by a shotgun blast**. (In the un-cut version, we do see his head on the slab at the morgue with his jaw and stuff missing.) We made a cast of Peter Messer, a local actor, then a foam head of him, and simply dug away a side of his face and inserted a plaster casting from a real skull, inserted a piece of a tongue, and drilled holes in the teeth, working from pictures of real shotgun victims showing the entrance wound and the exit wound. I then built two extra heads of Yarbro, filled them with plaster backing, prophylactics and other things, and actually fired away at the jaw with a long-barrelled 12 ga. shotgun.

For the Stephen King *"Jordy Verrill"* episode, I actually did very little. I did make a cast of Stephen King's tongue and made a fake tongue out of silicone, which proved to be too thick and not very realistic-looking, so it was not used in the film. *If I had this to do over again, I'd have made the tongue out of very thin latex which he could just slip over his tongue, and the weed growth on it would have looked a little better. As it was, the silicone tongue was so thick that he couldn't speak too well with it.* I also made some blisters for his lips out of liquid plastic material, dyed green, and the white blisters on the edge of his fingertips at the beginning of the growth.

With the exception of the tongue, all of the prosthetic appliances were constructed by the costume designer, Barbara Anderson, and her crew. Barbara actually built the final Jordy costume—the plant costume—used for the effect of blowing the head apart. *We had a lot of problems with blowing that head apart, mainly because we had to shoot it in the confines of the set within the studio, so I couldn't really shoot a real shotgun blast at a dummy head of Jordy Verrill inside the plant costume. This is what I would do to get the ultimate effect; I'd have had part of that set built in a special place—against a stone wall or a dirt bank somewhere—and actually blow it to smithereens with a shotgun.* What I had to do was act the part of a puppeteer, above the ceiling holding a stick with fish line attached, that hung down into the set to a special piece of Jordy's head that I would pull off, at the same time pressing a button to explode condoms (filled with a green goo) inside the head and a charge inside the shotgun (simply a detonator inside the barrel of the shotgun with flash powder). When I pressed the button, the gun would go off and the squibs inside the head would go off; the mistake I made was in just resting the condoms filled with green goo inside the top area of the head. They hardly blew at all, and seeped down *into* the costume. I should have taped them to something so the tape would compress them and hold them flat, ready to break if you even *looked* at them crooked, thereby allowing the squibs to really blow, splattering green everywhere. (The flash from the barrel of the shotgun itself actually ignited the costume twice in shooting this scene.)

For *"Something To Tide You Over,"* the beach scenes were shot in Island State Park, Seaside Heights, near Toms River in New Jersey. I just sent along two heads—Yarbro, or someone—and the second unit put wigs on them for behind-the-head shots of the actual ocean coming in and knocking the heads around and plunging them underwater. The front shots of the ocean hitting the two actors (Gaylen Ross and Ted Danson) were accomplished by a wave machine built by Ed Fountain, with the actors sitting in pits dug in the sand with plywood around their heads.

When the two of them come back as ghosts, they wore full face, hollow latex appliances—made as follows. First we made casts of Ted Danson and Gaylen Ross, got the positive plaster molds of them, and then, with the clay extruder, pushed out worm-like clay pieces in different thicknesses (1/16", 1/8"). These were fastened to the clay sculptures to make wrinkles, building up the cheekbones and the eyebrow area first. (Actually, while I did Ted Danson, Rick Catizone sculpted Gaylen Ross by using bands of cotton dipped in latex. When I saw that this worked, but without enough detail, I used the clay extruder to push out the worms, creating the same effect but it was already dry, it was clay, and it was easier to sculpt.)

I made a *million* wrinkles all over Ted Danson's face, making his lower lip and eyebrows thicker, and making heavy, overhanging eyes. *I called the county coroner to find out what would actually happen to a human body left in the ocean overnight, and actually not much would happen; if it were in for a week, it would turn black and the skin would start leaving the body, but I wanted to go more for this wrinkled and kind of "mushy" skin effect. (There is some license used here, since the bodies were only in the ocean (supposedly) overnight; but, after all, this is a comic book.)*

The latex pieces were glued around the mouth, the nose, the eyes and the forehead, and around the collarbone, the edges all blended in and, using an airbrush, I pre-painted the pieces with rubber cement paint, first by painting red and yellow and green veins all over them, then covering that with a slight flesh tone, and then covering that with a white. For the hands and feet, I simply took cotton, latex and tissue paper; I first placed a layer of latex on, then the tissue paper, and then bands of stringy cotton to look like tendons, painting them the same way as the latex facial pieces. (The hardest part was building the hands and feet from scratch and gluing the masks on *each day*). The actors were then covered by plastic seaweed made by Barbara Anderson.

For the effect of the ghosts being blasted in the face with bullet-holes, I took the negative molds of the finished sculpture of the make-ups and painted latex just into the areas where the bullets would hit, keeping the edges very thin, painting five or six layers. I cut a bullet-hole shaped hole and a passage leading to it out of plastic. I laid it on and then painted more latex on. When this

123

dried, I attached some blood tubing to it. When I turned it over, the outside of it was a perfect copy of that section of the make-up; I blended this into the finished make-up by simply moving it around to where all the wrinkles aligned, and glued that down. I cut a hole into the latex where I knew there would be a chamber created by the imbedded plastic, and covered that with tissue paper which was glued and blended in. When I made up the masks, I simply painted over the tissue paper and over the false latex bladder.

When it came time for them to be hit by the bullets, you saw Leslie Nielsen fire the gun and either Gaylen Ross or Ted Danson react to being hit, with me pumping the blood so that it went through the tissue paper and appeared as if it was actually coming through layers of flesh to reach the surface and spill out over the face. (We didn't use blood; we used a watery black fluid which gave an eerier effect to the ghosts, since they had been waterlogged.)

The shot that hits Ted Danson's chest was actually the condom squib bullet effect. We also made a cast of the revolver Leslie Nielsen used in shooting them because, when he runs out of bullets, he throws it and smacks Gaylen Ross—his wife's ghost—in the head. *It didn't make it into the final film.* We made a foam rubber gun from the cast for the close-up of the gun actually hitting her in the head.

For *"The Crate"* episode, we've already discussed how Fluffy was made, and the puppet, and the various biting effects on people. We also made a cast of Adrian Barbeau for a scene where her remains float out of the crate in the underwater sequence. It was never used, but it was created as a duplicate of Adrian, with glass eyes, false teeth, and hair. This was made by taking a negative mold of Adrian in alginate and plaster bandages and pouring wax in to make a wax positive of her face, and cutting grooves in the wax as if Fluffy had taken his hand and chopped into it or bit sections out of it. An ultracal negative mold was made of that, foam poured into it, dried, the foam pulled out, then painted accenting cuts and the various wounds.

PHOTOS: TOM SAVIN

There is a scene where **Hal Holbrook fantasizes that he's killing his wife (Adrian),** and for this we had to shoot her between the eyes with a .44 Magnum. The illusion here: we see Hal Holbrook fire the pistol, and then we see the bullet-hole appear right between the eyes of Adrian Barbeau, going out the back of her head and splashing blood against a tree behind her. The effect of the bullet entering her forehead was done by using a technique invented by Dick Smith, where we need to see a bullet-hole in an otherwise clean skin surface.

I've already discussed the very crude method I use to accomplish this effect in DAWN OF THE DEAD, by pulling a sewing button from beneath a blob of mortician's wax. In this case, Dick Smith came up with a way of using a very thin piece of *elvacite* plastic.

> **Elvacite—Dupont Elvacite 2042 (ethyl methacrylate) powder 100 grams is mixed with methyl ethyl ketone 150 grams and di butyl pthalate 50 grams to make a flexible, soft plastic material for scars and appliances.**
> **Note: This information is presented in good faith but no warranty, express or implied, is given and Dick Smith assumes no liability for the use of this material.**

We brushed the solution into a negative or silicone impression of Adrian Barbeau's forehead, brushing in a thicker mixture of elvasite where the bullet-hole would be. When that dried, I put in a passageway for the blood, just about the same way I described the bullet-hole technique for the ghosts in the *"Something To Tide You Over"* episode, except in this case I used the liquid plastic material to make the appliance instead of latex. (I don't want to discuss this technique in detail because it was improved upon by another technique of Dick Smith's: imbedding a passageway for blood leading to the bullet-hole, and another passageway for air, through which 50 lbs. of air pressure was pumped, popping out a little plastic button. So, instead of pulling out a button from this little plastic piece with fishline or monofilament, I used compressed canned air to release air behind the button, which forces the button out and then releases the blood through the same hole.

However, for the Adrian Barbeau bullet-hole effect, I used only the single passageway for the blood. Into the tube connected to the blood passageway, I connected a "Y" valve, connected two hoses to it, one for the air and one for the blood. I pumped the blood into the tubing, past the "Y" connection so there was blood there ready to be pumped through the hole, and when I executed the effect, I pumped the air into the same blood passageway, which not only popped

the button but also sent a small amount of blood spurting out. Then I released the blood from the blood syringe, letting more blood flow out. I also pressed another button on my detonator, exploding two blood-filled condoms on the back of Adrian Barbeau's head which were placed over a padded metal plate bobby-pinned to her hair. Inside the blood-filled condoms were the squibs. So I was pressing the button on the detonator, exploding the blood on the back of her head, squeezing the trigger on a can of dust-off, pushing the air through the blood passageway to pop the button on her forehead, and had an assistant pump the blood through the hole afterward. *NOTE: Since the piece glued to the skin is plastic, if the edges are thin enough you're able to use a Q-tip or brush to take acetone and blend those edges into the skin area.*

The end of this segment—**the scene underwater where Fluffy breaks out of the crate**—we shot in a specially-made tank built by Ed Fountain which had clear glass on all sides. (The same tank was used for the underwater shot of Ted Danson drowning in *"Something To Tide You Over,"* with wires and seaweed floating around his submerged head.) Another Fluffy head was made with the fiberglas underskull beneath the foam latex mask, rubber teeth made from the mold of the "real" Fluffy teeth, but without the tongue. In place of the tongue was a scuba regulator so the actor could breathe inside the crate. Since the shot of Fluffy was only seen from the left side, the regulator was stuck in on the right side; all we needed to see underwater was some semblance of Fluffy's face, and maybe the teeth. We used the regular Fluffy hands under-

126

water—this is one of the last scenes we shot—and only a section of the crate was duplicated in a lightweight balsawood so it would be easy for the actor to break through it; multiple takes were possible by building multiple sections of this particular part of the crate.

For the very last segment in CREEPSHOW, *"They're Creeping Up On You,"* we had to show *lots* and *lots* of cockroaches. We did experiments with vaseline. We built a little tunnel and experimented with putting a light at one end of it; the cockroaches scurried away from the hot lights, so we put the camera at the dark end to film a scene of them coming right out at the audience. We began breeding them to get as many as we needed; we hired two entymologists to bring in thousands and thousands of them. Despite all this work with actual living, breathing, scurrying bugs—there are scenes in CREEPSHOW where you'll see a whole mess of bugs coming off a kitchen counter—a majority of those "bugs" are just dates or figs or raisins, all sorts of things that *weren't* moving on their own. We just put the real thirds—real bugs—over that, and when you see this huge mass of black things coming at you—and there are a *lot* of things moving within that mass—you get the impression that it was an entire mass of bugs, which it wasn't at all. *At the end of the sequence when they fill the room, most of what you see is just platforms with stuff like dates and raisins and things glued to it, with dead bugs glued on and thousands of bugs poured on top of that. The final impression is that the room is completely filled with bugs!*

The illusion is, E.G. Marshall has a heart attack, falls down on the bed, and later on thousands of cockroaches appear, crawling out of his mouth and bursting through his chest. For this I made a life-cast of E.G. Marshall's head in alginate and plaster bandages, poured hot microcrystalline wax in that mold (giving me a positive wax head) and sculpted the eyes open, correcting any deformations (little wax pimples, fill in wax holes, etc.).

From this I made two negative molds, the front and back of his head, pressed ¼" of clay into them, put them together, then reached inside and blended the clay together at the seams so that I could pour stone into this to give me a core—*a positive core.* I separated the molds, removed the clay, and put all three molds back together; there was a space where the clay was, into which I poured foam latex, baked it in an oven, and had a foam latex skin of E.G. Marshall. From the core, I made rubber molds and poured fiberglas into them, giving me a fiberglas core of the head, over which I placed the foam latex skin-mask. Hair and eyes were added, and behind the mouth

area I took a gasket, thredded on the inside (bought from a plumbing supply place), and built a syringe of plexiglas, attaching the male part of the thredding to the end of the syringe. (I could reach in behind the head and screw in the syringe right behind the mouth area.)

Later, this was filled with cockroaches, which were pumped through the false head. I made a plaster bandage body cast of the accountant who worked on CREEPSHOW, David Ballie, and into this I poured expanding urethane foam, which gave me a likeness of his body in the position that E.G. Marshall would later assume on the bed. I attached the fiberglas head to that, added the shoes, socks, bathrobe, pajama costume, and it looked like E.G. Marshall lying on the bed. A hole was dug through the bed for the syringe, underneath the sealed set which would later be occupied by the cockroaches. The "bug wrangler," entymologist Ray Mendez, filled the syringe with cockroaches, and on cue from us pumped them through the mouth of E.G. Marshall. *(See color section)*

127

For the effect of the roaches coming through his chest, I dug out the foam chest area of the E.G. Marshall head and put in a much larger syringe-screw adaptor behind that. The plumbing pieces were hot-glued to the inside of the fiberglas understructure of the foam head, just behind the huge hole I'd carved in the chest. I had some tubing leading to the mouth area so that after the roaches were loaded into the syringe blood was pumped through, covering the cockroaches with the blood as they made their initial escape from the syringe and tracked "little bloody cockroach footprints" all over the false E.G. Marshall head—a little trap door, made by cutting a slot in the tip of the syringe and placing a piece of round plastic there, barred the open end of the syringe and was pulled out just before the roaches were pumped out of the mouth.

A separate shot was done of the cockroaches exploding through the false chest, achieved from a suggestion by George Romero. I glued tissue paper over the escape area (the ragged hole I'd dug in the chest area) and placed two tubes underneath the hole so that when blood pumped through them, it would squirt blood on the underside of the tissue paper, making it soggy. *And we know how easy it is to push through soggy tissue paper.* After the tissue paper was glued down on the chest, and the edges blended in (easy because the tissue paper was so thin that once it touched the glue, the edges simply vanished), it was carefully made up with flesh color and old age spots, and powdered; on a cue from me, the blood was pumped against the inside of the chest. The cockroaches in the large syringe were pushed up, and easily tore their way through the tissue paper, making it look as though they were tearing through E.G. Marshall's chest.

Before all the roaches start bursting through various orifices, there is another illusion. **A close-up of E.G. Marshall—the real E.G. Marshall—showing blood appearing on the side of his temple, and then squirting out; then an area of his temple starts to swell up in the shape of a cockroach.** What I did here was "the old latex bladder routine"—but instead of cutting a hole in the bladder for a bullet effect, I simply pierced a tiny hole at a slight right angle so that when the blood went through it would simply squirt out just a little bit from that hole. I cut a piece of plastic in the shape of a cockroach and that was imbedded in-between the layers of latex so when blood was pumped it would fill only that area, in the shape of a cockroach. I pumped it up with blood, and cut a small hole in the very edge of the swelling head area of what looked like a cockroach. I squeezed the blood back out, and glued the appliance to E.G. Marshall's head, and blended in around the temples, above the eyebrows and on the bridge of the nose.

When I pumped blood into it, we saw a little blood escape, and then what looked like a cockroach appearing beneath the skin. The illusion here is that, from underneath his skin, a cockroach was trying to eat its way out. *This effect came to me after I learned how Dick Smith accomplished the swelling vein effect in SCANNERS—the same technique, except I used latex instead of a liquid plastic material.*

SCRAPBOOK

Jason and his prototype.

EFFECTS
THE SHOCK OF YOUR LIFE

STUART S. SHAPIRO presents an IMAGE WORKS PRODUCTION
Starring JOSEPH PILATO·SUSAN CHAPEK·JOHN HARRISON·BERNARD McKENNA·DEBRA GORDON·TOM SAVINI
Written & Directed by DUSTY NELSON Produced by JOHN HARRISON and PASQUALE BUBA Director of Photography CARL AUGENSTEIN
AN INTERNATIONAL HARMONY RELEASE R

GEORGE A. ROMERO'S
KNIGHTRIDERS

The Games...
The Romance...
The Spirit...

Camelot is a
state of mind.

UNITED FILM DISTRIBUTION CO· A LAUREL PRODUCTION
"KNIGHTRIDERS" ED HARRIS · GARY LAHTI · TOM SAVINI · AMY INGERSOLL
PATRICIA TALLMAN · CHRISTINE FORREST
Produced By **RICHARD P. RUBINSTEIN** Written & Directed By **GEORGE A. ROMERO**
Executive Producer SALAH M. HASSANEIN · Associate Producer DAVID E. VOGEL
Director of Photography MICHAEL GORNICK · Production Design CLETUS ANDERSON · Music By DONALD RUBINSTEIN

When the DEAD
Drink the BLOOD of the LIVING!

MIDNIGHT
If You Have a Weak Stomach – Don't Come!

John Russo's MIDNIGHT
Starring LAWRENCE TIERNEY · JOHN AMPLAS · MELANIE VERLIIN
ROBIN WALSH · DAVID MARCHICK · GREG BESNAK
Produced by Written & Directed by Executive Producers
DON REDINGER JOHN RUSSO SAMUEL M SHERMAN & DAN Q. KENNIS
Cinematography by
PAUL McCOLLOUGH
in EASTMAN COLOR R RESTRICTED

From the Best Selling Novel
—By the co-author of
"NIGHT OF THE LIVING DEAD"
an Independent·International presentation
Soundtrack Album on
SOUND CASTLE RECORDS
R RESTRICTED
* Copyright MCMLXXXII Independent·International Pictures Corp

**Sketches by Phil Wilson
of possible crate creature
for *Creepshow*.**

130

In high school, my first alien. (1963)

My alien tries to get my attention.

My Phantom of the Opera mask (1970).

Joe Spinell and his victims from Maniac.

Hall Huntsinger gets a new point of view at Carnegie Mellon University.

Leon McBryde (Buttons the clown) at the Fantasy Film Celebrity Con 1978

With my son Lon (1980)

The crew of Fluffy.

133

Pat Reese made up for King Lear. 1971

Creating my own head to be blasted away in Maniac.

Dick Smith visits the Creepshow workshop.

134

**Mechanical underskull of the Chinese Demon.
Cinema City Co. Ltd. Hong Kong.**

**Wong Ching is made up for comic role in
*Till Death Do We Scare.***

"One of the things that is always
haunting you when doing a film is *time*.
Time becomes a real problem.
Time becomes your enemy sometimes;
it keeps you from making an illusion perfect.
Lack of time makes you work long
hours to create an effect when it is due.
Time is money.
And now, *time is up!*"

GRANDE ILLUSIONS BOOK II

By
Tom Savini

www.AuthorMikeDarkInk.com

TABLE OF CONTENTS

DEDICATION

This book is dedicated to everyone who has worked for me. I hope they feel they worked *with* me on these projects. In many ways, I've learned a great deal from these people, and I hear occasionally from some, "we learned that from you." For helping me look good I thank: Greg Nicotero, Mike Trcic, Gino Crognale, Everett Burrell, Mitch Devane, John Vulich, Bart Mixon, Debbie Pinthus, Barry Gress, Greg Funk, Jerry Gergely, Will Huff, Taso Stavrakis, Jerome Bergson, Daryl Ferucci, Jesse Nathans, Sean McEnroe, Kevin Yagher, Alec Gillis, Larry Carr, Jill Rockow, Jim Kagel, Jeannie Jeffries, Nancy Allen, Howard Berger, Dave Kindlon, John Woodbridge, Michelle Wong, Jerry Bergson, Mike Maddi, Ed French, Nancy (Hare) Savini, Pat Tantalo, Derek Devoe, Michael Burnett, Gabe Bartalos, Mike Deak, Earl Ellis, Frank Marano, J.J. Hommel, Tom Rainone, Benoit Lestang, Brett Moore, Brian Freiberger, Tom Vukmanic, Jerry Constantine, Chris Martin, Dave Jose, Chris Stavrakis, Toni Savini, Toni Laudati, Joe Laudati and Lia Savini.

CREDITS
Editor: Jim Lynn
Illustrations: Brad Hunter
Layouts and Cover Design: Bob Michelucci

A special thank you to Jim Lawrence and Phil Morris of Morris Costumes.

FOREWORD
By Dick Smith

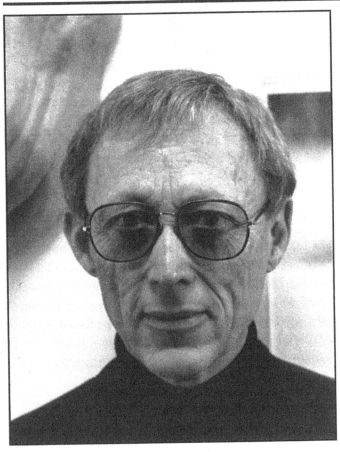

Tom Savini and I have a lot in common. Of course, we are both special makeup effects artists, but it goes deeper than that. We were both fascinated by makeup in the movies when we were young and taught ourselves the basics by experimenting on our own faces. Most of all, we liked monster and horror movies.

This fascination with horror that many people experience when they are young, is, I think, a subconscious emotional process that is a part of growing up. It begins with the gradual realization that we can be terribly hurt and that we must die someday. We don't think about this consciously very much, but these fears live in the back of our minds.

Watching horror films becomes a way of testing our ability to face what we fear even though it's not real. It's sort of a rehearsal, a trial run in which we try to imagine that we will be brave. Of course, girls don't have this problem; they don't have to prove their manhood.

A much more effective way of dealing with these subconscious fears is doing horror makeup on yourself. Just creating blood and wounds on your body makes your fear of the real thing a little less terrible, and being able to wash it all off gives you a feeling of control that lessens the sense of helplessness.

There's another basic fear that we all have to contend with as we grow up that monster makeup can help. When we are young and small, we are ruled by many authority figures, parents, teachers, clergy, police, bigger kids, bullies, etc. They all frighten us in varying degrees. How many times did you wish you were big enough, old enough or strong enough to disobey, fight back or punish some bigger person? So although monsters frightened you, it was wonderful to imagine being Frankenstein's monster, King Kong or Freddy Kruger and have everyone else afraid of you. The magic of makeup is that it enables you to become a monster and to experience a feeling of fantas-

tic power. If you were brought up like I was, to restrain your aggressive feelings, making up as a monster helps you to act out and release the "Mr. Hyde" feelings by scaring a few friends. But it is harmless aggression because you always know that you control the monster – you can wipe him out with cold cream.

Of course, there are many other satisfactions to horror makeup. It combines many skills: design, sculpture, painting, invention and all sort of crafts. Just learning and using them is a great joy. But the greatest for me is that when the makeup is finished I feel that what the actor and I have done is kind of godlike. We have created a new being, whether human or monster, that lives and breathes for a time. No other art can give this feeling.

On top of all that, we have the special effects type of makeup that came into being in the early 1970's and that takes even more skills. "Special makeup effects" (or special effects makeup) originally was coined to describe changes in the physical appearance of the actor's face or body (not covered by clothing) that were effected while the camera was rolling. That could be anything from a bullet hole appearing in the skin to the whole face changing shape. The term has become so popular that now it is used to refer to any kind of special kind of makeup.

Special effects, in the true meaning of the term, is where Tom Savini excels. He is the master illusionist. Of course he is a fine artist, sculptor, designer, etc., but what I admire him for most is his incredible ingenuity in making the impossible happen on camera. I've had a few special effects problems that were the very devil to figure out, so I can appreciate Tom's genius in this field. I think we should call him, "The Magician of Makeup." Tom has done so many makeup effects that his first book GRANDE ILLU-SIONS, could not contain them all and of course he hasn't stopped producing them. Now we can enjoy them in GRANDE ILLU-SIONS II.

I'd love to write about so many of Tom's illusions but I'll limit myself to a few of my favorites. One that I'll never forget, nor will anyone else who saw it, was the last episode of CREEPSHOW called THEY'RE CREEP-ING UP ON YOU, starring E. G. Marshall. The effect started with a cockroach appearing under the skin on his face as he collapses with a heart attack. Then quickly through his open mouth, gush quantities of live bloody cockroaches that run all over, followed by an even bigger hoard that bursts out of his chest. Before you can think, the room is a sea of scrambling roaches. It was fantastic! If you don't know how Tom engineered all that, read GRAND ILLUSIONS.

The effect that wins my award for "triumph in spite of..." is the one in TRAUMA where Piper Laurie's severed head goes rolling over the floor as it says, "Nicholas." First, Miss Laurie would not permit Tom to make a life mask of her. Then the director wanted the head to speak. I won't get into the problems that were due to shortage of time and money. Tom's solution of all problems was brilliant. It was brilliant because it was technically simple and it worked beautifully.

The illusion that stumped me appeared in DAY OF THE DEAD. I had to ask Tom how he made a person's whole head disappear. The man was lying on an autopsy table, almost naked, with virtually nothing left were his head should be. It was a real body, not a dummy. How Tom did it and dozens of other feats of makeup effects magic is the subject of this fascinating book.

DICK SMITH

INTRODUCTION

Movie magic," or "The magic of movies," you've heard it before. Why magic? Think about it. Movies do not exist as tangible objects for us. You can't see the action, or the tears, or hear the laughs from that film-can over there, or that video tape lying there. You have to load the film on a projector and pass light through the speeding frames before you can have THE MOVIE. You can't touch it. All you can do is pass your hand through its smokey, dust filled light in a dark room, as if your hand could touch its soul. Only your mind and heart can do that. You have to sit back and look with your mind and soul to have THE MOVIE, like meditating about some other existence, some fantasy, shaped and formed for you by a magician. I'd call that magic. I'd call that... Grande Illusions.

We're back again, by popular demand, and these Grande Illusions are the makeup tricks that fool you into believing, temporarily, in the nightmares we throw your way. They are also just reflections off a white wall, but let me share with you a bit of what it takes to put them there.

I hope my work, and my writing, has improved since Grande Illusions part one. That's the fun of having these two chronicles of the work. To see improvement from the first film to the last. A lot has happened. There are twice as many films for me to tell you about. I may refer to part one occasionally in explaining something so that we do not cover the same ground twice. If I explained something in part one that applies to something here, I'll simply refer you to the first book. I'll also refer to actors, both male and female, as "actors."

A lot of people have helped me over the years. This book is dedicated to them. I hope I haven't left anyone out. I've learned a lot from them, and maybe they've learned from me. That's also part of the fun. And YOU, you readers there. Thanks for making this possible. Thanks for asking constantly, "When is Grande Illusions II coming out? Thanks for being patient. Almost every time I sat down to write, a job would appear. It got so consistent that in a lull, when I hadn't worked for a while, I'd purposely sit down and write hoping to make a job appear. It would, and that's why there's so much to write about now.

Enjoy.

FRIDAY THE 13TH, THE FINAL CHAPTER

I was at the podium as presenter of the annual Starlog Amateur Film Search Awards, and someone asked how my plan to stop creating gore and do more creatures and character makeups was coming.

I said, "I know I've been saying this is my plan, but tonight when I leave here, I fly to California to start **FRIDAY THE 13TH, THE FINAL CHAPTER**." Cheers, howls, boos, and laughter filled the auditorium. That sums up the variety of tastes at such an affair. I've been saying I don't want to do any more gore and now I'm off to do another **FRIDAY THE 13TH**, the King of the splatter movies.

But, my feeling was that I would be fulfilling my plan, somewhat, by creating the creatures, masks, and makeup, called for in the script, to make the young Tommy character a makeup whiz. Interesting that his name was Tommy, huh? Also, I don't think the public really knows how much sculpture, and painting and mechanics go into creating this "splatter." Besides, at that time, 'Jason' was one of the best "Creatures" in my Portfolio. I created him, and I thought it only fitting that I be the artist who kills him in **THE FINAL CHAPTER**.

Of course, time reared its ugly head again and said "you're not going to get enough of me," because production had already begun.

"No preparation time?" I asked when the director, Joe Zito called.

He replied, "...and we don't know how we're going to kill Jason yet."

So, I'm in California and the method of Jason's death was up to me and my crew: Alec Gillis, Kevin Yahger, Larry Carr, Jill Rockow, Jim Kagel, and John Vulich. Alec Gillis has since worked with Stan Winston on **ALIENS**, and formed his own company creating effects for **ALIEN 3** and **TREMORS** and **DEMOLITION MAN**. Kevin Yahger now has his own company creating effects for **NIGHTMARE ON ELM STREET II**, **CHILD'S PLAY**, and **TALES FROM THE CRYPT**. Larry Carr worked on **CUJO**. Jill Rockow worked on **DEADLY EYES**. Jim Kagel has also worked for Stan Winston and Rick Baker and is one

Building the mechanical Jason.

of the finest sculptors I know. John Vulich, with Everrett Burrell, has since formed his own company called Optic Nerve creating effects for my **NIGHT OF THE LIVING DEAD 1990**, **THE FANTASTIC FOUR**, **HOT SHOTS PART DEUX**, **ROBIN HOOD MEN IN TIGHTS**, and **BABYLON 5**. John also worked with me on **DAY OF THE DEAD** and **TEXAS CHAINSAW MASSACRE II**.

Jason's death had to be glorious. It would be like in the cartoons, if the Cayote finally caught that little bastard Roadrunner. The audience would want him to kick the shit out of that Roadrunner after all the hilarious suffering the Cayote has endured over the years. It would be the same with Jason and all the teenagers he laid to rest in parts 2 and 3. The audience will want him to get "his" in a painful and bloody way.

We all thought it would be great to kill Jason using a microwave oven. We would establish in the story that along with being a

Attaching and testing the machette slide and bleeding effect.

makeup whiz, Tommy is also an inventor. We see in his room a disassembled microwave oven with a reflector now attached behind the wave shooter allowing him to aim it. A voltage regulator controls the beam with a dial that reads from one to ten.. He melts down a plastic toy soldier on a setting of just one. During the fight between Jason and Tommy's sister at the end of the film, Tommy manages to insert this wave shooter into Jason's face, turn the dial up to ten and pressure cook his head from within until it explodes. Everyone in California liked this idea but I had to "sell it" to the MONEY PEOPLE in another state. But, their consensus was to stick to the successful **FRIDAY THE 13TH** formula of killing naked teenagers with old fashioned household implements.

This limitation spawned creativity. One day John Vulich held the trick machete used in DAWN OF THE DEAD to his head and I thought that's it! But we'll go further than just whacking Jason in the head with a machete. We'll have him drop to his knees, fall forward on the machete in his head, and in an ever so sickening way, show his head slide down the blade of the machete. His face grimacing all the way down. Hey, we're grown-ups, we do this for a living.

The audience loved it and I think they were satisfied judging from their reaction in all the theaters I've seen this scene play. But, Jason is still around! What the hell? I sliced his brain in half! This was called **THE FINAL CHAPTER**! There's been part 5,6,7,8 and 9. Are we heading toward FRIDAY THE 13TH, PART 13?

This death scene occurred late in our schedule and I'll talk about how we did it later on. Meantime we busied ourselves with creating Jason's look, and the many props we would need.

I wanted Jason to look like a 38 year old version of the makeup I created for part one. Jim Kagel did the sculpture working from a

photograph of the younger Jason that appeared in
GRANDE ILLUSIONS. It was going to be a BREAK-
DOWN makeup, and the first time I had ever tried one.
A BREAKDOWN makeup means sculpting a character
completely in clay over a whole head-cast. The face,
the neck , the top and back of the head, everything.
You breakdown the finished sculpture by slicing the clay
into individual sections that eventually become indi-
vidual foam latex appliances of those sections. The
nose, the chin, the upper lip, etc. I'll go into more detail
about creating a BREAKDOWN makeup in the TEXAS
CHAINSAW MASSACRE II section with the 'Grandpa'
makeup. I have many photographs of this makeup and
almost none of the Jason breakdown. The technique
was exactly the same.

Way before any Jason makeup could possibly be
ready, we were told he had to be seen "almost immedi-
ately" in the shooting schedule. The makeup we had to
create for him wasn't needed till much later in the shoot-
ing schedule for the unmasking scene, and it would take
time to get it ready. We had the finished sculpture of
Jason sitting there ready for the long process of break-
ing it down into foam latex appliances, but we had to
have a Jason ready " almost immediately."

So, instead of cutting into the clay sculpture to
begin the BREAKDOWN process, we made an alginate
cast of the sculpture, just like casting someone's head.
We poured melted microcrystalline wax into this algi-
nate negative, creating a wax positive. We removed
any imperfections and made a plaster mold of this wax

positive. Pouring
Latex into this mold
gave us a mask the
actor could wear.
By cutting out the

*(Upper Right)
Original Jason
Make-up from
FRIDAY THE
THIRTEENTH, PART 1,
used as a guide for
grown-up Jason.
(Remainder of
photos) Sculpture of
matured Jason.*

face area of such a mask, the actor could wear the hockey mask over the cut out area and no one would know the difference. The audience would be able to see the distorted Jason head with its warped ears, and the actor wouldn't have to go through an elaborate makeup each time he was needed. It also meant we could have him ready in no time. It was just putting on and taking off a mask.

By the time I arrived in California, Kevin Yagher had already created a mechanism for the first effect in the film. The 'hitchhiker' who is stabbed through the throat from behind. He built a flexible knife that traveled through a thin flat plastic tube around the actor's neck. A foam rubber appliance of the actor's neck was glued over the plastic tube. You could

Upper) Kevin Yagher's trick knife gag for first victim.
(Lower) Rubber torsos for raft victim's murder.

push and pull on this knife and the effect was that it was going in the back of the neck and out the front .

I assume when I say things like molds and foam rubber appliances that you know what I'm talking about because you've read GRANDE ILLUSIONS (or BIZZARO) part one.

For the effect when the young naked girl lying in the raft is impaled from below, the crew cast the actor, before I was hired, from her neck down to below her buttocks. From the cast, large polyfoam appliances were made duplicating her own body from the neck down. They were painted to match the girls body and glued to her back just behind her neck and along her shoulder blades. Her lovely, long (and convenient) hair covered the seam. She was actually standing in the water through a hole in the raft. The rubber body glued to her made it look like she was in the raft. Jill Rockow and I were in the water and at the proper cue I pushed the machete up and through a blood filled plastic bag and the rubber body. Jill pumped the blood and the rubber back seemed to bleed when the machete broke through.

Two young medical people (a female nurse and a male orderly) get 'theirs' at the beginning of the picture. The guy gets his head twisted around and the girl is stabbed while being held in mid air. The girl's effect was more hilarious than deadly, which was my slip-up. It had to look like Jason stabs her, so we made a fake plastic surgical knife from the cast of a real one. We stabbed the real one into a dummy wearing the nurses uniform for the close up. For a wider shot, we cut the plastic knife in half and Jason held it against the real nurse making it look like it was in her. Blood tubing glued to Jason's hand squirted blood against the nurse finishing the illusion. We glued tubing to the inner thigh of the nurse and the idea was that blood would squirt against her thigh and run down her leg as

Jason held her up and against the wall. The tubing must have come loose and just dangled there under her skirt. When it came time for blood to run down her leg, it shot out from beneath her nurse uniform in one steady red stream as if she was taking a leak. Joe yelled "Action," and she peed this nice little red puddle. Joe simply said "very nice." You had to be there.

To really see the male orderly's head twisted effect you may have to watch it on your VCR in slow motion. Joe showed it in a very quick cut which, in my opinion, was a great idea. The temptation when you're doing effects is to get self indulgent and give them lots of screen time. But Joe did something with **THE FINAL CHAPTER** that I thought was clever. He showed every effect very quickly. It made you really watch for them and created a certain tension that might not have been there if the effects were shown in a slow, clinical way. Until Jason's death when you did see everything slowly, you expected

not to see everything and you did. It added so much to this climactic moment.

The orderly's head had to twist completely around. The illusion required using the real actor and a dummy we made of him. First we did a shot of Jason, who is standing behind the actor, twisting the actors head around as far as it would comfortably go. We stopped the camera and put the actor in his shirt and jacket backwards so that his head was facing Jason, but his tie, shirt and jacket were still facing the front away from Jason. Before rolling camera, we made the actor turn his head as far as he could to the left and Jason placed his hands on the actor's head just like the first part of the shot. On "Action," the actor simply turned his head quickly toward Jason. The two shots cut together would make it look like his head was twisted completely around. For additional coverage, we set up the dummy, and Jason actually twisted it's head around. Now we have the first two shots, and the dummy shot which

Rubber Raft, Rubber Torso, and VERY WET effects people.

could be edited in "wherever." There was also an appliance on the actor for his backward position making his neck look twisted.

Another character has his face crushed in while taking a shower, and is found later impaled on the bathroom wall. We cast the actor's head and made a foam rubber skin of it and placed it over a thin fiberglass shell. We added teeth, glass eyes, hair etc., and let Jason really crush the face in. For the shot of him hanging on the wall we simply showed his feet suspended off the ground (he was holding onto a make shift chin up bar) then you see his head and shoulders (he was standing on a box) and we glued a rubber spike onto his back making him look impaled there.

Later on, another character stands in front of a home movie screen and a big knife plunges through it into the back of his head. Once again, the illusion required using the real actor and a dummy. For one shot the knife was physically stabbed through the screen into the dummy head of the actor.

The next shot required the actor to slide down the screen while the knife sticking out of his head sliced the screen in-two. We used the real actor wearing a brace against the back of his head. A similar big knife was welded to the brace. The actor simply slid down the screen as we pumped blood through tubes connected to the brace and onto the screen.

In another scene, a character is crucified across a doorway. Jason needs to exit so he yanks the character down. There is a close up of the crucified hand being pulled apart on the spike. It's really just a form rubber hand, I don't know whose, spiked into the wall. We just pulled down on it until it tore away.

For Jason's death, Tommy, wearing a bald wig with scraps of hair glued to it, (in the film he shaves his head to look like Jason) whacks Jason in the side of the head with a machete. Tommy lets go of the machete and it stays there sticking into Jason's head. Jason drops to his knees and falls forward landing on the machete and his head slides down the blade as his face contorts in pain and horror.

(Below) Alec Gillis, Jason and Larry Carr. First bloody test...

We built a mechanical Jason dummy. We were able to pump blood into the head area, stick out his tongue, make his brows move up and down, and his eyes look around. It had a track inside the head area allowing the machete to slide easily along the inside of the skull from the eye socket to the back of the head. It took the entire crew, seven people, to operate this illusion. We tested it in the workshop pumping water through the head at first, video taping so later we could show Joe what this elaborate puppet could do. On the set we did many takes without blood, just the dummy sliding down the blade. We pumped blood for the last few takes, first just a little, then a little more. On the last take we really let go and it was like a keg of wine had exploded. I think a non-bloody take was used in the film. ☠

(Below) (L-R) Larry Carr, John Vulich, Jim Kagel and Jill Rockow on the set.
(Upper Left) Fully operational Jason waiting for his close-up.
(Lower Left) Jason's Stand-in.

DAY OF THE DEAD

When I think of DAY OF THE DEAD, I think of days without sunshine. We went into the mines at about 7 A.M., dark, and came out about 8 or 9 P.M., dark. Except for a two week jaunt to Florida for exteriors, we didn't see daylight for about three months. But underground in the mines, in the dark, we saw in our golf cart headlights, mushroom farms, a 27 acre pitch black lake touching the cave ceiling in the middle, hundreds of zombies, assorted actors, stuntmen, and special effects guys.

This chapter owes a great deal to the journal kept by Greg Nicotero on the making of DAY OF THE DEAD.

But let's go back a bit to my basement where Greg Nicotero, Mike Trcic, Derek Devoe, Dave Kindlon, and John Vulich crowded into two small rooms to begin creating the effects. It was way before the mine was chosen and our location workshop was set up, and before we hired Howard Berger and Everett Burrell.

We sent out a cry for "body parts" and "corpses" to other effects artists. Anything that would save us a lot of work, and pad our inventory of gruesome

delights needed for this bloodbath called DAY OF THE DEAD. We bought some polyfoam cadavers from Steve Johnson, who threw in a zombie head as a little surprise, and from Ed French we got some arms, hands, a female leg, and a few heads. Carl Fullerton rented us the molds of the bodies he made for GORKY PARK. Greg went to Rye, New York, where Frank Farel, Al Magliochetti, and Gabe Bartalos helped him make latex and polyform bodies from the molds.

I decided to be the first "effect zombie". I came to be known as Dr. Tongue because the side of my head would be blown away by a shotgun removing half my jaw so my tongue would just hang down out of my head. The credit DAY OF THE DEAD appeared across my chest at the beginning. It wasn't really me,

Punching hair into the mechanized "Dr. Tongue."

We tore away the foam latex skin to produce the damage , and added the hair, tongue and blood

Quickies.

but a mechanical dummy made from me. A plaster bandage cast was taken from my torso, and a fiberglass copy of me was made. My head was cast separately, and the mechanical articulation was done by Dave Kindlon.

Our idea was to create small, medium, and large generic zombie appliances that we could throw on anyone who walked into the make up room on a given major zombie day. We used face casts from me, medium, my ex-wife Nancy, small, and my friend Leon Mcbryde (Buttons the Clown) , large. The same was done for hand appliances, and generic zombie teeth, small, medium and large. If you were to walk into our shop as a potential zombie, we would note your size for an appliance, glue it on and color you, then throw some alginate into the right size zombie teeth for a tight fit, and you were on your way.

To avoid having to do hundreds of make ups like this in a single day, the idea of using zombie "masks" was developed with Al Taylor and Terry Prince. We bought two hundred of

these masks and only zombies in the deep background wore these. However, every time a photographer came to the set to photograph George Romero, it was these zombies, and not our wonderfully made up ones, who crowded around him. So, every time I saw a photo of George in some magazine, he was surrounded by guys in zombie masks.

Greg Nicotero's head was cast for a scene where the soldier he played was shot and his head was used in experiments by the "Doc Frankenstein" character. We all thought that using ourselves in the film would be better than waiting for people to be cast in the roles by the production. We could get a head start on the effects this way, and all of us were zombies eventually, except the one person who can't stand to have glue on his face, me. We could have put Greg under a table with his head sticking out an opening in the top, and put a severed head neck appliance on him to make his own head look like his severed head, but the idea of having his head lying flat on a table so you could see the entire diameter of the

Adding hair to one of the background Zombie masks.

slice through his neck was what I wanted. Dave Kindlon took the fiberglass under-skull and foam latex skin and mechanized a brow movement, a blink, a chewing action for the jaw, and a wince. I did the hair work, and Greg's severed head came to life nicely. So nicely that he borrowed it for his family get together that Thanksgiving, stuck it on the pillow of his bed, hid on the floor with the operating cables and when his mother entered the room spoke to her from his

Tim's real arm and did the old cut-a-section-out-of-a-machete trick, placed it over his real arm and you could see Tim wiggle his fingers and move his hand while his arm is being amputated. To show the blade separate the sections a rubber upper and lower arm was used. And finally, a charred stump was attached for the cauterizing section of the scene.

Greg Nicotero's mechanical severed head.

severed head on the bed. He tells me she wouldn't speak to him the rest of the day.

Needless to say this is one of the reasons I wasn't allowed in many of my friend's houses when I was a kid. Their mother's were tired of jumping and screaming, and early gray hair

For the scene in which Miguel (Tim DeLeo) is bitten by a zombie on the arm making it necessary to amputate the arm, we made a cast of Tim's arm including part of his shoulder. We made a number of arms for various parts of the effect: A stump that Tim would wear after the amputation. Tim's real arm was behind his back for front shots, and in front of his chest for rear shots. A gauze bandage was used to hide the attachment of the stump to his shoulder. A hard rubber arm was made for the initial whack from the machete. Tim was lying on floor of the cave. His real arm was in a hole in the floor behind him. The rubber arm was in his rolled up sleeve. Lauri Cardille used a real machete and chopped down into a mortician wax section of the arm. Then for a shot of the blade pushing down into the arm, we used

Three arms for the chopping effect.

We did almost the same thing for the zombie that gets the top of his head chopped off by a shovel. This time we began with a cutaway shovel and placed it over John Vulich's face just above the upper lip. Blood was pumped through the shovel handle into John's face. Then, a real shovel was used to separate a dummy head of John from the rest of his body

For the actual bite on the arm, Tim wore three appliances. A foam latex bite hole glued down and painted a dark blood color, over a bladder appliance. The bladder appliance was made by brushing liquid latex in a balloon shaped pattern on a plaster positive of Tim's arm. After three coats, a similar but smaller Saran Wrap pattern is laid on the latex. More coats of latex are applied over the Saran Wrap and when dry, small holes are cut into this latex coating. The Saran Wrap is pulled out and blood tubing is glued into the entrance section of the balloon pattern. When blood is pumped it appears to come out of the bite hole. Bits of Chunks-0-Flesh (liquid latex, pigmented red, and painted on a flat smooth surface like glass, dried with a hair dryer, powdered, then rubbed until holes ap-

pear and the latex bunches up into a web-like structure, and stretches and tears like human tissue) were glued to the bite hole appliance, and to the undersurface of a foam latex plug appliance that covered the bite hole making the arm look unharmed.

(Dave Kindlon) actually bites the plug appliance away from the bleeding Bite-hole appliance stretching and tearing the Chunks-o-Flesh.

The Autopsy Zombie, our favorite, was made by casting Mike Trcic while he lay on a table with his butt and upper back in a hole. This made his profile in a lying down position sunken in the chest and stomach area. We cast him in this position so that when the skeletal chest appliance we made from the cast was glued on him, it wouldn't add too much height to his chest and stomach shape, and look real. This skeletal appliance was covered by a foam latex normal chest appliance. An incision was made into this appliance creating a door-like flap that would open. We glued a rubber intestine into the abdomen section of the skeletal appliance and wrapped pounds of pig intestines and fake slime around it When Mike sat up on the table his guts just naturally poured out. Nothing moves, and falls, and sounds, and SMELLS like the real thing. Later Mike is killed with a drill to the head. We simply gutted a Dremel tool, put the housing back together and inside was a spring loaded soda

Applying fake blood to the intestines before the camera rolls,

straw painted black to look like a drill. When it was placed against Mike's forehead we pumped blood through it. The sound was added later.

Moose-C—t is the name the crew gave the appliance used to accomplish the faceless living cadaver Dick Smith referred to in his

Mike is drilled with the retractable Dremel.

Foreward. It was the strangest decapitation ever. All parts of his head were removed leaving his brain, part of his skull, and some viscera around his spinal column and throat.

We put the actor, Barry Gress, on his back on a table and let him bend his head back- wards as far as he could into a hole in the

Casting what's left of Barry with his head under the table.

table. Like a guillotine we closed, or rather filled in the space around his neck and cast this part of his upper body including the flatness of the table around it. This gave us a positive mold on which to sculpt Moose-C—t. John Vulich sculpted the beautiful, anatomically correct, appliance. We simply put Barry on the operating table, constructed like our casting table, with a hole for Barry's head and glued the finished foam latex appliance to blend into his collarbone, made it up, added the brain and wires, and Barry was able to move his body giving life to a cadaver that appeared to have no head, or not very much of one.

(Above) John's sculpture with plastic brain. (Below) Appliance, attached to Barry.

Blood, wires and hair are applied to Barry to finish the effect.

Taso's head, being carried away like a bowling ball by a zombie

Once we discovered we could do this with a human head, we decided to do something similar to Taso Stavrakis who plays Torrez. In his case, since Taso is our friend, we decided to tear his head off. We did the same kind of preparation on him, but instead of an appliance we glued a foam rubber mechanical head to his body for the zombies to tear off. It was only mechanical in that the jaw could open an close and "chew the air" screaming.

Taso's head appliance, before we applied it to his body.

The eye sockets were filled with blood to ooze when a zombie grabbed the head like bowling ball. Once again we had a real body moving as something terrible was done to the head.

The killing of the Rhodes character (Joe Pilato) had to be something special so we decided to tear him in half. Here it was a real head and arms moving as something terrible happened to the body. We knew we could hide a head while showing a real body, why not hide the body while showing a real head?

We cast Joe's hips and legs in plaster bandages, laid in some plastic sheeting and poured in polyfoam. The result was a foam lower body that would look like Joe's once the costume was on. We also cast his chest and made a foam latex one that was glued to a fiberglass form fastened to the floor. Joe's body was under the floor so that only his head, neck, shoulders, and arms stuck out just above the fiberglass form and foam latex chest. The chest was attached to Joe at his collarbone, and to the foam lower body. A packing company near the location was contacted and 44 pounds of pig entrails were bought. Why? Because nothing moves and slides and sounds like the real thing espe-

cially when it comes to intestines. Most of these entrails, plus some kolbassi, and I think a rubber chicken were loaded into the stomach area of Joe's fake body. We pumped in some blood and the zombies tore it apart and walked away with Joe's lower body. Did I mention that this was one of the last effects we did on the film? And that it took place after we returned from the Florida shoot, after we found out that the refrigerator keeping the entrails fresh had been unplugged for two weeks? The stench was incredible!! The zombies stuffed their noses with cotton or wax but Joe couldn't because you would have seen it. The camera was looking right up at his face in close up. He suffered for his art that day.

Joe Pilato spills his guts.

Bub, played by Howard Sherman, was *the* zombie. He was smart and getting smarter. We took a lifecast of Howard's face and teeth and John Vulich sculpted a one piece appliance that he applied and painted every time Bub was called for in the schedule. ☠

MONKEY SHINES Guest writer: Greg Nicotero

At this point in my career, I had relocated to Los Angeles and been working back and forth with Stan Winston, mark Shostrom and a few others. Tom Savini and I, of course, had kept in constant contact since my move, and I looked forward to the opportunity to work with him again and get back to my home town of Pittsburgh. I had just finished doing some reshoot work on PREDATOR, when Tom called and informed me that George Romero was about to begin production on a film called MONKEY SHINES and would I be interested in coming back and working on it.

The film centered around ALAN (Jason Beghe) who is crippled in a freak accident and paralyzed from the neck down. A research scientist and friend (played by John Pankow) supplies him with a Capuchin monkey named ELLA that has been trained to perform certain tasks for ALAN that he can not accomplish, due to his handicap.

Little does Alan know that the monkey is part of an experiment in telepathy. An unusual "mental" link develops between Ella and Alan. Ella then begins to act out the "animalistic" rage and frustration that Alan feels. The end result is an amazing psychological thriller that ends up pitting Alan against his own primal rage in the form of Ella.

Basic wire armatures on which monkeys were sculpted.

I jumped at the chance to work with a lot of my friends again, and recommended Everett Burrell and Mike Trcic as sculptors/moldmakers. Since Everett, Mike and I had all worked on DAY OF THE DEAD, Tom was very comfortable with all of us as a crew. After doing a breakdown of the script, we determined that we would have to create the following monkey effects:

Full size posable and floppy Capuchin monkeys.

Articulated puppet, with rod-puppet arms and cable articulated head with side to side and up and down movement.

Two sets of actual size monkey arms.

One set of "oversized" monkey gloves (sculpted and worn by Everett) to be used for very specific actions that neither the real nor fake monkey arms could do.

In addition, there were several other gags that had to be built above and beyond the monkey effects. They consisted of:

A brain surgery sequence (later cut from the film) of local actress Stacy Foster, with a section of skull removed and her brain exposed.

A matching makeup on Jason Beghe of the brain surgery makeup for a dream sequence.

John Pankow's character (who developed the serum that links Ella and Alan) is constantly injecting himself with several different "serums." Tom designed and built several syringes that could actually appear to inject the liquid into a vein when in reality the liquid as being injected into a tube that ran down the off-camera side of the syringe.

Tom also made several retractable syringes that could be filled with any color liquid we wanted, and the needle would appear to enter the skin, when it really slid back into the barrel of the syringe.

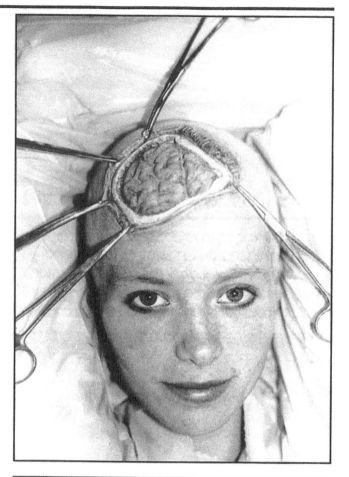

Stacey Foster, in makeup for brain operation (before blood was applied.)

Once the "link" began to take place, both Alan and the doctor actually began to grow very subtle "fangs," something that is played very low key in the film. Two sets of dentures were made to progress this effect.

The real challenge to this entire project was going to be making the monkeys look real enough to actually intercut with the real trained Capuchins. Most of the time, when an effect is designed, it is either a fantasy character that you can design on your own (like FLUFFY), or it is something that will only be used for a "gag," i.e. blowing up a head. These monkeys we were going to create had to be able to sit side by side with the real monkeys and look identical.

There was talk about anesthetising one of the live monkeys and taking an alginate cast, but potential harm to the animal as well as the

question of how to deal with the alginate sticking to the hair ruled that out right away. The monkey trainers (Chris Handlin, Alice Levy, and Alison Pascoe) brought down one of the trained monkeys and we took extensive photos and measurements. From here, Everett began sculpting one of the monkeys with it's arms and legs in a sprawled out position while Mike began sculpting a monkey in the sitting position, later to become known as BUDDHA. This process took about two weeks. After the sculptures were approved, silicone molds were taken of both sculptures.

The plan was to run several self skinning polyfoam pulls of Everett's monkey, some with imbedded armature wire and some without. For the floppy ones, we would cut the joints and replace them with spandex so that the arms and legs would have a bit of mobility. We used a self skinning foam from a company in New York called Foamex.

After several of these were run, Tom, Everett, Mike , and I began the laborious task of laying the hair. Greg Funk, a local Pittsburgh effects tech was also hired to help in the process. We used Yak hair that we purchased from Bob Kelly in New York and mixed the hair to match the live monkeys. Once the hair was mixed and blended using a hackle, small portions were pulled from the hackle, cut straight at the end and laid onto the bodies using rubber cement., starting from the bottom. Of course, this task was quite time consuming, mainly because you could only lay so much hair at one time and keep it realistic looking. The heads were punched, using a needle cut off at an angle. The longer prong pulls the hairs one or two at a time and punches them into the foam. You generally don't want to punch more than a few hairs, or you'll get a "Barbie doll" look, where several strands of hair come out of one hole in a clump. A bit of vaseline on the

(Top to Bottom) "Sprawled" monkey sculpture, beginning "Buddha" monkey sculpture, Mike Trcic finishes "Buddha," and monkey head sculptures.

needle is suggested to help the needle penetrate the foam without leaving holes. (See PUNCHING HAIR)

Even though the trained monkeys were quite capable of pulling off the majority of the tasks scripted, the one thing they didn't like to do was sit still. We decided early on that a cable articulated monkey would come in handy for over the shoulder shots shooting from behind the puppet. We utilized Mike Trcic's "sitting" puppet and turned it over to Rick Catizone. Rick (as you will recall) was responsible for the animation on CREEPSHOW I and II and had done some work for Tom in the past (see GRANDE ILLUSIONS I.) Rick gave the puppet head movement, (up and down as well as side to side,) with a simple hand grip, and the jaw opened and closed with a trigger mechanism. The arms were run with square brass stock to allow for the insertion of puppeteering rods if the arms were to be moving throughout the shot.

Once shooting had gotten underway, Mike and I returned to LA and Everett and Tom executed the remaining effects. Including the design and con-

Monkey Hair!!! From "punched-in" to cropped/dressed to finished.

struction of the oversized monkey gloves. The script called for specific action of Ella terrorizing Alan with a straight razor, so the gloves came in handy for this as well as several other shots. The prop department had oversized props made (in the same scale as the gloves) for Everett to handle and simulate as the small monkey.

The original ending has Alan having a dream about having brain surgery (to duplicate the makeup we had done earlier.) We had studied several Medical school films for reference and Tom sculpted the makeup. A band dressed around the forehead assisted in hiding the edge, since the eyebrow area is always tricky. Subsequently, these scenes were cut from the film and a new dream sequence was added where Alan is having back surgery and once the incision is made, a monkey head pops out (sort of like ALIEN but not really...) For all of the incisions and surgery shots, we used gelatin appliances and actually cut into it with a real scalpel, pumping blood from the off camera side of the blade.

All 'n all, we had a great time putting all of this stuff together, and ultimately were very pleased with the final result. The film is very powerful and probably one of George's best. ☠

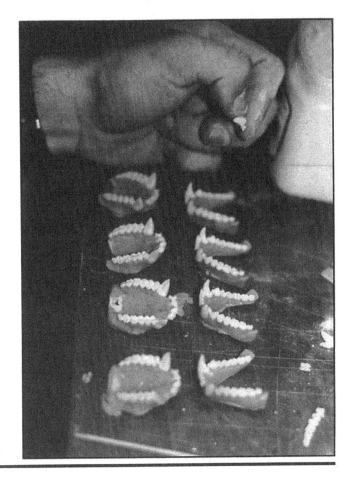

(Above Right) The Robo-chimp mechanical monkey.
(Right) Monkey dentures to be inserted in foam rubber monkeys.

Red Scorpion

A phone call from Namibia, South Africa: "Tom, you're coming to Africa." That's how Joe Zito, the director, hired me to do **Red Scorpion**.

"But Joe..." I said.

He cut me off with, "You're coming."

That's Joe. I packed some materials, grabbed my wife·Nancy and my three year old daughter Lia, called England and hired John Woodbridge, and in the blink of an eye I was in Africa on a hillside watching Joe direct a scene where soldiers fired at targets while peasants near the targets ran for cover. Between takes, we discussed what he wanted from me on this film. A guy's arm blows off while holding a grenade in a raised position. I said I can do it with the arm in a lowered position like it was throwing the grenade underhanded.

"No, no, no, it has to be in the raised position!"

"But Joe," I said, "I don't have the supplies or equipment, we're in South Africa."

"You can do it," he said.

"How," was the next question I asked myself. Luckily, I soon found myself in the workshop of John Richardson. He had done some James Bond movies and always traveled with lots of tools and equipment. He was very helpful and generous with his time and supplies and let me build a harness and armature that the actor, and soon to be good friend , Carmen Argenziano would wear. The harness enabled me to fasten an armature to Carmen so that a fake arm, from the hand to the elbow, could be mounted on it in a raised position. Carmen held his real arm behind his back. The fake arm was cast from Carmen in a hotel room. The prop people gave us a lightweight plastic grenade and we glued it into the hand's grip. Once his costume fit over the harness and armature, it looked as if Carmen was really holding up a grenade about to throw it.

Foam Latex chest appliance in place and pierced.

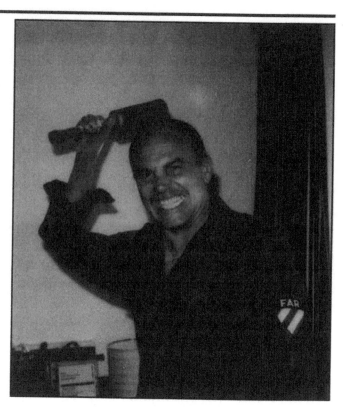

(Above Left) Carmen Argenziano posing with REAL arm.
(Above Right) Carmen Argenziano wearing the pre-explosion fake right arm.
(Below Left) The appliance showing the under-structure.
(Below Right) Carmen (post-explosion.)

(Above) A real arm was brought out through a hole in the second story floor of the barracks.
(Left) Foam rubber arm that explodes off the harness.

In the scene, Dolph Lundgren is pointing a very nasty rifle at Carmen. Carmen is the bad guy threatening Dolph with a grenade. Dolph's solution is to simply shoot Carmen's arm off. It falls to the floor still holding onto the grenade. Dolph escapes. Carmen now has to get to his severed arm and the grenade before it goes off. He doesn't make it.

The fake arm fit onto the armature like a bayonet. Inside the arm was a piece of hard plastic tubing that slipped over a thinner piece of copper tubing on an extension of the armature. Using some high strength fishing line, I could yank off the arm and put it back on as many times as I liked. I got some explosive squibs from the special effects guys and loaded them into a blood filled balloon fas-

(Above) Flimsy water-based sculpture over soft foam mannequin head.
(Below) The best exploding head possible from such a sculpture.

tened at the base of the fake arm on the armature. My plan was to yank off the fake arm and at the same time explode the balloon so blood would splatter out as the arm disappeared from Carmen. It worked great. One take!

In my opinion, no arm, however well made, can stand up to a lingering close up. For the next shot Joe wanted a close up of the arm. I gave him more. I gave him a close up of the arm and made the fingers move slightly as if the severed arm was having a few muscle spasms. We were shooting on the second floor of an army barracks, so I had the crew cut a hole in the floor. Another crew member stood on a ladder on the first floor below the hole and stuck his arm through the hole so his arm appeared to be on the second floor. Get it?

I put the sleeve of the fake arm over this guys real arm and decorated his elbow with "chunks of flesh" making his arm look like the severed arm laying on the floor. For the shot, we simply asked the guy to wiggle his fingers. It was creepy for anyone who wandered in thinking that there was a fake arm lying on the floor, and seeing it suddenly move and give them the finger.

I suggested that during a battle scene where Dolph was running around shooting people that he blow someone's head off. I like blowing heads off. I've done it enough times. Plus it just seemed logical with all the fire power around. But, all I had to make it with was water based clay and a soft foam dummy headform. Trying to sculpt a realistic head over the foam dummy head was like trying to sculpt with Jello. Don't try it.

When it finally looked good enough, I knew I could make it look better with hair and a beard.

For another scene, Dolph was tortured by a guy, Alex Colon, who drove these hideous long needles through his chest muscles, biceps,

and neck. The real needles had already been made as well as a few retractable ones. This saved me a lot of trouble. The real needles were established as terrible torture devices when they were pulled out of their case. The retractable ones were used for shots where they went into the muscles. But I needed to make something that would produce blood on demand. I made a cast of Dolph's chest in alginate and from this, made a plaster cast of his chest. Then I sculpted a new section of one of his pectoral muscles, the outer section that the needles would pass through. I also cast a small section of his trapezius neck muscle so that I could make another foam piece for the needles to pass through. This was going to be *the* **money shot**. The special effect of the film, if done right. Well, it became a nightmare. It was either the humidity or the crude oven that John and I had to work with, but the foam never came out right. We made a dozen attempts at producing the chest and neck appliances and every single time, they **double skinned**. This means that the top foam skin would separate from the bottom at the edges. So, in fact, there were two edges. Time ran out and the day came to do the effects. I carefully tore away the bottom skin and hoped the upper skin would glue down and blend away. It sort of did, but there was this visible mound protruding. I was petrified that it would be too noticeable. Thank God, Dolph had freckles. I painted little dots on the appliance that helped blend into the freckles. I also covered the appliance with KY jelly, giving it a shine like sweat. The shine on his real skin blended with the shine on the appliance helping to hide the edge. What really saved us was the way Juao Fernandez, the director of Photography, lighted the scene. I actually went over to him beforehand and said, "Help!" The neck appliance was a lot better. Dolph had more freckles in that area, so the appliance was flawless.

For the scene, Alex pierced the chest appliance with the real needle. It was dulled, but Dolph felt it and I could tell he was getting agitated at Alex. Alex was getting a little nervous also because in the next scene, Dolph had to knee him in the balls. After the real needle pierced through the chest appliance, we stopped the camera, and a special needle that I had built was inserted now into the appliance. The special needle was a piece of copper tubing, the same diameter as the needle, with holes in it like a flute. I painted it silver like the needles and attached a length of tubing to one end. We rolled the camera and I pumped blood into the needle under and eventually out of the appliance, making Dolph bleed. I did the exact same thing for the neck appliance. After the bleeding close ups, we removed the bleeding needles, replaced them with the real needles so that from a wider shot, Dolph could yank them out before his escape. ☙

TEXAS CHAINSAW MASSACRE II

THE BADLY EDITED AND LAUGH ABLE FIRST EFFECT IN THE FILM: There is a scene at the beginning of this film where two yuppie types are driving along a texas highway shooting at road signs. They are the first victims in the film. The makeup effects were well planned, but the only death that occurred was the death of the illusion, due to the poor editing of this sequence. It was not the fault of the director, Toby Hooper. It happened somewhere in the nightmare land of post-production limbo. I watched this film the first time with friends who were crew members of mine on other projects. They laughed at this sequence. It was embarrassing. Especially since the rest of the film was pretty creepy. It has become a cult favorite in the series.

What we shot and what you were supposed to see was as follows: The chainsaw doing damage to the yuppies' car. Somewhere in the attack, the driver is hit. From the front you see this huge, gaping, ragged edged slice in his head. It begins to spread apart and bleed as his hands come up and into frame. Then we cut to behind the driver, substituting a dummy head. This head was rigged to spread apart and the top would slide off into the drivers hands while blood spurted and brains slowly slid from their cavity. However, in the finished film, we cut from the front shot of the drivers head with that gash, to the back of the dummy head and the scalp piece is **already off**, the head shooting out streams of blood against his gyrating hands.

We made a lovely appliance for the driver to wear, featuring the horrible gash in his head. A thin fiberglass dome, was fastened beneath the appliance. We stuck a condom underneath the fiberglass plate, and inflating it made the gash, hinged over the actor's right eye, spread wide like the top of his head was coming off.

There were five of us in that tiny car to achieve this effect. John Moio, the stunt coordinator, drove the car while leaning out the driver's side. The cameraman and I were

Yuppie chainsaw victim....

on the back, on top of the trunk. The dummy head and stand were fastened to the floor of the driver seat area, and an assistant was lying under it. His job was to be the hands of the driver/victim entering the frame during the effect. His hands needed to be seen in this shot to match the front angle of the actor's hands. It is always a good idea to feature some live, real body part in a shot of a fake one. It adds life to the fake one. Another assistant was on the passenger side floor, pumping the blood. I pulled an invisible thread raising the scalp, making it slide off.

The film was released unrated, but so much stuff, effects stuff, was left out. Stuff that would have given some more personality to the film. For example: The scene in a parking garage where the chainsaw family catering van pulls in amidst football fans who are celebrating the game by destroying someone's car. "Hook 'em horns" was the cry as the fans gave the extended index and little finger horns sign with their hands. The chainsaw family cook character peeps out yelling, "Free croissants!" The fans approach the van, 'Leatherface'

jumps out, chainsaw screaming, and slices them to bits. Part of my job that night was to sit within the scurrying fans, throwing body parts under the van to land at specific spots on the other side, near the camera.

(Above) Three heads and three "takes" for the chainsaw decapitation effect.
(Below) The aftermath. This scene was cut from the final film.

One poor fan gets the chainsaw right across the face cleaving the top part of his head off. Another fan gets his hand sawed off. The hand hits the floor, quivers, and its 'Hook em Horns' sign changes into the extended finger "F---- You" sign.

We made up a bunch of body parts by casting each other and making polyfoam body parts from the castings. I'd dip them into a blood bucket and toss them under the truck, and was scored for the accuracy of my throws. I think my best throw was a 9.6. John Vulich (Optic Nerve) volunteered to be the fan whose hand is sawed off. John is also the guy in **DAY OF THE DEAD** who got the shovel in the face. We cast his hand to below the wrist in alginate, filled the cast with a 50/50 mixture of Roma Plastilina and Leisure clay. The finished clay hand was then reshaped to give the "Hook 'em Horns" sign. We made our negative stone molds from this reshaped clay positive then duplicated it in polyfoam. Blood tubing was inserted through the polyfoam to the wrist area, and the hand was taken off. Copper tubing in the hand section fit over slightly smaller diameter copper tubing in the arm section. When the chainsaw approached the wrist, we simply pulled back on the tubing in the arm, it disconnected from the tubing in the hand, and hand fell off. For the quivering hand on the floor of the truck, I had the special effects guys cut a hole in the floor of the van, and I laid under it with my hand through the hole. Bart Mixon had sculpted a severed hand appliance to attach to my wrist. John Vulich applied it to make my hand look like a severed hand laying there. When the director cued me I twitched and gave 'Leatherface' the "Bird." When we first tested this hand and appliance trick we did it with my hand in a cardboard box, and I walked through the

(Top) severed hand "gag" appliance sculpture.
(Center) My hand made up for the hand gag, also cut from the film.
(Bottom) First fitting for the face mask.

production office showing the secretaries this box with a severed hand in it. You should have seen them scream when I made it move.

The 'Leatherface' mask was sculpted by Mitch Devane, (BRAM STOKER'S DRACULA, MRS. DOUBTFIRE) from a combination of our ideas. We wanted it to look like it had been made from two or three people's faces of different ethnic backgrounds. One section had a punched-in gray beard. Another had a different skin color and texture. A simple plaster mold was made of the sculpture. Latex was brushed in, reinforced with burlap cloth and stained to look like leather. We cut it apart and crudely stitched the sections together with leather shoestrings. R.A. Mihailoff's lips were coated with a hideous raw, red, sore encrusted stipple. The final touch was a set of rotten dentures I made for him to wear.

Bill Mosely, who played Johnny in NOLD, mugs as Platehead.

The 'Platehead' makeup on Bill Mosely ('Johnny' in my **NIGHT OF THE LIVING DEAD 1990**) began when Bill let me shave his head. I convinced him it would be a lot easier, and take less time to apply each time, if he were bald. We cast the section of his head that would be metal, and had a plate made of sterling silver. Actually, two plates were made for days when we had to makeup his stunt double to look just like him. Sean McEnroe (**GREYSTOKE, MICHAEL JACKSON'S THRILLER, AMERICAN WEREWOLF IN LONDON**) applied a doughnut-like appliance over the plate, blending it into his bald head. Sean devised the face color and the hairpieces which were glued onto Bill's head. Bill also wore a set of rotten dentures.

One day, the producers sent over a bunch of guys and said pick one to be 'Grandpa'. I picked Ken Everett because of his sunken eyes and thin face. I wanted 'Grandpa' to look thin and sunken even after the addition of a foam latex makeup. Ken had very long hair and a full beard. It was necessary to shave him completely for this role. We made a cast of his head and shoulders and hands and arms. Old age sculptures were made on the back of his hand and arm casts, and then molded and duplicated in foam latex. The head and neck of Grandpa required a BREAKDOWN makeup like Jason in **FRIDAY THE 13TH PART IV**.

The BREAKDOWN procedure is to first coat the lifecast with a dental separator like Alcote before any clay is applied. Two or three coats are necessary. When the Alcote dries, the sculpture can begin. John Vulich sculpted 'Grandpa' over the coated lifecast with suggestions from me like the sores around his mouth. I thought most of the chainsaw family would be especially creepy with sores around their mouths. We followed the Richard Corson book **STAGE MAKEUP** and the section on Dustin Hoffman's makeup

for **LITTLE BIG MAN** by Dick Smith. There were five foam latex sections comprising our makeup, plus hollow latex ears.

When the sculpture is complete, lines are cut into the clay separating the sections that will eventually become the foam latex appliances, **(Figure 1.)** The nose and upper lip, the forehead and top of the head, the chin, the hump on the back of the neck, and one section making up the cheekbones jowls and neck. The ears were sculpted separately. These lines are cut into the clay along natural lines. You must think ahead when sculpting a character so these areas will be quite thin. After the clay is cut, the whole thing, lifecast and sculpture, is placed under water for a few hours. We were in Texas, so finding a horse trough made it easy to soak these sculptures. A large garbage can lined with a plastic bag will do.

The water soaks into the lifecast re-wetting the Alcote separator under the clay sections. The clay can be removed now with gentle prying. Sometimes, if you are lucky, it just slides right off. The clay sections are carefully stored away until individual molds are made on which these clay sections can be placed. These individual molds are made from the lifecast. We'll use the nose as an example.

Place the clay nose back on the lifemask. Draw a pencil line around the nose about an inch beyond the clay edge. Remove the clay and make a cast of the penciled nose area of the lifecast in alginate, **(Figure 2.)** Cast the positive in Ultracal 30 and give it a nice base. To create a base you can use rubber floor matting from a hardware store. Tape a section together in the shape of a cylinder slightly larger than the nose area positive and pour in an about an inch or two of Ultracal 30. (See Grande Illusions part 1, Foam Latex). When it reaches the gelling stage, you can imbed the Ultracal 30 nose positive, **(Figures A & B.)** Remove the floor matting, clean up the rough areas, and you now have a plaster based

(Left) Painted foam skin for the hitchhiker dummy.
(Right) The finished effect.

Sculpture for Lou Perry, who played "the skinned man."

nose positive on which you can place the clay nose sculpture. The edge is tooled down, keys are made on the surface, and a separator, Vaseline, is applied to the plaster around the nose. A negative plaster mold is made of the nose by using the floor matting taped together again so that the nose mold and base are sealed within the rubber cylinder. Pour in the Ultracal 30 to make the top half of the foam latex nose molds **(Figures C, D & E.)** The other sections are made this same way except you don't need a base for the cheekbone-jowl-neck molds.

The 'Hitchhiker', for those of you who might not know, is the dead brother of "Platehead." He was the creepy guy in the first film, with the weird tattoo on his face, who did all of Grandpa's bidding. The Chainsaw Family kept him around from the first film and Leatherface used him as the killer puppet at the beginning of this film. It involved two sculptures by Mitch Devane. The hands, and the face, neck and shoulder mask. Our idea was that whatever was left of this guy had been maintained over

the years by the Chainsaw Family. He should have the damage incurred in the first film, plus crude stitches holding part of his head together, some exposed bone, and large marbles where his eyes were.

Mitch sculpted into a clay casting (Clay Press, which means melting clay to pour into an existing mold) of Bill Mosely. A foam latex skin was made from this and stretched over a plastic skull. It was painted like old dry leather, the face was stitched, hair was punched in and the marbles added. Sean McEnroe and I built his body out of dowel rods and foam sheeting. We built it so the joints would bend realistically. The hands and feet were made of polyfoam and attached last.

The 'Skinned Guy' was played by Lou Perry. He was also the guy in **POLTER-GEIST** leaning through the kitchen window tasting the food on the stove, wearing a Teamster T-shirt. Obviously, this is some kind of statement. He was a lot of fun for us and a great sport about wearing the makeup. I as-

Lou Perry with appliance in place for "the skinned guy."

signed this project to Gino Crognale, who I affectionately call Onig. He calls me Mot. Get it? I don't know why. He made incredibly anatomically accurate sculptures of a skinned head, face, neck, collarbone, chest, forearm, hand, and leg. In the dark! I remember constantly walking over to this dark corner of the workshop where he was working to say, "Onig, throw a little light on the subject." There were no lights on in his area. Just dim room light but there he was sculpting away, and the results were amazing!

On a head and shoulder cast of Lou Perry, Onig sculpted the head, face, neck and collarbone and did a Breakdown into separate appliance molds. The chest, leg, and hand were sculpted and produced from individual casts. We had daily foam latex runs in the foam room, or The Hell Hole as I called it, where Gabe Bartolas ran the foam. He had the music so loud that I could walk in, unseen, scream his name as loud as I could and he wouldn't hear me. I had to tap him on the shoulder to get his attention. This, and the strong ammonia smell made it The Hell Hole, from which a steady stream of appliances came forth daily. Onig painted the 'Skinned Guy' appliances and on the day when 'Skinned Guy' was needed, it took all of us hours to apply them.

A strange thing happened on the set with this makeup. As you can see from the photos, the skinned makeup had what's left of the facial skin still around the eyes and mouth. Gino created a separate mask of Lou with these areas of his facial skin missing. Toby Hooper used it in the film for the scene where Leatherface places Lou's skinned face on the head of Caroline Williams, the 'Stretch' character. On the day we filmed this sequence Toby had Caroline take the skinned face off herself and place it back on Lou. This was not anticipated by us and not scripted. The cut

(Top) Chain-sawed stomach effect sculpture.
(Center) Painted appliance.
(Bottom) Finished effect.

out areas lined up, even though made separately, and looked just like Lou Perry. It was creepy.

The final effect scene was the chainsaw fight between Leatherface and Dennis Hopper. For the finale, Dennis Hopper stabs his chainsaw right through Leatherface. The effects guys built this great trick chainsaw, like the Steve Martin arrow through the head gag. Once it was strapped onto a stunt guy, the chain blade rotated in front and in back of him. All that was missing was a juicy belly wound for the front part to rest inside. I asked Sean McEnroe to sculpt one for us and I swear, ten minutes later he was done. It was like I turned to look at something, turned back and there it was. He sculpted it in water-based clay, made a quick plaster mold and we had appliances the next day. Or was it that afternoon?

The 'Grandmother', as well as hundreds of set decorations, was sculpted and created by this really cool guy, the Assistant Art Director, Daniel Miller. The last I heard, Dan had created the huge cookie in **HONEY I SHRUNK THE KIDS**. ☠

Gramps, start to finish.

BLOODSUCKING PHARAOHS IN PITTSBURGH

I know, I know, what a title. Well, it could be worse, it used to be called **PICKING UP THE PIECES**.

Whenever I show my resume to someone, this one always gets a laugh. Which is fitting since it is a comedy. But we got to do some serious makeup effects in it. One of them was a unique way to do an autopsy. The Director wanted to begin the shot in the autopsy room with the tag on the big toe of the victim, then pan up to show the autopsy in progress. This meant an extreme close-up of the foot, which had to look real, rising up to reveal the autopsied cadaver which had to look real, without cutting away. My solution was to use a real person from the neck up, and from the knees down. I could explain this but just look at the photo and I think you'll get the idea. All we had to make was an autopsied torso and lay it on Debbie Gordon for the shot. That's Carol McClenahan underneath the table. We used the same torso for an autopsy scene in HEARTSTOPPER. We could just lay it on anyone and it would work. Yep, one size fits all.

Gerry Gergeley works on cadaver makeup on Debbie Gordon, while Carol McClenahan give this effect legs to stand on.

We made the autopsied torso by casting Debbie Gordon's torso with plaster bandages and then brushed latex into the finished cast. We backed the latex by pouring poly foam into it. The result was a rubber torso with a thin latex skin. We simply dug out the center section and glued in a piece of skeleton rib cage we had lying around. Jerry Gergeley sculpted the rest of the interior autopsy look with latex and cotton.

I'm always doing terrible things to my friend Taso Stavrakis. For **DAY OF THE DEAD** we were sitting around thinking of ways to kill the actors, and when it came to Taso, I said, "He's my friend, let's tear his head off." And we did. For this film I shot him in the chest a few times, blew his ear off, and shot him in the head. Don't forget, this is a comedy. The shot in the head is two techniques and two kinds of explosions. You have to see an entrance wound and an exit . I've talked about a sophisticated way we did squibs on Adrian Barbeau in Grande Illusions part one for the **CREEPSHOW** section, but with the limited budget and time on this film, I had to kill Taso with a simpler technique. First of all I must tell you that you need a **Federal Explosive License** to buy and use the squibs I'm talking about. **You** are not allowed to use them without such a license. I am **not** responsible if you do. You are warned.

THIS INFORMATION IS PRESENTED IN GOOD FAITH BUT NO WARRANTY, EXPRESS OR IMPLIED, IS GIVEN AND TOM SAVINI ASSUMES NO LIABILITY IN PRESENTING THIS INFORMATION.

Whew! There, I hope I scared you.

For the entrance wound, a small section of Taso's hair was lifted and pinned back. The area under this hair was painted with surgical glue. A specially made cushioned metal plate was imbedded into this glue. A small **professional** squib, or explosive device was super-glued into a special chamber on this plate. A little blood bag is glued over the

Autopsy Effect.
(Top) Generic autopsy effect torso worn by Debby Gordon (Below)

explosive, and hair is glued onto the blood bag. The pinned up hair is released and combed into the fake hair on the blood bag.

You really don't see the exit wound. What you do see is blood splash against the wall from behind Taso's head. This was done by using a larger cushioned metal plate that is simply clipped over the hair behind the head. You don't have to conceal it under the hair because it is not seen in the shot. The squib is placed inside a blood filled condom glued to the plate. The entrance wound squib and this condom squib are wired together so when detonated they both go off at the same time. The result is that you see the entrance explosion with blood and hair flying the same time that blood splashes out against the wall. The exit is best when the victim is standing next to a wall or something so the blood explodes against it.

I've seen a lot of different techniques for body hits with squibs, but they're all basically the same. A cushioned metal plate is used to protect the victim. I've also seen leather plates used. A squib is glued into a special chamber on the plate. I always glue the squib to the plate. I don't want to take any chances that the squib might move away from the plate before detonation. A blood bag is fastened over the squib. I usually tape all this together like a sandwich in a nice little package. The section of clothing taking the hit is turned inside out and distressed or weakened with sandpaper or a razor blade. The package is taped securely to the distressed area with the squib facing the costume, of course. You press the button and blam, the squib blows a hole through the bottom of the blood bag and the costume, the victim appears to bleed a bit, and you have a body hit. We did this to Taso a lot. He was a bloody mess by midnight.

The first victim in the film has the top of her head sliced off and her brain is stolen. *Don't forget, this is a comedy!* We don't see any of

The foam rubber cast with glass eyes, and plastic skull plate.

this happen to her. We see the aftermath. So, that's what we had to build. We cast the actress from the shoulders up in alginate. We poured a clay positive of her and sculpted on a pair of huge you-know-whats. Hey, it's a comedy! Well, they weren't that big. We made a silicone mold of the finished sculpture, eyes open wide, mouth open wide in surprise, and poured in polyfoam, giving us a rubber dummy of the victim. We tore off the top of it's head, glued in the bottom half of a plastic skull, put in a little brain matter (cotton and latex), added glass eyes, lipstick, makeup and hair, stuck it in the car window and voila', instant special makeup effect. Oh yeah, we also drenched it with blood as you can see in the photo.

The killer kills another hapless little lady with a parking meter. A what? A parking meter! This one was a lot of fun. It's a summer night, and anyone walking, or passing by on a bus,

(Above) Wig, eyebrows, eyelashes, makeup and costume are added.
(below) Brain matter and blood complete the gag.

(Above) Clay sculpture for stomach wound.
(Below) Arrow-thru-the-head gag with a parking meter.

Appliance in place and ready for the blood to complete the effect.

saw in the bright lights... us... attaching a parking meter to this woman lying on the sidewalk. Hey, it's a living!

For this, we cast the actor's stomach area and sculpted a latex piece that we thought would be fitting if someone stuck her in the stomach with a parking meter. The piece was glued onto her stomach and bloodied up. She lay down inside what is basically the old Steve Martin Arrow-in-the-head gag, but in this case, it's a parking meter built by the prop guys.

The best effect in the film is the meltdown of Farouk. He's sitting in a magical brew of body parts, including the aforementioned brain, a ditsy Egyptian bimbo drops a tear into the mess and he sort of disintegrates. All on no budget and no time.

We made a cast of the actor's head and shoulders and created a foam latex likeness of him. Just a skin really, using the techniques described in Grande Illusions I for making a core mold.

The plan was to stretch this skin over a mechanical skull to give this false Farouk some movement while he melted away. Actually he never really melted away. His

face kind of slides off revealing all this underlying smoking, bubbling tissue. Then his eyes explode. Comedy!

Will Huff and I welded a framework for the skull and shoulders to a baseboard. Will mechanized the whole thing so the head could tilt up and down, and open it's mouth.

Mechanical underskull.

(Upper Left) Underskull with "juice" tubes.
(Upper Right) Farouk effect, ready to shoot.
(Lower Right) The aftermath/pre-exploding eyes .

We lucked out. The foam skin fit perfectly over this mechanism. Even the teeth on the skull lined up behind Farouk's rubber lips.

We removed the skin and glued pairs of tubes all over the inside of the skull. Through one tube we pumped Citric acid, and Tartaric Acid through the other. Each was dissolved with red food coloring first. The tubes emptied out onto various sections of the skull. The eye sockets, the cheekbones, the mouth. When these solutions hit each other, they went nuts. We pumped a smoking solution through other tubes as well.

In the scene Farouk reaches up to his face and screams. We painted little red cracks all over his face. We cut away and then come back to the dummy of Farouk with

someone's hands pulling the face apart at those cracks. We pumped the solutions and the smoke while someone made the head move and the mouth open. Red bubbles and foam spit at each other. The real hands stayed in the frame adding realism to the dummy.

Then his eyes explode. Comedy!

We blew up condoms just enough to make a ball the size of an eye. Greg Funk painted eyes on the condoms, and I added a dab of five minute epoxy over them to get a raised cornea and shine. We tucked these neatly into the eye sockets. I had planted little explosive squibs in the bottom of each socket. When I thought we had enough good foam, bubbles and smoke, I cued Will to make the dummy scream and I exploded the eyes. Juicy!

I've cut the heads off some of my closest friends. Why should Pat Logan, my best friend for over thirty-five years, be an exception. Pat played Lobar. (He also played Uncle Rege in my NIGHT OF THE LIVING DEAD), and we decided he should lose his head. I'm glad I suggested that he shave his head for the audition because he got the part, and it made it easier for us to cast him... Pat's a big old guy, but he wasn't too jolly when we cast his entire upper body to produce his likeness in polyfoam. We made three poly-foam heads and one upper body from a huge separate plaster bandage mold. This mold was so big, we nicknamed it Robocop. We made a ghastly neck wound and glued in some tubing to spray blood. The torso, the costume, and a replaceable head were strapped onto a tall director's chair and I actually swung the ceremonial blade off-camera decapitation yet another friend. It's a living. ☠

(Top to Bottom) Pat with spare head., more spare heads, looking down his neck, and dummy ready for beheading.

HEARTSTOPPER

HEARTSTOPPER is a neat little vampire story directed by Jack Russo, where I play Lt. Ron Vargo, and chase down a colonial vampire played by Kevin Kindlon. Like a snake, this vampires' saliva causes physical trauma like the swelling of little Dina's (my niece) hand. A cast of her hand was made in Alginate, and a stone positive was made. The swollen hand sculpture was created on the positive and a foam latex glove was created, applied and painted. The autopsied female was a recycling of the autopsy prosthetic created and used in BLOODSUCKING PHARAOHS IN PITTS-BURGH. When I finally catch up to the vampire, I shoot him in the chest and then blow his brains out before he falls off a bridge into one of our major rivers here and regenerates. Both appliances were made from casts of Kevin's chest and head in foam latex. ☠

(Opposite Page) Kevin Kindlon wears chest wound appliance.
(Above) Dina wears hand appliance.
(Bottom Left) Autopsy appliance in place.
(Bottom Right) "Brains-blow-out" appliance.

TALES FROM THE DARKSIDE

INSIDE THE CLOSET

This is the first thing I ever directed and I wanted the creature to be something special. I had never done a full size mechanical creature before. There wasn't a lot of time and hardly any money, and that was the challenge. I budgeted my time into first creating the creature (affectionately named "Lizzy,") then creating a shot list for the story. Over a wire armature, I sculpted Lizzy in Roma clay in two weeks. I laid her on her back on a pipe stand and hot glued blocks of wood together to a height that would be about halfway into her torso. The blocks served as a base on which I could lay water clay to form a separating wall to pour plaster on to create the front half of her upper torso mold. I remember waking my wife up at three in the morning to come downstairs and help me turn Lizzy over to do the back half. Once I had the upper torso molded, I cut off her arms, to be molded separately, and molded her lower body overlapping the area

Lizzie, in her bed of boards.

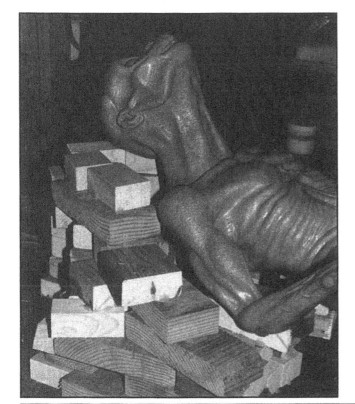

Lizzy sculpture, ready for lower torso molding.

of her midsection covered by the upper torso mold. From a core made from the upper torso, a fiberglass chest and head was made for the foam latex Lizzy to fit over. This is the same technique used for making a fiberglass underskull for a mechanical mask like "Fluffy" in CREEPSHOW. While I created the shot list, Dave Kindlon mechanized Lizzie's face and hands and Pat Tantalo ran the foam latex. I created her teeth and painted her. She runs around nude, so I gave her a hanging sort of belly to disguise her sex. She was basically a rod puppet with rods that could bend around the actors, moving her arms. Me, Greg Nicotero, Dave Kindlon, and the Lauditi brothers, Anthony and Joe, were the puppeteers.

(Top) *The Arms are cast separately.*
(Middle) *Solid foam lower torso.*
(Bottom) *Mechanical underskull*

Grande Illusions Trading Card #62

Greg Funk in NIGHT OF THE LIVING DEAD '90

The best zombie in NIGHT OF THE LIVING DEAD

Grandpa

Brad Dourif as Geletinhead

Me and my daughter Lia

The "bloody" crew for BLOODSUCKING PHAROES IN PITTSBURGH

Making up Andy Warhol for INTERVIEW magazine

C-4

C-5

Butch from CREEPSHOW 2

Me, Greg and Butch

Peeling off the Creep make-up for CREEPSHOW 2

Me as The Creep

Darianne Egisio with a KNB alligator

Will Wheaton as Mr. Stitch

Me as a vampire in DUSK TILL DAWN

Pat Logan as Uncle Rege

Bernice cadaver in TWO EVIL EYES

Cat sculpture from TWO EVIL EYES

Greg and Will customized dust masks

Me, Jerry Gergely and Greg Funk

The kitten meal in TWO EVIL EYES

(Top) Lizzie and her lighting/stunt double. (Bottom) On the set, preparing the Lizzie attack on Roberta Weiss.

the fake hair on the blood bag.

HALLOWEEN CANDY

If Christmas has Santa Claus, and Easter has the Easter Bunny, then Halloween has "Butch." That's the premise in this story I directed, and once again no time and little money to create "Butch," and the effects in the story. I decided to bastardize the underskull of a demon I made for a film in Hong Kong. We tore the demon skin off and covered the underskull with plastic wrap and made an alginate negative mold of it, which produced a plaster positive on which Howard Berger sculpted an entirely new creature... "Butch. This saved us a mountain of time. Howard also played Butch in the close-ups, wearing the special lenses that were made for the Hong Kong demon. He also sculpted the finger extensions. Greg Nicotero did the hand appliances for John Edward Allen, the little person who played Butch in the wide shots. The Hong Kong demon underskull was already fully mechanized. The facial movements fit the face of Butch because he was sculpted over a cast of the underskull and its' mechanisms. Meantime, Ed French created the withered gelatin head of the Grouchy Old Man, played by Roy Poole.

(Top) Howard Berger wears the mechanical Butch.
(Bottom) Punching Butch's beard.

(Above) Me and my pal, Butch (Howard Berger.)
(Below, Clockwise, starting Upper Left) Howard's finger extensions, Greg's hand sculpture, Ed French creates the gelatine "old man's cadaver head."

FAMILY REUNION

This was the last Darkside episode that I directed, and had to transform a woman and her little boy into werewolves. Do I have to mention "no time or money?" Casts of the boy, Daniel Kelly, and the mom, Patti Tallman, were made by Mike Maddi and sent to me. I duplicated them, lined them up on a table, and created stages in the makeups. I sculpted the upper and lower lip snouts, two for Daniel, and two for Patti, while Taso Stavrakis sculpted the various ear appliances. The beginning stage snouts for both of them were just wolf noses and lower lip pieces. These were worn with fangs over their real teeth. The second stage sculptures included the teeth and longer snouts. They were just foam latex appliances, but the teeth were painted and

Sculpting the upper snout for the little boy werewolf.

60

covered with five minute epoxy which made them look hard and shiny. I hired Mike Maddi to apply the prosthetics. The actors had to stick their tongues out constantly to make these longer snouts look real. Patti's transformation took place, stage to stage, as she turns from one camera angle into another. I wanted Daniel's transformation to be interesting in the time we had to create it. I thought of THE WEREWOLF OF LONDON and Henry Hull transforming as he walked behind pillars. So, I made Daniel transform as he walked towards us, in and out of shadows created by the moonlight through a nearby window. He'd walk into shadows, we'd stop the camera, and Mike would apply more makeup. Then he'd walk out of the shadows in a new stage, etc... ☠.

(Upper Right and Above Left) Sculpting the stages.
(Middle Right) Patti in profile wearing test make-up.
(Bottom Right) The werewolf family reunion.

TWO EVIL EYES

This was really two movies, **THE FACTS IN THE CASE OF MR. VALDEMAR**, directed by George Romero, and **THE BLACK CAT**, directed by Dario Argento.

Bingo O'Malley played Valdemar, a dying man whose will is manipulated by his wife and her lover/lawyer. Before he can sign the last important papers, and while under an hypnotic trance, administered by the lawyer, he dies. His wife finally cannot stand the ghostly moans rising from the basement where Valdemar, hypnotized in death, groans from inside the freezer where they dumped him. She shoots him a few times in his frozen head, but he rises from the basement to kill her. She shoots him a few more times before she dies, then he falls to the floor and disintegrates. Actually more like he deflates as his life finally leaves his frozen, hypnotized, bullet ridden body. We had to do all this to Bingo.

We cast his head and neck, and made two body casts. One lying on his back so we could build his dummy for the freezer shots, and one lying face down, **(Figure 1.)** From this, we made a foam latex skin that stretched over a fiberglass underskull, **(Figure 2,)** so we could build an inflatable/deflatable head **(Figure 3.)** That little tiny hole in the photo is over the one nostril he breathed through during the casting.

Casting Bingo O'Malley for the Mr. Valdemar Cadaver.

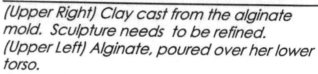

(Upper Right) Clay cast from the alginate mold. Sculpture needs to be refined.
(Upper Left) Alginate, poured over her lower torso.
(Center Left) Our model, Delilah, ready for the body cast.
(Lower Left) Lower body clay cast, refined.
(Lower Right) Gelatin cast of upper torso.
(Below) Same technique created a clay cast of her upper body.

(Upper Left) Gelatin cast, painted, with hair, teeth and eyes added.
(Upper Right) Severed gelatin body, ready to go to the set.
(Center Right) On the set, the finished, severed body.
(Lower Right) High angle shot of severed body.
(Lower Left) Preparing upper body section for shooting.
(Below) Viscera sculpture on upper torso.

(Upper Left) Clay cat sculpture for close-up cat. (Upper Right) Finished mechanical cat for "screeching" and "hissing." (Left) Everett Burrell sculpts the hungry kittens. (Bottom) Mechanical kitten in place for the "eating" scene.

(Above Left) John Vulich's sculpture for the Rami zombie.
(Above Right) Full-face zombie appliance, made from John's sculpture, applied with teeth added.
(Below Left) The mechanical kitten for scene where tail wags and back legs move.
(Below Right) Dead kitten and mechanical kitten in place inside victim's stomach area.

NIGHT OF THE LIVING DEAD '90

This was the first feature film that I directed, and without going through the mountains of problems such an undertaking can create, I'll simply refer to the last page of GRANDE ILLUSION I, on how time can become your enemy on a project. Actually, it was the lack of time that robbed us of some juicy "stuff" we had planned, and the ratings board robbed us of some of the juicy stuff we did shoot. You didn't get to see the head squibs that we did on some of the zombies, or the actual head explosion when Tom shotguns the burning zombie from the truck. I actually fired both barrels of a double barreled shotgun into the fake head of that dummy. The make-up effects and memorable zombies that you did see were created by John Vulich and Everett Burrell (Optic Nerve.) They experimented with gelatin appliances, and used a computer to design zombie concepts. They even did clever little things like enlarging the ears and jawbone of certain zombies to make their faces look more emaciated.

John Vulich and Everett Burrell, OPTIC NERVE.

I am constantly asked at conventions, and by mail, about what was cut from this film, and if there were things I didn't I get to do. Here are storyboards showing some cuts we had to make to satisfy the ratings board, and things we couldn't do due to lack ot time.

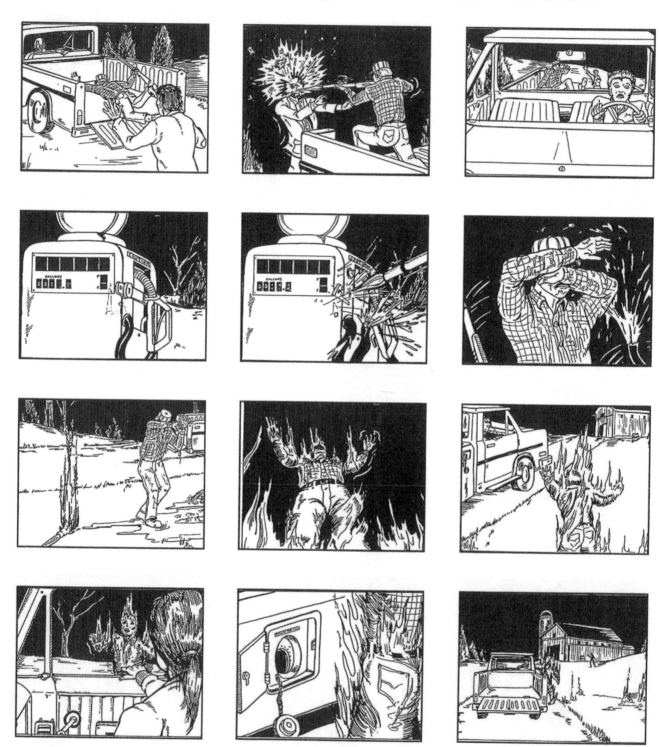

Young Tom actually catching on fire and running to the truck which causes it to explode.

Ben, who is trying to save Barbara from an approaching zombie, sticks the barrel of his gun into the mouth of a zombie which is attacking him, and fires, but the chamber is empty. There's only one round in the pistol and it slowly makes it's way toward the hammer. When it finally fires, we travel (as the bullet,) through the zombie's head to splash blood on Barbara.

Harry's death, at the hands of Barbara, was longer as I originally conceived it. She finds him hiding behind a mirror in the attic and fires through her reflection to kill him. What's left is her distorted image in the mirror. She has changed.

I wanted Barbara to see Ben and Harry placed on the fire together and we would watch, through the photo montage, as they burned into bones, ending on a close up of Barbara's eyes.

We learned an unforgettable lesson: You never have enough time on a movie to give the audience everything you plan. ☠

TRAUMA

Dario said, "Tohm, can-a-you make a leeezzard?" This was at a meeting months before pre-production began. He needed a large mechanical Gecko lizard head for a film called TRAUMA. I said, "Of course Darrrrio!", and looked forward to another illuminating, exciting, and entertaining experience on a movie set with Dario Argento. I wasn't dissapointed.

I never had to build that lizard head but, I could tell from the script and my dealings with the producers, there were things they'd expect from me that were some other

Mummified baby head.

department's problem. So, I made it clear, I was not going to build the murder weapon. I don't do that sort of thing. It was a job for the prop department. They said that was fine and even wrote it into my contract. When Dario heard this he said, "No-No-No-No-No-No!" He insisted that I build the murder weapon. "I trust Savini." So, Will Huff and I designed it, Will built it, and Andy Sands named it the NOOSE-O-MATIC.

It was an electric garotte. A long, thin, sharp wire protruded from a powerful looking device. The killer threw the wire around someone's neck, pressed a button, and SCHWWLLAAAPP, off came their head. In fact, a lot of what we did was make false heads of most of the actors. We started with the handle of an electric screwdriver, added pieces from a surplus bin at a local hardware store, added three 9 volt battery connectors to the surface to show it needed lots of power, and inserted a cable wire pulled into the device on a spool when the button was depressed. The whole thing was a deadly black color. Dario wanted part of it chromed, so we sprayed the top block and Voila', the NOOSE-O-MATIC. When the film was over a member of the prop department stole it for the producers, who took it back to Italy with them.

THE MUMMIFIED BABY is what sends the killer running around decapitating everyone. Her baby was accidentally killed while she was delivering it. It's years later and now she's demented, killing the hospital staff responsible. Hey, I don't write this stuff. I

sculpted the baby from photos of fetal skeletons in one of our many reference books. Chris Martin (friend, fencing partner, joining our staff after hanging around the Pittsburgh workshop and proving himself an 'Artiste') molded him in silicone. We poured him up in polyfoam, painted him, added scraggly white hair, and attached him to a toy baby doll body.

We busied ourselves in the Pittsburgh workshop and eventually moved to one provided us near location in Minneapolis. We couldn't cast actors until we got to Minneapolis. So, we worked on creating rubber hammers and crowbars, the NOOSE-O-MATIC, heads required apart from the actor/victims in the film, including a mummified woman's head cast from among our friends, and my head and torso. I was to play the first victim in the film, decapitated accidently on a construction site by a cable. My head was to roll down a long stairway. The crew cast my head and shoulders in ALGINATE to below my chest, and we poured in melted Roma Plastilina clay

Finishing touches on mummified woman's head.

and Leisure clay (CLAY PRESS). When dry, we cut off the clay head, and Greg Funk sculpted the eyes open, the neck viscera, and the torso. "Bigger pectoral muscles Greg!" We cast it in Foamex XF 111, varying the ratio to produce a dense hard polyfoam head for the stairway roll. We also made a soft one inserting plastic eyes, teeth and a tongue. The effect was cut from the film and the hard head and torso were given to the Fangoria reader auction.

My head and shoulders cast, never used in the finished film.

Will Huff sculpted the mummified woman's head from a CLAY PRESS (melting clay and pouring it, or smearing it into a mold), cast it in polyfoam, painted it, added hair and an old film-covered eyeball inside half-closed eyelids.

The hospital staff victim heads (Issabella Monk, Toni Savini, and Brad Dourif) were all made the same way. Alginate casts were made of their heads and shoulders, and close-up photos were taken of their eyes, ears, hairlines, mouths, and faces with varied expressions, mostly surprised. CIAY

Finished victim heads.

(1) and (2): Threading a hypodermic needle with a long strand of hair. (A) Punching the hair in loops into the head. (B) Shaving the tops of the loops off. (C) Results: A beard stubble.

PRESSES were made and the eyes were sculpted open, or half closed, or one eye open and the other half closed, details were sharpened, molds made, and the heads poured in polyfoam. A severed head-neck-viscera appliance was attached to most heads, made from Greg Funk's sculpture on my torso, or from another generic appliance sculpted by Lou Kiss (another fencing partner, writer, sculptor, martial artist and yes that's his real name). The heads were painted, plastic eyes inserted, teeth and tongues added, and hair was glued on, or punched in, or both.

The polyfoam Brad Dourif head was used as a stunt head. We also made a gelatin head for a required close up. Greg Funk painted very realistic eyes on the stunt head, and Will Huff punched a beard stubble into the gelatin head, one hair at a time using a hypodermic needle. Dario wouldn't touch it. He said it was too real. The stunt head was used in the scene where Brad's head is severed by an elevator, and hurtles down the shaft toward us. The camera was placed high up in the shaft. Greg Funk held the head, mouth first, against the camera lens and let it go falling down the shaft **away** from us. The camera was rolling in reverse, so what we get is the head hurtling **toward** us, mouth first. The gelatin head was used (this didn't make it into the finished film) when the head lands, mouth first, on a steel spike at the bottom.. The spike enters the mouth and protrudes a few inches out the back of the head, which then slides down the spike about half a foot. This was done using a very strong invisible fish-line which had been imbedded in the gelatin head. The head was

placed on the lubricated spike. I was in the shaft above the head, with the fish-line, and yanked it **off** the spike. The reverse camera again, and the head looks like it's landing **on** the spike.

Piper Laurie wouldn't allow a head cast to be made of her. I don't blame her. She had a bad experience with one, and knew she was claustrophobic. However, a scene required her severed head to roll along the floor speaking the word "Nicholas" before it rolls to a stop against a wall. The solution was to make an appliance for her neck which made her own head look like a severed head. Once the appliance was glued on, the area beneath it on her neck was painted black. We sat her on a swivel stool, and the art director placed a floor upright on a track behind her head. The camera framed her a little bit below the appliance. On "Action" we'd spin Piper Laurie on the stool, at the same time moving the floor along behind her. Slightly shaking the camera made it look like her real severed head was rolling along as she spoke. For wider shots we used a head made from an old cast of her, located by our good friend Greg Nicotero (the N of KNB Effects Group).

This same technique was used in an earlier scene where a hospital staff victim's head is lying on the floor trying to speak to (Chris Rydell). This time the actor, wearing a similar neck appliance, is beneath the floor sticking her head up and through a carpet. Dario placed the blood around her neck himself for this scene.

There was a scene where Dario wanted a guy to say something like "I can count that on the fingers of one hand" revealing his hand only has two fingers. An actor was cast who had been born with only a thumb on one hand. The rest of his fingers were just little stumps. Greg Funk made a stone cast of his hand. He cast my index finger in alginate, did a CLAY PRESS of it, and placed it on the index stump of the actor's stone hand cast. When he got it

(Above) Piper Laurie with severed neck appliance.
(Below) My finger attached to fingerless man.

to look like it belonged there, he molded the area and produced a foam latex finger, that could be glued to the actor's hand, making it look like he had two fingers. The actor, who had never had a finger on that hand, joyfully brandished it all day. ☠

PUNCHING HAIR

I have found that most makeup artists I come in contact with, know very little about hair-work. To be well rounded in this science, you should be able to ventilate a realistic hairpiece, build a beard from scratch on an actor, or punch in a hairline on a fake head or appliance. Richard Corson's book, STAGE MAKEUP, has great techniques for ventilating and building. In GRANDE ILLUSIONS I, I explained how to make a hair punching needle out of a sewing needle. Here is how to actually punch a realistic hairline. The main body of hair should be a mixture of hair colors mostly the shade you want. For example: brown hair is made up of mostly brown hair but the body of it should also contain some light brown, some red, some blonde, etc... First, some main body color hair is usually glued on, leaving about a two inch, or more, space before the hairline. At this point, the hair you choose to punch in, using the shades in the body of hair, should start getting lighter in color the closer you get to the front. The lightest being at the very front.

Start by wrapping a length of hairs around the index finger of your left hand if you are right handed, or vise versa for left-handers. With the needle in your right hand you can grab hair off the left index finger, (Figure 1.) The slightly longer prong created on the needle hooks and grabs the hair, in essence, loading the needle, (Figure 2 and 3.) You simply inject, or punch it into a gelatin head as illustrated, (Figure 4 and 5,) or a polyfoam head, or an appliance, or a ball of cheese, if you want to. You should become a hair punching machine able to punch hair into anything, and quickly. The first batches of hair you punch, or plant, can be twelve hairs thick. Don't count them, just plant a generous amount with each punch to start building the body of the hair. The hair isn't just punched in at random until the area is covered, nor is it punched in very straight lines, like a cornfield. In a way, it is both. The first batches are planted in straight lines as if marching out of the glued in hairline, (Figure 6.) You angle the needle to give direction to the hair. Angle the hair so it lays down over the glued in hairline, covering it with newly planted hair. Do this for an inch or more, then start using a mostly lighter shade. Vary the angle of the hair so the direction crisscrosses through the lines, (Figure 7.) Soon it will be like those magic 3-D pictures that look like a lot of random dots until you stare at them for a few seconds. Your eyes will see a natural hairline forming. Extend the lines, crisscrossing again, using lighter shades, and fewer hairs each time, until you are punching in one hair at a time for the lightest shades in the very front. You can pull hair out or punch more in at any time to get the best hairline possible. ☠

Fig. 1

Fig. 2

Fig. 3

Fig. 4

Fig. 5

Fig. 6

Fig. 7

KILLING ZOE

Some guy named Roger Avary wants you to do the effects in his movie, KILLING ZOE." My friend Greg Nicotero hereby recommends me for another job. A few negotiations later, I was in Los Angeles, meeting someone I was to respect and enjoy as a brilliant mind, director, and friend, Roger Avary. He was the guy on this year's (1995) Academy Awards who needed to pee. Remember? I worked for Roger again recently on a thing called MR. STITCH, and I remember telling him at dailies, "KILLING

Soaped-out hair with lace used to distort the actor's features.

ZOE" was no accident, you are brilliant." On almost no money or schedule, he made one truly unique action drama.

With no advance preparation, I had to work out of my makeup kit on the spot. What fun!

I was reliving my past, where my initial love of makeup began, the basics. Creating stuff right out of the kit, no face casts, no appliances, just open the kit and build a makeup just like a kid on Halloween.

ROGER: "Can we shoot a guy in the face, like DAWN OF THE DEAD?"

ME: "Gee, we have no time to make appliances with blood passages and resealable holes... Let's glue buttons onto his face and yank them off through morticians wax."

That's what we did. Of course the effect was cut by the !#$&@#$& MPAA.

ROGER: "Let's shoot the bank manager through the head."

ME: "O.K., we'll do a John Amplas on him from DAY OF THE DEAD."

Also cut... !@^!%@$#&!!! AUGH!!!!

ROGER: "All right, let's blow the old lady's brains out!"

ME: O.K. Cut @#^%$!&^@%!!!

What did remain in the film was a cut on Eric Stoltz's face delivered to him by his psycho friend, actor John Hughes Anglade, by a switch-blade that I rigged with blood tubing. An old trick. It's my hand doing the slicing. For the rest of the film, I simply painted on the cut with highlights and shadows and fake blood.

Vaseline, black powder, fake blood and toilet paper used in a test burn on my arm.

Also remaining in the film is a burn makeup that I did on a gung-ho bank guard after an incendiary grenade is tossed into a vault that he is guarding. From a fabric store, I bought some lace material and glued a piece to his nose, eyelid, and lower lip. I pulled his nose and eyelid up, and his lip down, gluing down the ends of the lace so that his features would stay that way. I flattened out a section of his hair with mousse, soap would also do, and covered this whole side of his face with nonflavored gelatin touched with a bit of red food coloring. When it dried, I covered it with black stage makeup powder and wet sections of it so that the red gelatin would show through.

I also taught John Hughes how to ignite flash paper in his hand from a cigarette for a strange mood setting scene showing his

I also taught John Hughes how to ignite flash paper in his hand from a cigarette for a strange mood setting scene illustration his oncoming madness. John can act more with one eyebrow than some actors can with their whole bodies.

When John is blown away at the end of the film, something like fifty squibs were detonated on him. Roger wanted more blood on him... There were some people dabbing blood on him from a dixie cup with a brush. The last thing I did on the film was to walk over to John and dump two gallons of blood all over him. ☠

(Upper Right) Toni Savini wears painted cut. (Below) Burn makeup over lace (used to pull facial features) and soaped-out hair.

MR. STITCH

Leaping at the chance to work again for Roger Avary, I accepted the job of turning Wil Wheaton into MR. STITCH, a man put together from 44 women and 44 men. A patchwork quilt, if you will, from all walks of life and nationalities.

Once again, Greg Nicotero and KNB EFX GROUP was there for me. They cast Wil Wheaton's head and sent us the molds and vacu-form faces we needed to prep the job at my studio in Pittsburgh.

Mr. Stitch would shoot in Nice, France, and we had about a week and a half to prepare. The script called for Mr. Stitch to escape his secluded environment and discover a room with a beating heart in a vial, a brain, a rejected live Mr. Stitch head and... Roger

Wil wearing special "eyes-rolled-back" lenses.

on the phone, long distance from France..., "Can we have breathing lungs?" I said, "yes," and immediately cut out lung shapes from foam cushioning material, fastened some balloons on them and covered them with sheet rubber. A cotton and latex build up over the tubing that connected them, and, voila', breathing lungs.

Chris Martin sculpted extension arteries and veins on an existing clay heart, remolded it, and with some help from Brett Moore and Brian Freiberger, made the resulting foam rubber heart beat.

For the live rejected Mr. Stitch head, we made a foam latex skin from one of the head molds in our collection. We ripped the skin off the mechanical Greg Nicotero head from DAY OF THE DEAD, and after Chris Martin refurbished and repaired the mechanisms in it, we reskinned it and served it up as the reject live Mr. Stitch head.

We made a foam rubber brain from one of our DAY OF THE DEAD molds and the art department created the wires and gizmos for the scene.

Mr. Stitch played almost every day, so our day began with Wil Wheaton in the make-up chair, the stereo blasting Techno Rock, while we airbrushed diluted rubber mask greasepaint colors through vacu-form masks placed over his face. There were nine vacu-form masks made from Wil's life cast. Chris Martin cut specific shapes out of them, based on

(Above Left) The vacu-form color templates.
(Above Right) Master color guide.
(Below Left) Wil, ready for the airbrush.
(Below Right) First template in place.

designs we received from France. Starting with mask number one, we sprayed a rubber mask greasepaint color, diluted with alcohol, through the cut out shape onto Wil's face. With the mask still in place, we sprayed a shadow color around the border of the shape. Another mask, another color and shadow. When we finished the ninth mask, Wil had a pattern of colors on his face that joined together creating the approved Mr. Stitch pattern. We suggested certain changes in the colors to balance out the finished look. After the makeup

This Page:
(Upper Right) After a few template colors are applied.
(Lower Left) I touch up the edges.
(Lower Right) Wig, eyebrows and Pros-Aide scars added to Wil's face.
Next Page:
(Upper Left and Right) Lungs deflated and inflated.
(Bottom Left) Beating heart.
(Bottom Right) Assistant paints skin patches.

was powdered, we hand painted the stitches. A vacu-form stitch pattern mask we made proved unusable. A pink scar color mixed into Pros-aide and Cabosil was extruded through a small hypodermic syringe creating raised scars separating the colors. The wig was glued on, the hands and feet were sprayed or hand painted, a woman's red fingernail was applied to one finger, and a blue contact lens was placed in his right eye. The Techno music helped. ☠

(Upper Right) Wil, with shaved head and sclera lenses, plays his own embryo.
(Below) the living/mechanical mad-lab head, separated, but attached to its' brain.

CASE MOLDS

In this section I want to show you the bust I sculpted of my father, and how I produced it in plaster from a CASE MOLD. The sculpture survived the process pretty much intact, so I used it to create a bust of FRANKENSTEIN, again from a CASE MOLD.

(1) The finished plaster bust, and the sculpture, of my father,

(2) I sliced off the face, and

(3) attached a CLAY PRESS from a life cast of Boris Karloff,

(4) resculpted the jaw line and ears, and

(5) added the large forehead

(6) and Brow.

(7) Spaghetti like strands of clay were laid on and

(8) flattened out into a hair pattern.

(9) The hair squiggles were smoothed and refined

(10) and I added the bolt in the neck

(11) the hollow to the left cheek

(12) and the scars

(13) finished the eyelids, and gave the whole thing some texture.

(14) The finished sculpture.

(15) After spraying a few coats of crystal clear over it, a water-based clay wall was built isolating the front half

(16) from the back.

(17) Wet paper towels are placed over the front

(18) and covered by half-inch thick water-based clay.

(19) A middle clay wall, and keys are sculpted. and a section of cardboard paper-towel tubing is placed into the clay at the top.

9

10

(20) The Ultracal 30 is applied. Usually when making molds with Ultracal 30, you start with a brush coat to get the detail. You follow that by laying on donut shaped wads of hemp fiber soaked in Ultracal 30 for thickness and strength, then a last coating

(21) to smooth things out. The same is done for the other side in the front.

(22) The clay is cleaned off the back

(23) and the same mold making takes place except the whole back is done at once.

(24) The back mold is removed as well as the half-inch water-based clay, and paper-towels, and the water-based clay is tooled right up to the sculpture creating a fine edge or seam for when the silicone is poured in. Holes are drilled into the raised outer edges of the mold for the screws that will hold the sections

together, and holes are also drilled into the whole back section to create escape vents for the silicone

(25) (This photo shows how the mold will look later with the screws and holes in place)

(26) Everything is ready to mix up G.I. 1000 silicone (10 to 1). Crystal clear is sprayed on the water-based clay edge around the sculpture. The back mold, which has been cleaned of any clay residue, is screwed into the front and silicone is poured into the back through the top paper-towel tubing. Someone should be standing by when the silicone is poured to press clay into the escape vents once a little silicone comes through. This, of course, is done from the bottom up as the silicone fills the mold.

(27) When the silicone is dry (overnight) the front sections of the mold are removed and you can see the layer of silicone around the sculpture, and the plaster encasing it.

(28) The same cleaning procedure is done to the front mold sections and they are replaced. I decided to lay the mold down on it's back before pouring the front silicone. I wanted to lessen the chance of getting air bubbles in the silicone, so I drilled a large hole in the front section for a cardboard pouring tube. The base of the mold was screwed into the turntable, and plaster bandages sealed the edge.

(29) The finished plaster bust, and once again the sculpture is pretty much intact.

(30) So I sculpted Frankenstein into Ardeth Bey, and Ardeth Bey into

(31) the Phantom. (in progress)☠

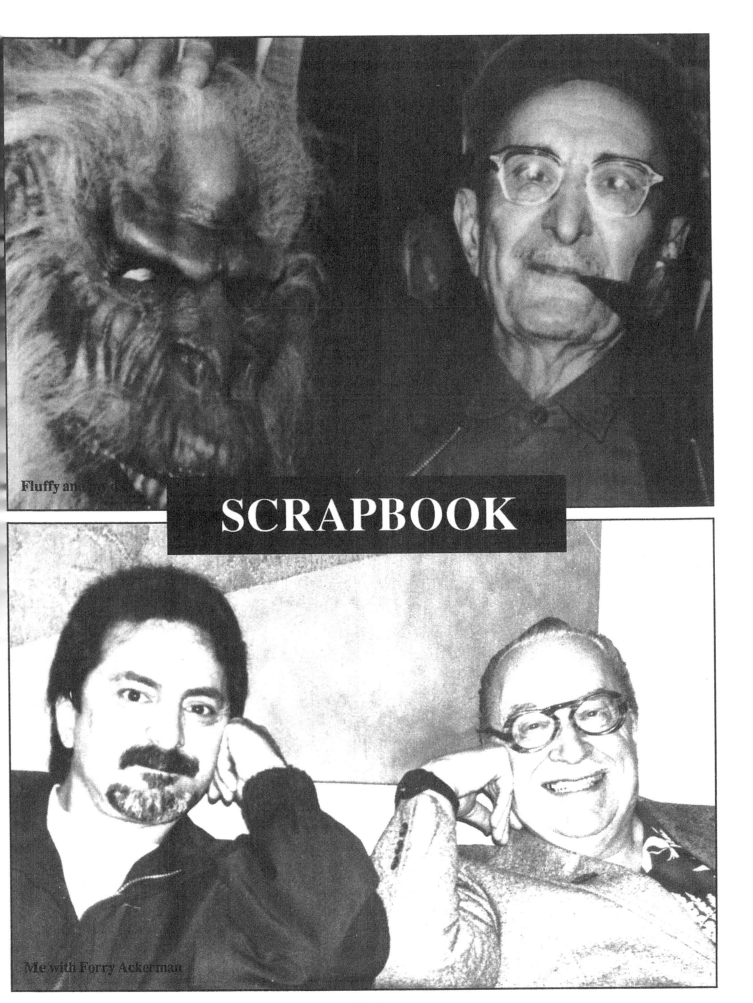

Fluffy and my d[...]

SCRAPBOOK

Me with Forry Ackerman

Makeup Gore Sequence from DUSK TILL DAWN

With Ramona Zini in ENTER THE DARKNESS

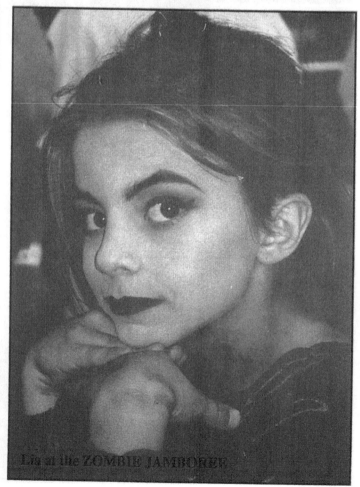

Lia at the ZOMBIE JAMBOREE

Lia Halloween 1994

SCRAPBOOK

BUSTS

My Busts at the Monster Café Universal Studios

I Collect My
Action Figures
Full Size

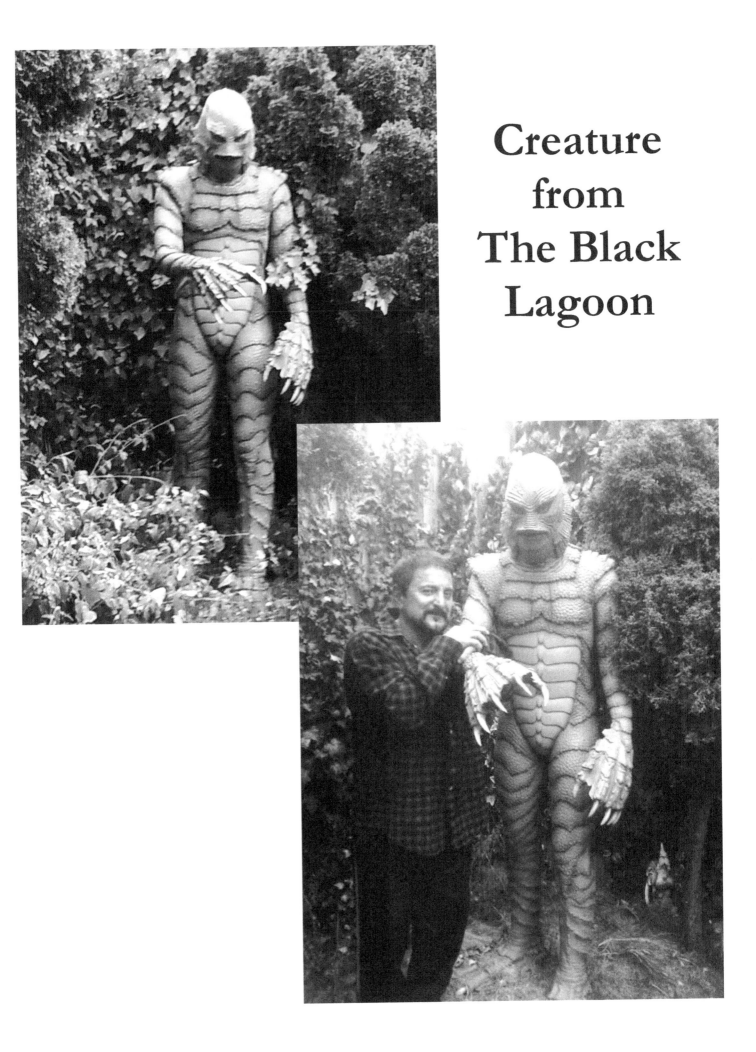

Creature
from
The Black
Lagoon

FLUFFY

With George Romero

My Dad, 85, Visits Creepshow Set

Fluffy Turns on His Master

HARD
AT
WORK

Yuppie on *Texas Chainsaw Massacre 2*

Making Up
Robert Mitchum
for
Maria's Lovers

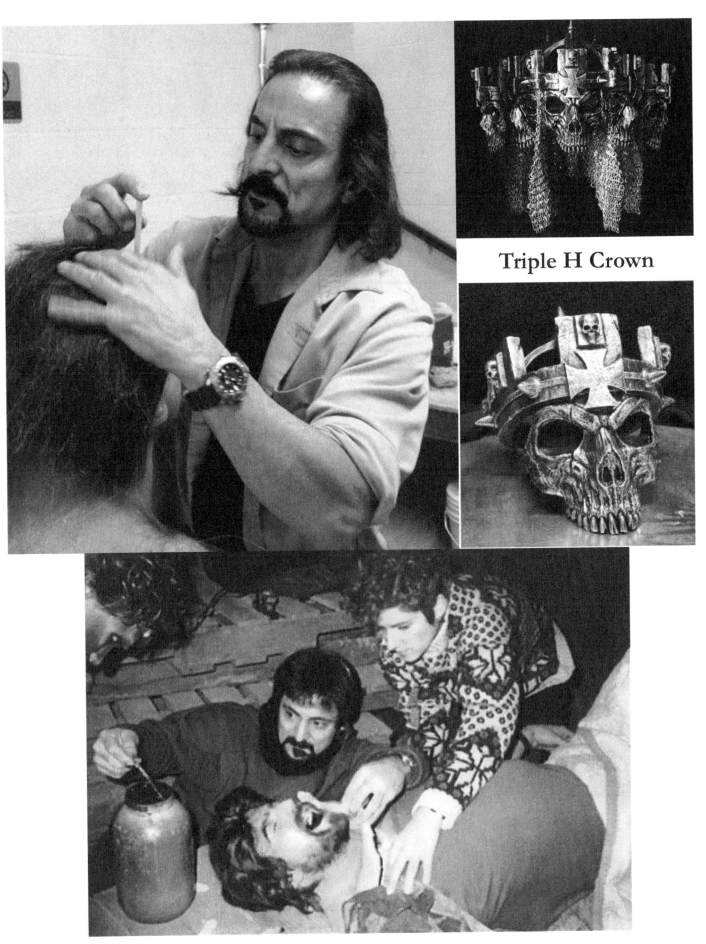

Triple H Crown

Taso's Decapitation, *Dawn of the Dead*

Me and "Regan"

Laying
On
*The
Exorcist*
Stairs

The Fantastiks

"The Great Savini" for Epix Network

Bill Hinzman

Jackie Chan

Dick Smith

Forrest Ackerman

Tom Savini's Terrormania

Gino Grognale and Greg Nicetero

Between Takes on *Texas Chainsaw Massacre 2*

Before the Head Cast for *From Dusk Till Dawn*

Rob Lucas at Universal Studios

Howard Berger

Bishop Make Up, *Loaded Dice*

Barry Gress Bending Over Backwards for Hours

Lia's
Playmate
"Lizzy"

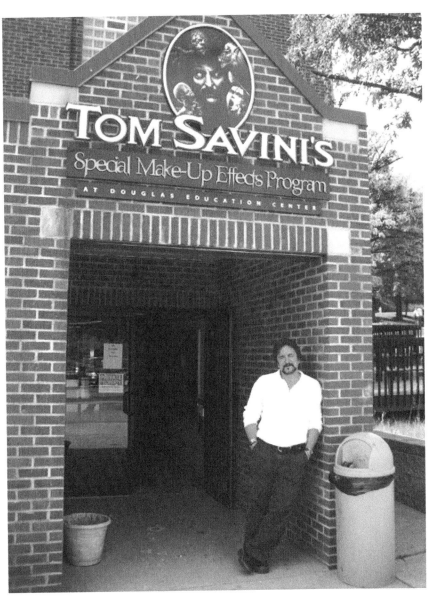

ACKNOWLEDGEMENTS

Forrest J Ackerman, Ackerman Archives, James R Aiello, Jimmy Aiello, Jamie Aiello, American-International Pictures, Maureen Anderson, Beau Barsotti, John and Donna Barsotti, Rob Bottin, Braddock Associates, Rick Catizone, Cinefantastique, Cinema City Company, Ltd., Clark Printing, Fred Clarke, Joseph Conway, Bob Creen, The Cropsy Company, Sean Cunningham, D&J Typesetting, The Darkroom, Inc., Larry Dawgiello, Dawn Associates, Donnis DeCemp, Europix, Fangoria, Filmet, Randall Flemming, Andy Gerroni, Michael Gornick, Barry Gress, Nancy Hare, Darlene Helsel, Barbara Hitler, Mike Kaplan, Stephen King, Katherine Kolbert, Laurel Entertainment, Inc., Laurel-Show, Inc., Lens 14, William Lustig, Magnum Motion Pictures, Bob Martin, Diana Michelucci, R.J. Michelucci, Robert V Michelucci, The Movie Poster Place, Jim Murray, Jessie Nathans, Herbert Nitke, Barbara Nitke, Orion Pictures Corp., Paramount Pictures Corp., George A Romero, Christine Forrest Romero, Richard Rubinstein, Sandhurst Releasing Corp., Annie Sillman, Dick Smith, Terry Smith, Taso Stavrakis, Al Taylor, T-H-S Productions, Inc., Frank Tobin, Cindy Veasy, Video-O-Video (Vic and Toni), David Vogel, Jeff Walker, Warner Communications, Inc., Harvey Weinstein, Richard Wernig, William Wilson, Glenn Wilson, Phil Wilson, Dolores Wilt, Linda Zimmerman.

MAKE-UP SPECIAL EFFECT SUPPLIES

Smooth-On Inc
2000 Saint John Street
Easton, PA 18042
(800) 762-0744
www.Smooth-On.com
(Silicone for molds, prosthetic skins and
appliances, plastic, polyfoams and more)

Chavant Inc
5043 Industrial Road
Farmingdale, NJ 07727
(800) 242-8268
www.Chavant.com
(Various types of clays/non sulphur clays)

The Monster Makers
15901 Hilliard Road, Rear Building
Lakewood, OH 44107
(216) 521-7739
www.MonsterMakers.com
(Latex mask making suppliers)

Ken Banks Tools
(951) 943-1217
www.KensTools.com
(Sculpting Tools)

Motion Pictures F/X Company
2923 Thornton Ave
Burbank, CA 91504
(818) 563-2366
www.MotionPictureFX.com
(All make-up effects stuff)

CPSIA information can be obtained at www.ICGtesting.com
Printed in the USA
BVOW10s1747090814

362252BV00003B/9/P